THE LEGENDS OF HIP HOP

JUSTIN BUA

Harper Design

An Imprint of HarperCollinsPublishers

HarperCollins books may be purchased for educational, business, or sales promotional
use. For information please write: Special Markets Department, HarperCollins*Publishers*,
10 East 53rd Street, New York, NY 10022.

First published in 2011 by
Harper Design
An Imprint of HarperCollins*Publishers*
10 East 53rd Street
New York, NY 10022
Tel: (212) 207–7000
Fax: (212) 207–7654
harperdesign@harpercollins.com
www.harpercollins.com

Distributed throughout the world by:
HarperCollins*Publishers*
10 East 53rd Street
New York, NY 10022
Fax: (212) 207–7654

ISBN 978-0-06-185497-2
Library of Congress Control Number: 2011928657

Designed by Ruby Roth for BUA STUDIOS
Los Angeles, California, USA

Photo credits: All Ruby Roth, except pages 4 and 26 by
Bryan Derballa, www.bryanderballa.com

This page: Detail, *Big Daddy Kane*

Printed in China
First Printing, 2011

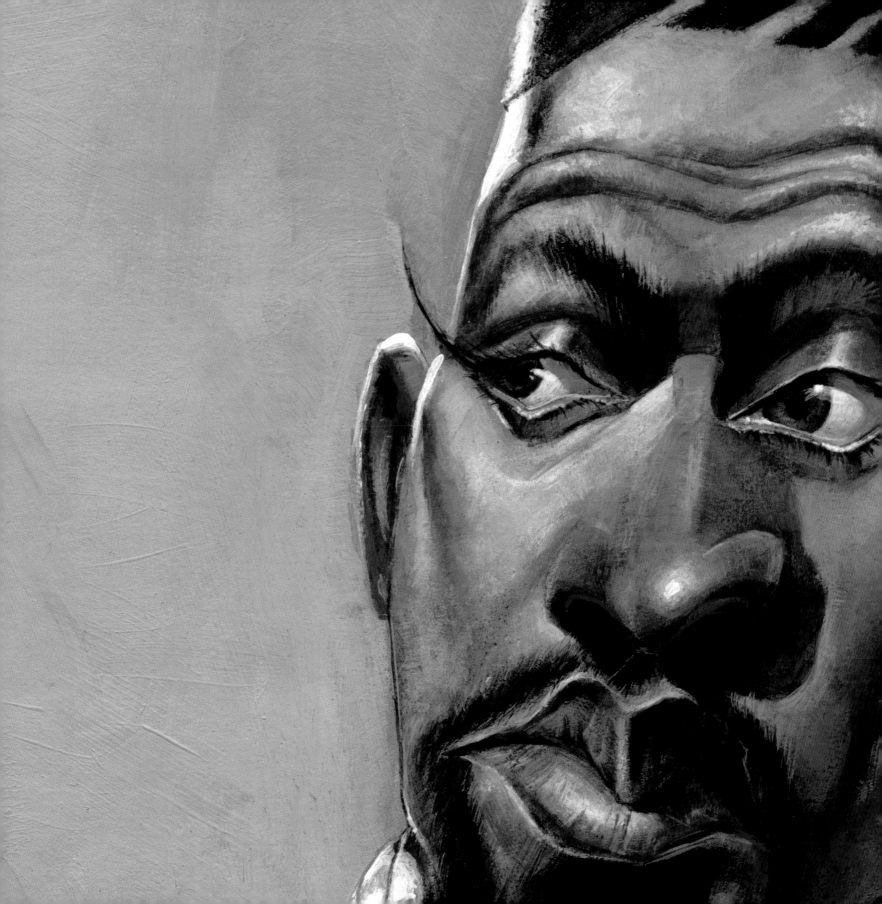

CONTENTS

FOREWORD

I was raised as an art student. My mom taught community theater. The music my parents played echoed off the walls and halls of our home with voices of artists who we welcomed as family. My grandfather taught me how to draw. I went through high school as a student of graphic design and architecture, which led me into a fantastic college experience that culminated with a degree in design in 1984. But enough of me. This is about old-school hip hop saying, "Game, recognize game."

Nearly a decade ago, I was in a gallery in Manhattan when I first peeped this painting of a DJ in electric motion. I was struck by seeing the essence of hip hop illuminated in such a classical style of painting. I couldn't take my eyes off of it. Bias and angular presentations gave off sound and great flow— just on the visual tip alone. The energy reverberated off the walls and into my ears. It felt like the 1970s, 1980s, and 1990s all rolled into one joint. Listed as classic material upon its inception, this painting's description was well-deserved. BUA was the name. Mr. Justin BUA. His work was damn near a flag for the genre I loved so much.

In 2010, I was personally introduced to Justin BUA the artist through a portal of greatness. We came together to work on a project for the legendary Kareem Abdul-Jabbar. BUA was creating complex, standout paintings for the film, *On the Shoulders of Giants*, a story about the under-heralded and greatly unknown Harlem RENS 1939 championship team. I drove into the arts district of downtown Los Angeles to visit BUA Studios, where we were to be filming an interview get-together with Kareem.

Behind the scenes, BUA and I delved into hip hop and art. He walked me around his giant paint-splattered easel, between stacks of canvases, and by bookshelves filled with the works of art history masters. I told him a bit about my design background and named some of my influences—masters like Caravaggio, Norman Rockwell, and J.C. Leyendecker—whose names jumped out at me from BUA's library. BUA took the floor and gave an intense exposé on each artist, going deeper and deeper into art, history, fact, and philosophy. Without a Ph.D., the man knew more about art history than any art professor I've ever known. As he waxed artistic, he wove the legacies of the great masters through time into the fabric of our hip-hop culture.

Justin BUA then showed me the middle stages of his great works-in-progress for *The Legends of Hip Hop*. Today, we are blessed to witness the culmination of this project by a native New Yorker, born and bred in ball, style, and hip hop—with a Cali-love touch.

Justin BUA's *The Legends of Hip Hop* is bringing a Nation of Millions the sight and sound of a movement unlike any historical account that has come before. *The Legends of Hip Hop*, with its first-person narratives together with BUA's portraits of the artists, is an achievement of joy and a lesson at the same time. As you turn the pages, you can't help but hear the soundtrack spit from the pages of this classic, seminal book. So, in the words of the Jimmy Castor Bunch b-boy classic: "It's Just Begun." BRING THE NOISE— this is Justin BUA's *The Legends of Hip Hop* part one!

—CHUCK D

Public Enemy
www.publicenemy.com

INTRODUCTION

First thing's first: This book reflects my personal top picks of the biggest names and legends in the world of hip hop. It is by no means an authoritative list. These individuals have made a profound impact on my life, either directly or indirectly, by virtue of their abilities, talents, and, in some instances, their larger-than-life personalities. In short, these cultural pioneers have helped shape the way I see, hear, and think about the world. I witnessed the birth of hip hop and conversely, hip hop birthed my artistic journey.

The men and women collected here represent some of the world's biggest names in the history of the game and beyond. In the last twenty years, some of the most influential figures of our time have been hip-hop legends. Not only have they chronicled the social and political climate of our age, but they have also transformed it. They are today's nobility, yet most are from the streets, born not from blue blood but from true blood. Because of their accomplishments, we dress differently, talk differently. We even walk, think, and vote differently. These leaders have made their way into the consciousness of the world.

Historically, portrait artists were enlisted to paint the elite aristocracy of their time— kings, queens, dukes, popes, and members of the upper class, the rich. The aristocracy paid good money to have an artist construct a dignified and glamorous portrayal of their life and time; the portrait ensured their place in the canon of history. In simple economic terms: The market dictated the works.

I grew up in New York City during the birth of hip hop, at the peak of Reaganomics. Raised by a working-class mother and an immigrant grandfather who valued art, intellect, and social justice, I've felt an obligation to both the legacies of historical painters as well as artists who were of the people, by the people, and for the people. I personally relate to those artists who painted the poor and the downtrodden, real people from the streets. Rembrandt humanized his subjects, challenging the forms of idyllic beauty so pervasive in Renaissance art. He was the first artist to challenge the idealized representations of Adam and Eve, depicting Adam as a hairy, sinewy, fear-struck mortal; Eve, as a pear-shaped, fat-padded woman, riddled with cellulite. Rembrandt's works spoke to the common man. Artists like Jean-François Millet, George Bellows, Jack Levine, Diego Rivera, and David Alfaro Siqueiros tell the story of the working poor, as does van Gogh in his portrayals of peasant life, Honoré Daumier in his illustrations of the inequities of class, and Kathe Kollwitz in her depiction of poor peoples' uprisings. These artists revealed the unwritten truth of their time and did so by capturing the rawness of life. They gave a voice and a face to the oppressed and the

forgotten, and were able to do so by expressing the latent emotion of their subjects. Art captures what lies beneath. So, while I aim to celebrate the strengths of my subjects, I also hope to dig beneath the surface a bit, if only to reveal genuine emotion or truth, in the purest sense of the word.

At my own gallery shows, I love to observe and listen to people dissect my art. Sometimes the critique is completely on point, and sometimes it's more complicated, and the commentary, while having little to do with my original intention, is so insightful that it resonates more powerfully to me than my own thoughts. Artwork reveals a kind of truth that may not be fully understood until we see it reflected back to us. (When Picasso painted a dark, strange, and brooding portrait of Gertrude Stein, for example, he famously commented, "Everybody says that she does not look like it, but that does not make any difference. She will.") Portrait painting has been a provocative and historical viewfinder through which we see our culture. For this reason, I felt that it was of utmost importance for me to chronicle the legends of hip hop—the kings and queens of my time—in paint, portraiture style.

This project is a culmination of all the legacies I admire and relate to—from the techniques and skills of master painters, to the creativity of MCs, DJs, dancers, and graffiti writers. I wanted to do right by all of them, documenting history, telling truth, and capturing their essences. While this book relates the history of hip hop, it also tells my story. I truly feel that my artistic journey, starting from the place and time I was born— New York City in 1968—has destined me to create this book, my favorite collection thus far. In the 1990s, when I first wanted to put out posters of hip-hop imagery, I came up against a brick wall of resistance. At the time, the market felt that works like *The DJ, 1981, The MC,* and *The Artist* were insignificant and would be unsuitable for the public. Against all odds and warnings, I moved forward. I believed in my paintings because I believed in hip hop. Today, *The DJ* is one of the best-selling posters of our time.

I feel deeply that I owe it to you, my fans, to share my love for these legends because I know that you share that same love. In this way, my art belongs not to me but to you, the people, and our generation, as a telescope for all to look through. This is for the people and the culture I love so much—hip hop.

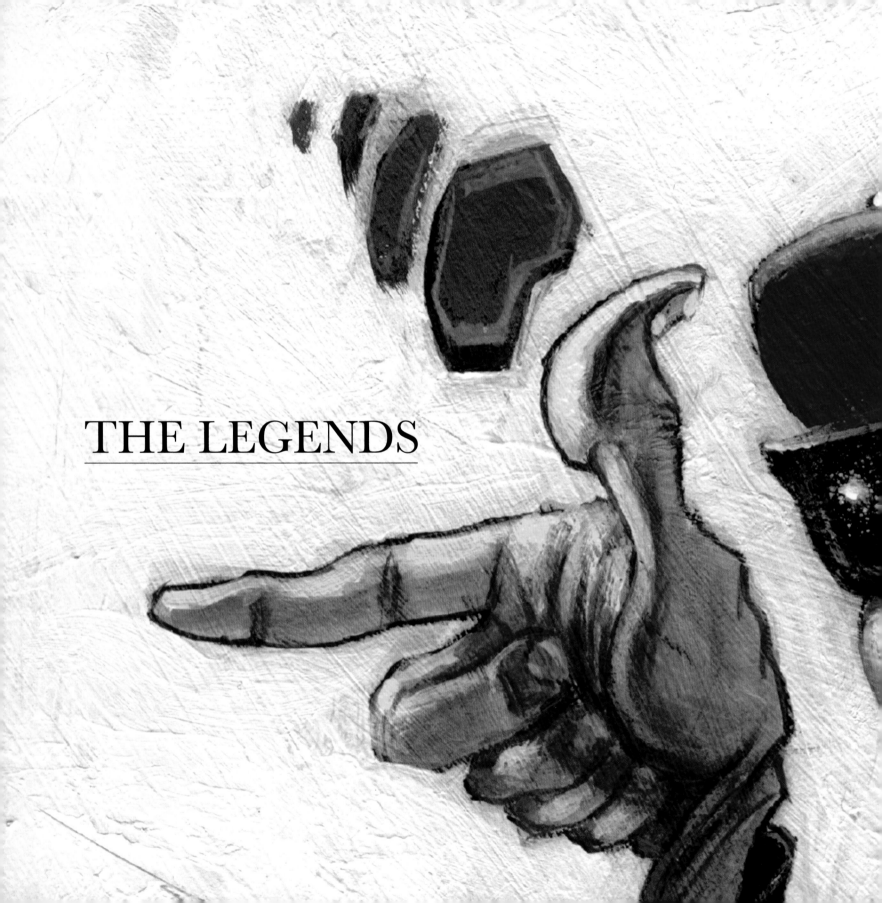

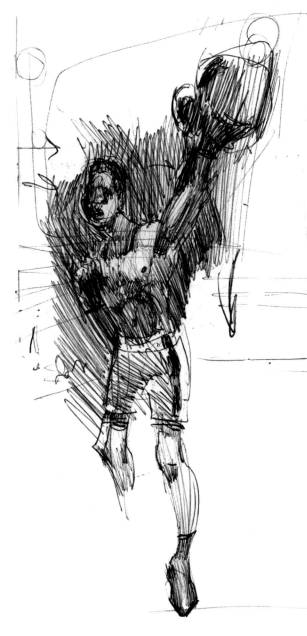

MUHAMMAD ALI

MANIFEST HIP HOP

One of my most vivid childhood memories is of my mom putting her ticket stub from the Muhammad Ali vs. Oscar Bonavena fight at Madison Square Garden into our photo album, right next to her most cherished photo of her mother. "Ali is the greatest man alive," she said. I could feel the love and admiration she had for this man, a stranger. It hit me especially hard because it was in this moment, having grown up without a father in my life, that my mom instilled in me the image of what a man could and should be. Ironically, when I met my father many years later, one of the first things he told me was that he had always wanted to be like Ali, "a legend, a hero, and the greatest of all time."

Ali was a fast-talking, lightning-wit loudmouth who took on superhuman battles and taught an entire generation how to use love, creativity, MC-style battling, self-aggrandizement, intellect, and a sense of humor to triumph over the haters. His dance between imagination and domination paralleled the original tenets of the hip-hop founders. Ali embodied all of the qualities that the hip-hop culture later adopted as its own. But Ali laid the foundation; everyone watched him and took a page from his book to write their own.

In the now legendary 1974 Rumble in the Jungle fight against George Foreman, the world witnessed Ali's absolute mastery of victory. In no way, shape, or form should Ali have been able to beat Foreman. Foreman was a concrete Goliath, and Ali was a mere mortal, but he called upon his masterful MC-like talents to instill the seeds of doubt

in Foreman's imagination. It began long before Ali even set foot in the ring, with Ali goading and prodding Foreman with psychological wordplay; it was a tactic we would see forever after in sports and in the hype that preceded MC, graffiti, and break-dancing battles. Ali's snaps were deep and multilayered, less about the power of physical skill and more about psychological control. He was the first ever to spit rhymes to a massive televised audience, "rapping" rhymes, dropping science, and verbally decimating his adversaries into silence or laughter. . .either way, signaling defeat. His poetry was eloquent and electrifying.

Ali's poetic, prophetic rhymes won over crowds, entertained the media, and penetrated deep into the caverns of Foreman's psyche. The result was a knock-out in the purest form, and an impression of victory that catapulted Ali's name into songs by future legends of hip hop, like LL Cool J's "Mama Said Knock You Out"; Ice Cube's "Stop Snitchin'"; A Tribe Called Quest's "Award Tour"; Digital Underground's "Heartbeat Props"; Erick Sermon's "Payback II"; and Kurtis Blow's "If I Ruled the World."

It didn't matter who you were—absent father, fatherless kid, mother, sister, or brother—anyone who ever had something to fight for loved Ali. He was a voice of resistance, a countercultural martyr, and the stuff that hip hop was made of. Before Public Enemy's "Fight the Power," Ali was already fighting it. Before there was rap, before there was hip hop, there was Ali.

"MUHAMMAD ALI IS A STANDING FIGURE, A CHAMPION FAR BEYOND A MERE PUNCH IN A RING. HE IS A GIFT TO THE EARTH."

—CHUCK D

Opposite:
The Greatest
Acrylic on canvas
24 x 30 in.
2009

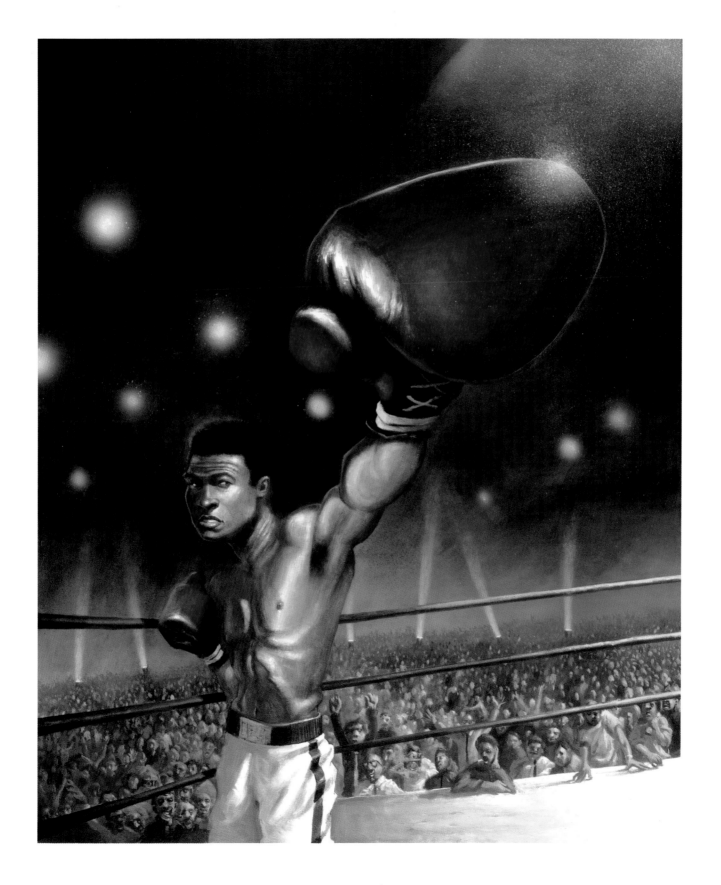

JAMES BROWN

THE EPITOME OF INVENTION

Since I was a child, James Brown has been a part of my consciousness. He has resided in my living room, on my mom's 45s, booming out from the speakers at the Roxy dance club during Afrika Bambaataa's set, in the rhythm of my feet during dance battles at Daisy Cortez's house when her mom was out. When I was fifteen, I danced on the same stage in Italy at the Bussola Domani, where my break-dancing crew opened for Brown during our tour. To this day, on "Boogaloo Night" at the Short Stop bar in Echo Park, James Brown makes my heart surge.

Watch a movie from the 1980s and you might be bothered by the conspicuous slowness of scenes and shots. The passage of time into today's fast-paced world is evident. But I can watch a YouTube video of James Brown now and feel as if I'm seeing him for the first time. His energy is timeless. There are few times in life where you witness something you know is great, not "great" like flash-in-the-pan great, but "Great" like history-of-the-world-genius great, with a capital "G." Brown has spilled over every decade. He is not of his time, of our time—he is *of all* time. He is then, he is now—James Brown is forever.

I don't think there *could* be hip hop without the Hardest Working Man in Show Business. Ask any old-school DJ what break beats they were spinning back in the day— James Brown. Ask any b-boy what they were breaking to—James. He was the funkiest, the freshest, and the most played at every block party. In fact, he is the most sampled artist in hip-hop history, so much so that his music lives in our collective audio unconscious without us even questioning its roots. However, his contributions to hip hop are way beyond just his samples. His moves alone inspired poppers, lockers, b-boys, and house dancers. James's soulful, staccato grunts inspired MCs to rhyme, rap, and "rrrrah" the crowd. We take for granted that without the Godfather of Soul we might all still be dressing like John Travolta and dancing the Russian to disco. James Brown's contributions to hip hop are way too vast and unbelievable to chronicle in one short essay. I'm sure there are books written on just how influential James Brown was on the culture. I can only scratch the surface of how influential James Brown was on hip hop. James Brown might not be hip hop *but* hip hop *is* James Brown.

Opposite:
James Brown
Prisma on paper
18 x 24 in.
2010

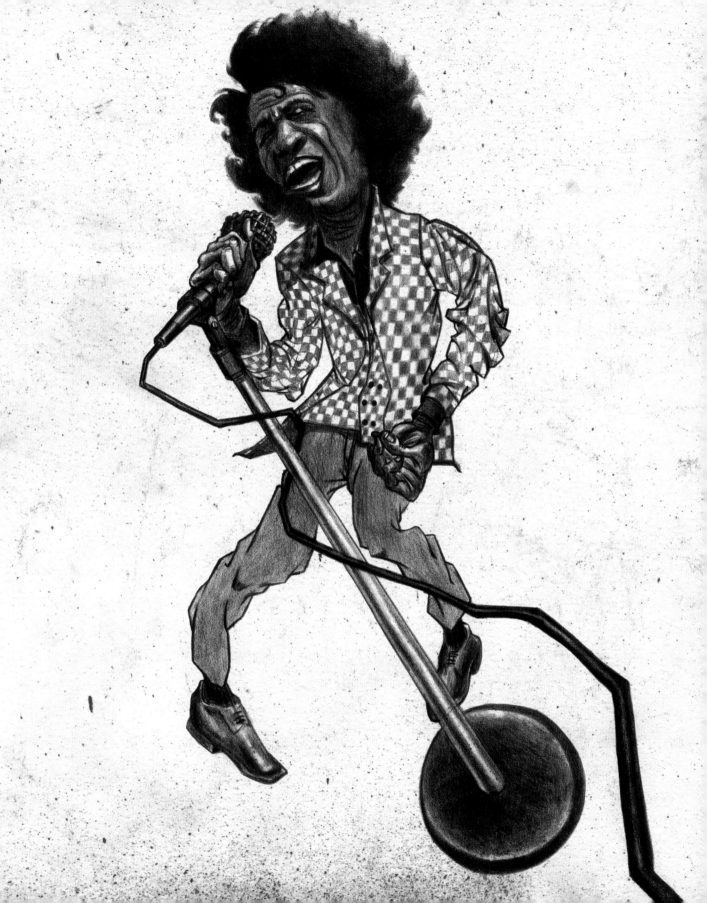

MICHAEL JACKSON

A MIRROR OF EXCELLENCE

When I was thirteen years old, walking around New York City was a little bit like walking around in a Michael Jackson video. Every hip-hop head in my neighborhood either wore a Michael Jackson–like red leather jacket or his signature sequined glove, or rocked a Michael Jackson–influenced Jheri curl. I recently found a photo of me and my boy Erik from 1981. We were probably cutting school and stoned out of our minds. I was wearing the classic black and red jacket like the one Jackson wore in the video for "Thriller." I'm not sure which was cheesier: my jacket or the thin Puerto Rican–style moustache riding my thirteen-year-old upper lip. I must have loved the shit out of Michael Jackson because that jacket— and my 'stache—weren't pulling in the girls, but I still rocked it.

Before Spike Lee came out with his Michael Jordan "Be Like Mike" commercials, *we all* wanted to be like Michael Jackson, from the Jackson 5. Every girl in the neighborhood was in love with him because he could dance, sing, and was hot, and every guy in the neighborhood wanted to be him because girls liked him. My friend Normski, a dancer in the Rock Steady Crew, would drive the girls crazy with Michael Jackson–inspired dance moves, proving that you could get some love just by copping his style. As much as we integrated Jackson's moves, he used ours, too. Jackson loved street dance—the original Electric Boogaloos street dance crew (made up of Boogaloo Sam, Popin Pete, and Skeeter Rabbit) taught him how to pop. He learned from some the best dancers in the world, like Popin Taco and Jeffrey "Pop Along Kid" Daniel from Shalamar. In return, Michael Jackson gave street dance a stage, and the whole world bore witness to its show.

In 1983, Michael Jackson performed "Billie Jean" at the Grammy Awards Show. His performance was a seminal moment not only for me, but also for the hip-hop community at large. That night Jackson brought street dance, including moves like the "camel walk" and the "strut," to mainstream America. It also marked his first time Jackson publicly performed the "backslide" or what the media called the "moonwalk." *That* moonwalk forever altered hip-hop as well as the future of dance and pop culture. Not only was every kid in bumblefuck middle America exposed to hip hop, but they also started doing it. Everyone discovered what my friends and I already knew: It didn't matter if you were an MC, a DJ, a b-boy, a popper, a locker, a breaker, or a kid from middle America, you strove to be great like MJ. The indirect and direct musical influence Michael Jackson has had on hip-hop culture is incomprehensible. There are no stats or graphs for his mark that he has left on all of us.

Michael Jackson was a perfectionist. Years of training in show business made him into the greatest performer there ever was. True hip hop represents excellence, and that was Michael. He inspired every single one of my friends in the hip hop game to be better. He spoke to us in dance, in music, in excellence, in greatness, and with *love*.

"MICHAEL JACKSON WAS
A CHILD PRODIGY IN SONG, DANCE,
STYLE, AND LOVE. AS THE GREATEST
PERFORMER EVER, HE WAS A MIRROR
OF EXCELLENCE THAT HIP HOP
COULD LOOK INTO."

—MR. WIGGLES

Opposite:
The King of Pop
Acrylic on canvas
18 x 24 in.
2009

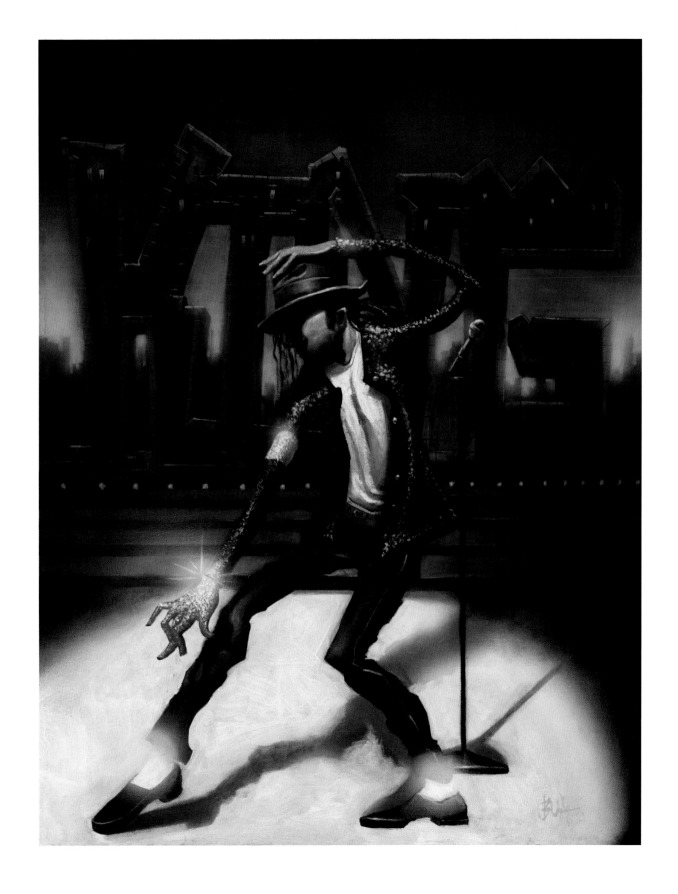

KOOL HERC

THE FOUNDATION IS BORN

When I met Herc a few years ago, I was taken aback at how much larger than life he is. His name, short for Hercules, is a perfect fit. Like that Greek giant, the stories passed down about Kool Herc and the birth of hip hop are so legendary, they loom mythic. Herc is, was, and still is everything hip hop strives to be: the biggest, baddest, freshest, dopest, the flyest. A true hip-hop god.

Like many of the original innovators of hip hop, Herc did not reap the financial rewards of those who came after. He never recorded an album and was eventually eclipsed by those who did. But everyone in hip hop is aware of his epic contributions. Herc not only had the biggest and baddest sound system on the block, but he was the first to isolate the instrumental portion of the record, which emphasized the drumbeat, otherwise known as the break beat. With two turntables and two copies of the same record playing, Herc was able to elongate the beat, and would switch from one break back to the other, a technique he called the "Merry-Go-Round." By doing this, he was able to keep the party rockin' til the break of dawn. Herc usually emphasized the part of the "break" that was heavily percussive because that's what the dancers got busy to. Once he isolated that break? Well, the rest is history. He set the blueprint for every new, up-and-coming DJ, icons like Flash, Caz, and Bambaataa.

To this day, Herc maintains that he never threw a block party for the money, that he was never in it for the fame. He says, "I never chased the glory train. And nobody expected it to go this far. I don't have to make a record to be known. My record is hip hop; nobody have that title. When the record finishing play, you've forgotten about it. But when they check the record of who started the culture, only one name will come to it. Like the presidency. Who started the presidency? George Washington: That's who I am to this game. Nobody can take that away from me."

What Herc did came first. He gave us the tools that built hip-hop culture, and he taught us to do it ourselves. He opened the door so the rest of us could walk through.

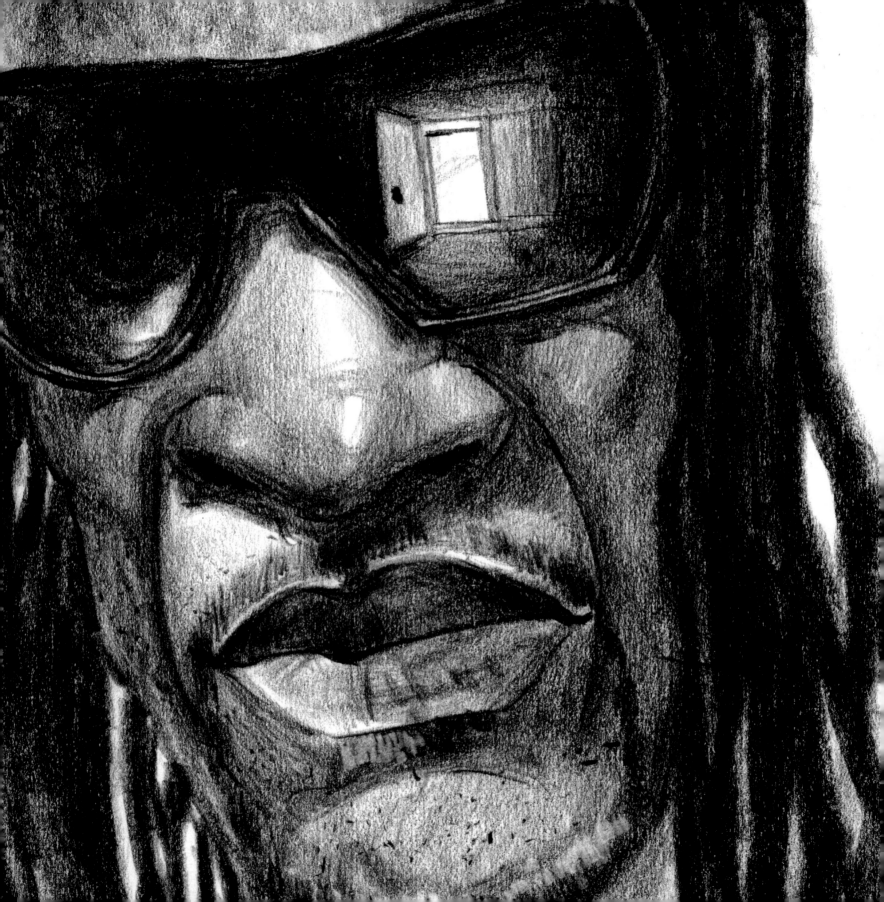

"HERC IS THE TRUE GODFATHER OF HIP HOP. WHEN I FIRST SAW HIM, MY FUTURE WAS CLEAR."

—MELLE MEL

Opposite:
Kool Herc
Acrylic on canvas
24 x 30 in.
2009

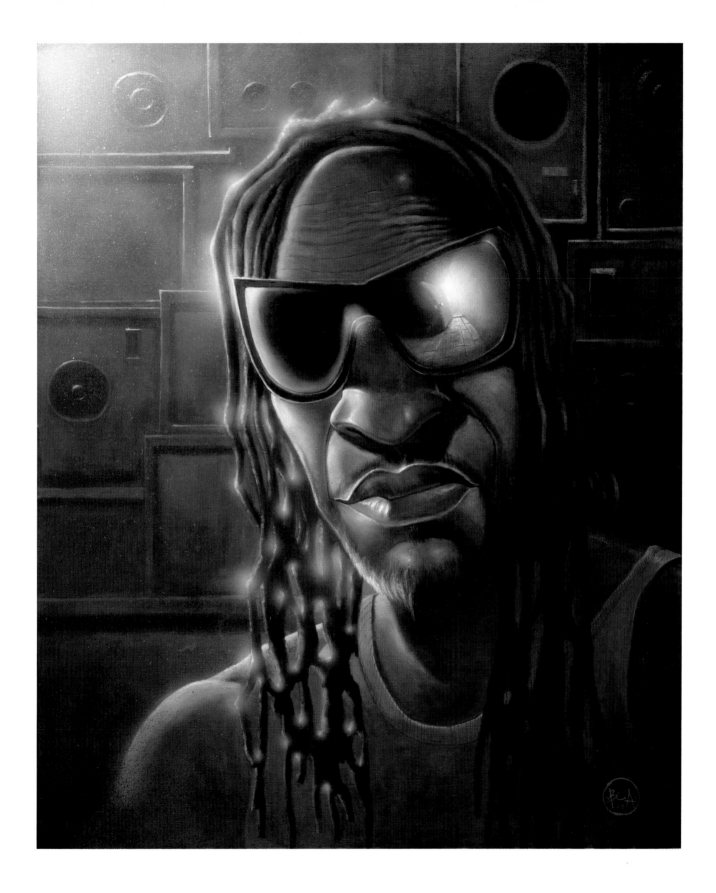

AFRIKA BAMBAATAA

THE CHILD GETS ITS NAME

Afrika Bambaataa was born on April 17, 1957, and raised in the South Bronx. As a warlord for the Black Spades, he expanded the gang into the one of the biggest and baddest in New York City. He rolled deep with thousands of members. After an inspired trip to Africa, Bambaataa made a Malcolm X–like metamorphosis and reformed the Black Spades into the Universal Zulu Nation—a community culture based on art, music, dance, and positivity. Suddenly, thousands of kids had a creative outlet and a sense of purpose and belonging. Mr. Wiggles recalls, "I wasn't down with teachers or the church when I was a kid, but Bambaataa made me feel comfortable with who I was. He enjoyed seeing blacks, Puerto Ricans, whites, and Asians all together at the same jam. He would wear all kinds of beads from our different cultures to make us feel equal. He's responsible for the integration of the culture." Bambaataa's vision became a movement. *Eventually, Bambaataa named the movement "hip hop."*

By the time I was thirteen, Bambaataa was a ubiquitous presence in the neighborhood. There was evidence of him everywhere—from neighborhood jams to Zulu members rocking beads to Bam's own music blasting on boom boxes in the streets. Every weekend, a group of us kids would trek from 103rd Street and Amsterdam Avenue to the Roxy, a club at 515 West 18th Street. On most nights, you could catch a set from Afrika Bambaataa, Red Alert, DST, Afrika Islam, or Jazzy Jay. Even though I loved all the music, I primarily went to see Bambaataa. When I heard him spin, my world shifted; his song "Planet Rock" single-handedly altered my life. To this day, it's my favorite song ever. "Planet Rock" borrowed musical motifs from German electronic music, funk, and rock, and birthed a new genre of music called electro funk—pure musical electricity.

When Bambaataa created the Zulu Nation in the 1970s, his vision of hip hop was a prophetic work in progress. Under his influence, the culture grew from an idea to a global movement, jumping overseas and spreading around the world. Today hip hop is a bona fide commodity, a multibillion-dollar industry that, some may say, has veered off course from Bambaataa's original vision of creative ingenuity, love, and integration. Still, we have Bam to thank every time we hear a beat, bust a rhyme, or hit the floor. But Afrika Bambaataa is so gracious, he would probably just thank us.

"BAMBAATAA IS THE GENESIS OF HIP HOP.
HE SAW HIP HOP FOR ITS POTENTIAL
AND MADE THE CHOICE TO NURTURE IT,
TO RAISE THE THINKING,
AND GIVE THE CHILD ITS NAME."
—CRAZY LEGS

Opposite:
Afrika Bambaataa
Acrylic on board
15 x 15 in.
2011

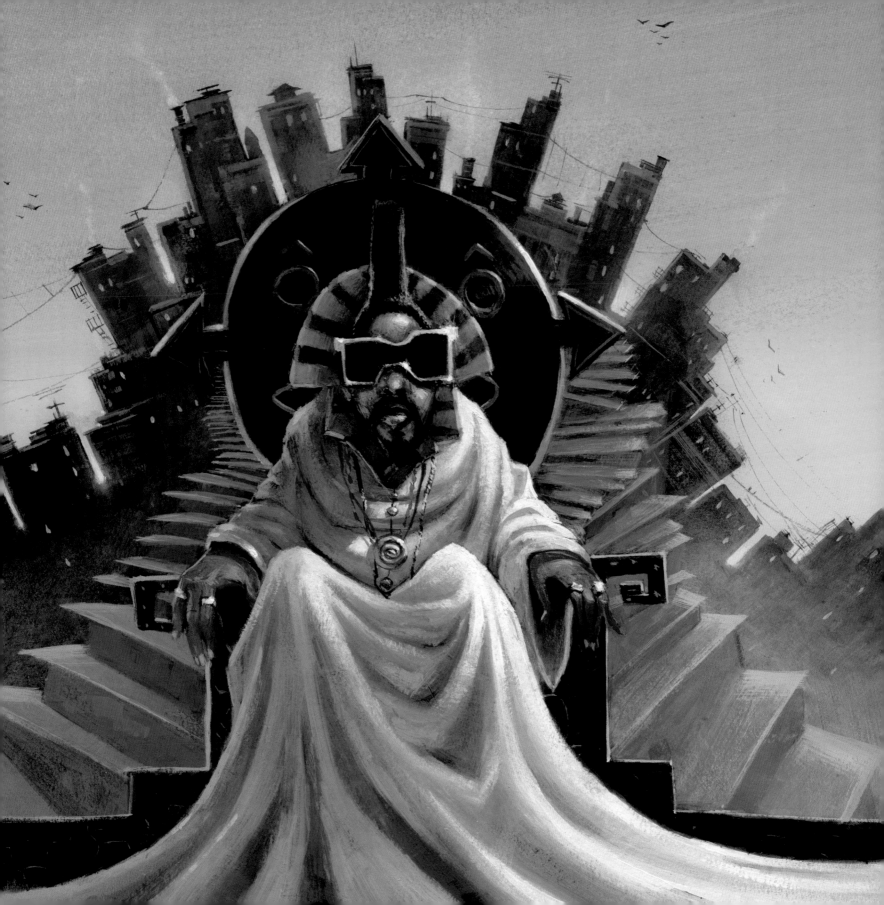

GRANDMASTER FLASH

ALCHEMY OF THE SCRATCH

It was 1982, my first year of high school. Music and Art was on 137th Street and Convent Avenue. To get there each day, I had to pass through a Dominican neighborhood so dangerous, we had to walk in "herds" to reduce the risk of getting robbed. In Harlem, you stood the best chances for survival the closer you were to the center of the pack.

There was a Dominican gang called the Ballbusters that hung out in front of this brownstone with their Doberman pinschers. I remember one fateful day I walked by their stoop...alone. I passed three men—my brows furrowed, eyes crazed, knapsack held tightly. No reaction. I got about ten feet ahead. I was in the clear. Whew.

"Yo, kid, come here!"

Fuck. I mentally ran through all of the items in my bag. Five dollars, bus pass, Yankee penant bat, Walkman, Grandmaster Flash bootleg tape.

"Yo, what the fuck are you doin' walkin' tru our neighborhood, mang?"

"Just goin' to school."

"You go to dat rich boy private school?"

"Nah, it's public."

"You callin' me a fuckin' liar? What's in your bag, mang? Give me dat."

I was scared. I remember thinking, what the fuck did these *men* care about vickin' a fourteen-year-old boy? He took everything I had. I remember thinking, "Whatever. It's all material shit." But when he took out my Walkman, I got chills up my spine. I didn't care about the Walkman. What I *did* care

about was my bootleg Grandmaster Flash tape inside the Walkman.

The tape had all kinds of genius stuff on it. Flash was the best—the fastest, most advanced DJ. Grandwizard Theodore might have invented the scratch, but Flash *was* the scratch. He was my hero, a DJ scientist who built his own equipment in his kitchen.

My fists clenched. I turned red with anger. *Am I going to fight these thirty-year-old men or am I going to live to see another day? Fuck it. I guess I'm down for a beatdown,* I thought. I was ready to die for my Flash cassette. It was my world.

"I guess I'll keep this stupid shit, too," the man said, handling my tape.

Then uncontrollably I blurted, "I guess it's a fight then!"

"Wha the fuck did you say to me?"

By this time I was insane with rage and yelled, "You heard what I said! Punch me in the face, I don't give a shit, just give me my fuckin' tape!"

Silence. Tension. Then an explosion of laughter.

"Ha-ha-ha, this fuckin' kid's cra-see. Ok, ha-ha, take your stupid tape. You're fuckin' funny, mang."

He threw the tape at me and looked back at his boys, laughing at the unexpected comedic moment that made his day.

I was humiliated, but I felt brave and proud. In my own way, I won. I walked away with my dignity intact, my Grandmaster Flash tape safely in hand.

Opposite:
Grandmaster Flash
Graphite on paper
9 x 12.25 in.
2008

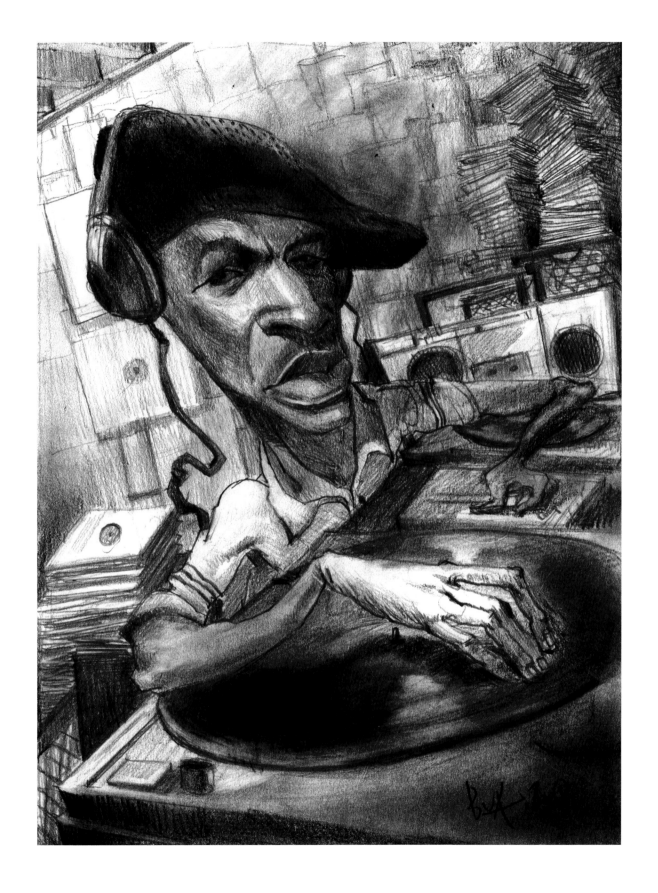

MELLE MEL

A VOICE OF THUNDER REIGNS UPON US

I grew up next to a welfare hotel that housed poor people, but was also refuge to pushers, hustlers, prostitutes, and criminals. It was a crazy place during a crazy time. Homeless people were overflowing on the streets. Health facilities bused the mentally insane into my neighborhood and dumped them on the streets, leaving them to fend for themselves. At the time, my home life felt equally chaotic. We had three cats and one dog despite the fact that I was allergic to animals. My mom's boyfriend, a macho Israeli war veteran, lived with, or I should say, lived *off* us. We had a tiny one-bedroom apartment; my mom and her boyfriend slept in the living room. Without a wall, they didn't have any privacy, but neither did I. I witnessed everything— good and bad. I listened to the music my mom had lying around—the Rolling Stones, Jefferson Airplane, Beethoven, Bach—as a way to build a mental fourth wall and escape reality. It wasn't until I discovered *The Message* by Grandmaster Flash & the Furious Five that I heard the story of *my* world, the one that was closing in on me from all sides.

Melle Mel was articulate and wise, and had the most potent voice I had ever heard. He rapped about life on the streets and painted a picture of the New York I knew, full of crime, poverty, and drugs. To this day, I wonder if Melle Mel is the reason I fell into the world of hip hop. If I had discovered Iggy Pop instead, for example, would the hip-hop scene have passed me by? Whatever the reason, Mel's articulate political raps allowed me to escape the harsh realities of urban life and my home. Through Mel, I fell in love with hip hop.

While I painted Melle Mel, I listened to his music and found myself back in 1982. It was a time when life was rough and scary but Melle Mel gave me the ticket to get out. His music is certainly the sum of his greatness, but to me it is so much more. It is the story, the soundtrack, of my early life.

Opposite:
Melle Mel
Mixed media on paper
10.75 x 13 in.
2011

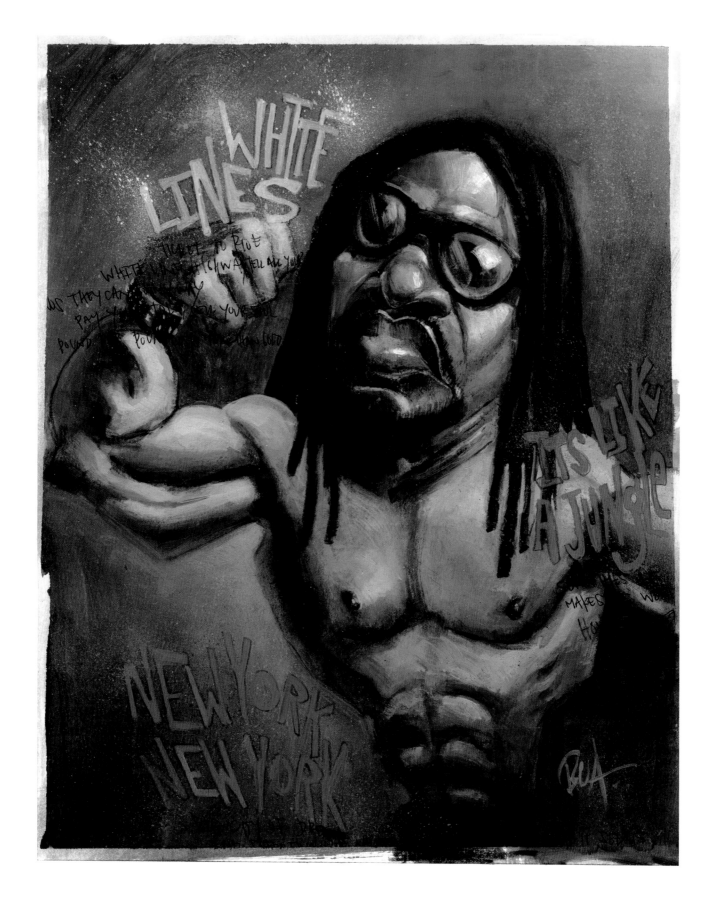

KOOL MOE DEE

THE VERBAL BUCKSHOT

It was December 1981. My friend Trevee-Trev, who always had his finger on the pulse of what was going down in hip hop, called me, all hyped up.

"Come over," he told me. "Shit went down…and I got it on tape." If *Trev* said that, then I knew it had to be the hottest shit off the streets. The truth is Trev probably got it from "Tape Master," the big Puerto Rican brother in the hood who recorded all the battles and sold cassettes at the flea market at Sound View/Castle Hill in the Boogie Down Bronx.

At Trev's crib, he played me a cassette of the battle between Kool Moe Dee and Busy Bee Starski at the famous club Harlem World on 116th Street and Lenox Avenue. At one point, Kool Moe Dee says, "C'mon, Busy Bee, I don't mean to be bold, but put that 'ba di di ba' bullshit on hold." With that line, Kool Moe Dee challenged not only Busy Bee, but also the entire rap world to give up that old-school style and take their skills to a new level. Kool Moe Dee wasn't just rocking the party with short, be-bopping, crowd-pleasing catchphrases. He was stringing sentences together in intelligent, complex ways and challenging the conventional rap game. Busy Bee, like most MCs of the era, didn't have the new-school flow that Kool Moe Dee had and couldn't hang with his battle skills. Moe Dee was well-read, educated, and articulate, but still straight-up street savvy. He represented the next millennium of rap for future MCs: Big Daddy Kane, Rakim, and Jay-Z. It was that day at Trevee-Trev's apartment that I bore audio-witness to a new era of MCing that would forever alter the face of hip hop.

The memory of that day still feels real to me and I wanted to depict that sense of authenticity and realness in my portrait of Moe Dee. When I draw, I usually use prisma sticks, a kind of wax that creates an indelible line that doesn't allow for easy erasing and, therefore, allows little room for mistakes. This makes me more attentive to my marks and doesn't allow me to go on autopilot and gravitate back to bad drawing habits. Consequently, the drawing usually has a feeling of staying "fresh." Drawn with his characteristic large sunglasses, 1980s hat, and leather jacket, I tried to keep this portrait fresh in *every* sense of the word.

Opposite: *Kool Moe Dee*, prisma on paper, 14 x 18 in., 2010

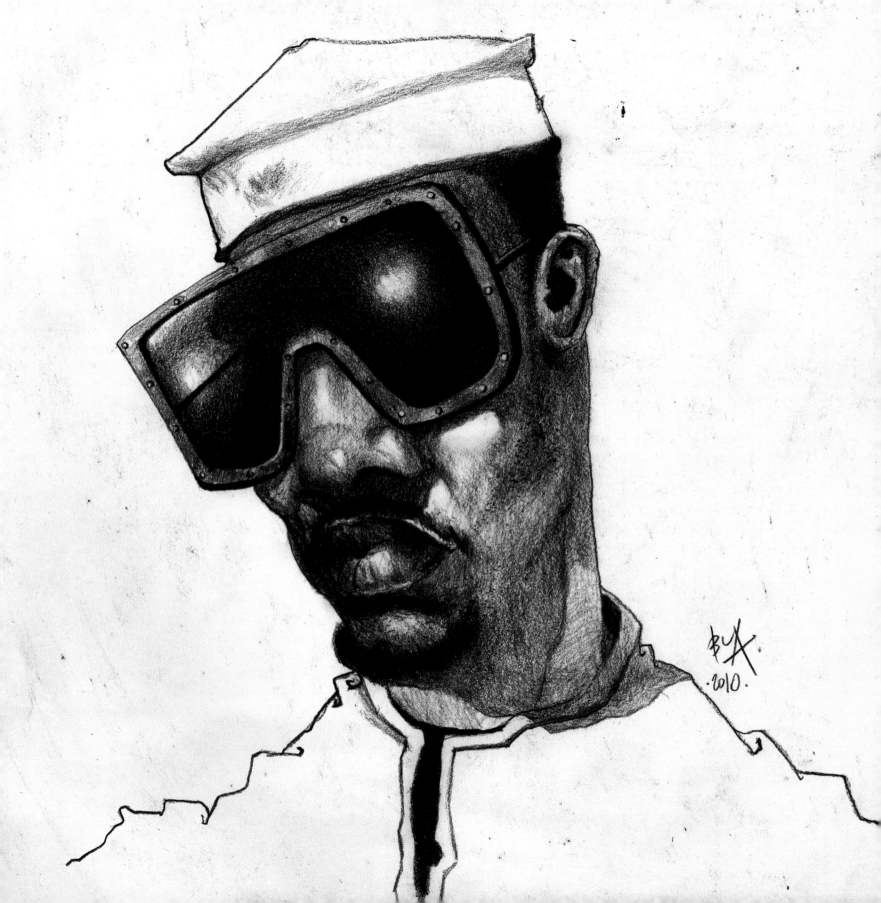

GRANDMASTER CAZ

THE THIEVES ROLLED IN

Grandmaster Caz was a household name in the projects. I first heard about him from this crazy drug dealin' brother, Carlos, from my neighborhood. He told me about this fly DJ who was putting it down uptown. His name? DJ Casanova Fly. Like many of hip hop's pioneers, Caz was a mythical figure to me. As one of the founding fathers of hip hop, he was the first DJ/MC combination. His group, The Cold Crush Brothers, was one of the most popular in the City and set the gold standard at the time for emceeing.

Recently, I was listening to "Rappers Delight." Everyone knows that song, but not everyone knows what really went down. If you don't, allow me to do a little schoolin':

In 1978, Sylvia Robinson was trying to produce a hip-hop album on her Sugar Hill record label. She was looking for an MC to rap on it. By chance, Sylvia stopped at a pizzeria and heard an employee rapping; she asked if he wanted to make a record. This guy's name was Big Bank Hank, Caz's manager at the time. Not really a rapper himself, Hank asked Caz if he could borrow some lyrics. So the young and naïve Caz shared his book of lyrics. Hank took his words, mixed them in with some Rahiem lyrics from the Furious Five, and a week later? The manufactured Sugarhill Gang recorded one of the most popular singles in hip-hop history. With no compensation, royalties, or credit, Caz was left in the cold. As Caz himself said, "Hank sings, 'I'm the C-A-S-A-the-N-O-V-A and the rest is F-L-Y.' That's my name spelled out: Casanova Fly; he didn't even change the lyrics to say 'Big Bank Hank.'" Legit MCs everywhere were mortified by Sugarhill's bubblegum production. Melle Mel stated, "What the fuck are they doing with our art form? They axe-murdered the shit!"

"Rappers Delight," represented the beginning of the co-option of the real, raw culture of hip hop. Parasitic outsiders started to exploit the culture in every way: stealing, wheeling and dealing, and commodifying anything they could get their hands on.

Awhile ago, I was at Kool Herc's birthday party in New York, surrounded by hip hop's greatest heroes. It was like being a kid who grows up playing basketball, loving it, studying the game inside and out and then—one day—is standing in a room with Dr. J, Magic Johnson, and Michael Jordan. Imagine having all of your childhood heroes assembled in one place; it was awe-inspiring. I looked around: There was Herc, Busy Bee, Mr. Wiggles…then I saw Caz and the room shifted. I got nervous but summoned up the courage to introduce myself.

"Hey, man," I said. "You probably don't remember me, my name is BUA."

"Yeah, I know your art. Whassup, man?"

I was floored. While I'd like to say that I was able to match him at every turn in our conversation, there's a reason why he's one of hip hop's greatest improvisers and rappers—so I let my artwork do the talking. Just meeting him was a gift. I'll leave it at that.

Opposite: *Grandmaster Caz*, prisma on paper, 14 x 18 in., 2010

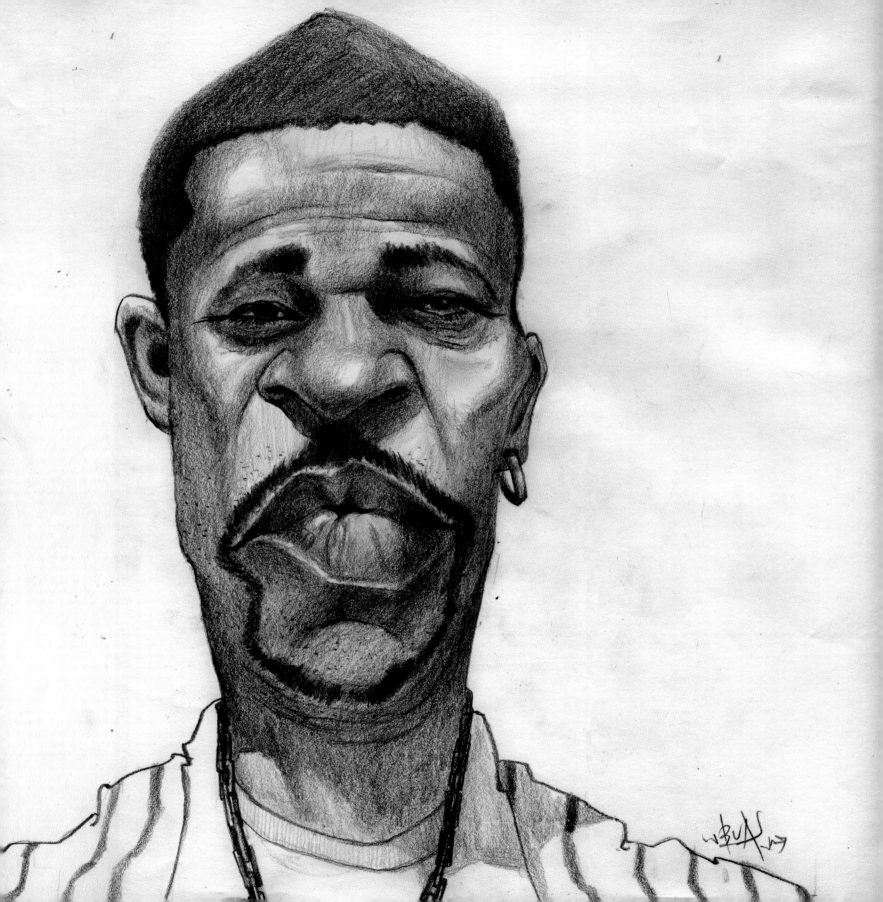

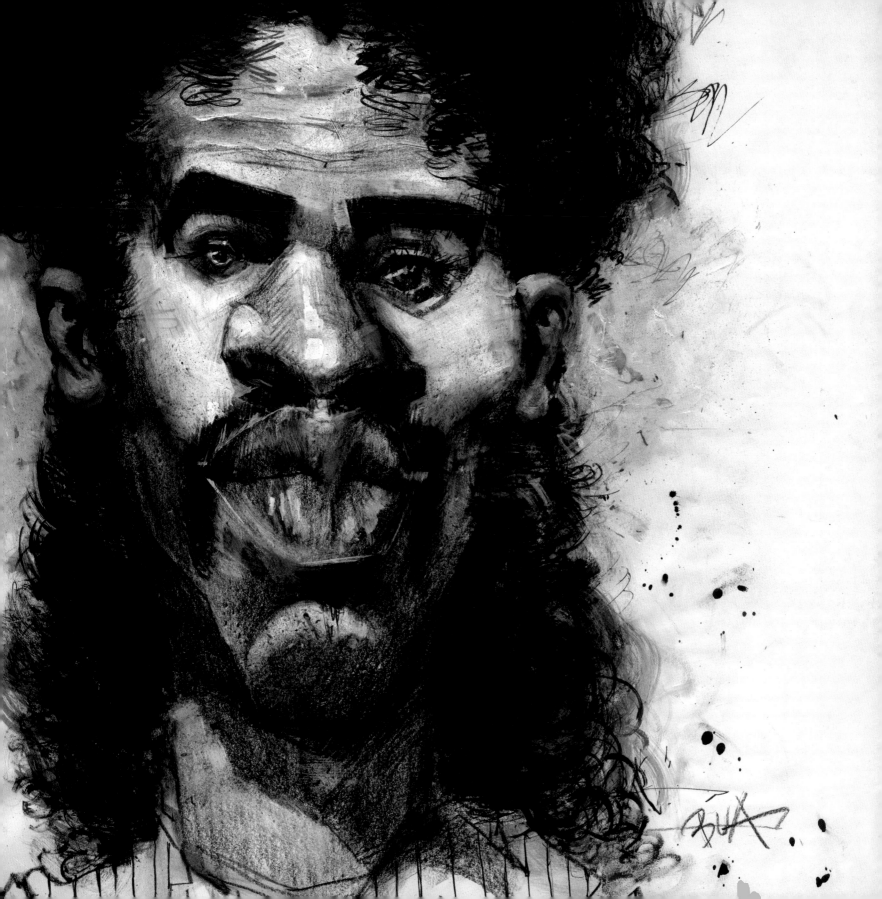

KURTIS BLOW

RHYMES TO LIVE BY

I lost my virginity when I was thirteen years old to a much older woman named Tina—she was fourteen. We were an odd couple in that I was a hip-hop head who loved b-boying and she was a rock 'n' roller who loved head banging. The only thing she liked about hip hop was Kurtis Blow's song "The Breaks," which she saw him perform on *Soul Train*—"The Breaks" was the first certified gold record rap song. Everyone loved it. Kurtis was blowing up. His music seemed to be the soundtrack to the seminal moments of our teenage years.

I dated Tina for a couple of months, but I really just wanted to hang with my boys and go to popping battles. This infuriated her. She wanted more of my time and affection. Finally, she came over one night and tried to seduce me into losing my virginity to her, but being young and inexperienced, I really wasn't feeling it. I dodged her out.

The next day, I walked into class to find everyone laughing hysterically. I had no idea what was going on until I looked down and saw, "Justin is a virgin!" engraved into my desk. I knew it was *her*. The same words were chalked across the blackboard…and as I found out later, in the bathroom stalls. That day, it seemed the entire school had seen the writing on the wall. It wasn't the name-calling that bothered me, but that everyone had found out I was a virgin. As the day progressed, school became a nightmare, kids pretend-coughed "homo" and "virgin" at me as we passed in the halls—I even got the wet finger smack on the back of the neck. It was as if I had a scarlet *V* etched into my forehead.

The peer pressure from my boys was overwhelming. I felt like I had to do the deed just to survive. So I invited my passive-aggressive girlfriend over while my mom was at work. I got the candles lit, took out the jimmy hat, and got ready. I put on Kurtis Blow's "Do the Do." It was my attempt to find common ground; Kurtis was my Marvin Gaye. Then I did *it*. Or I think I did. I may have made love only to the outside of her thigh and the bedsheets, I'm not sure, but in any case, I finally had a story to tell.

It never got better with her. Tina had wanted to deflower me, but she had defaced me, dissed me, and now it was payback time. I was in over my head. In order to exit the "relationship," I orchestrated an outro that couldn't be challenged. After school, I put my boy's giant ghetto blaster on top of his car and waited for her to come out. When she appeared, I blasted Kurtis Blow's "Baby You've Got To Go" in front of five-hundred kids. A resounding "Oh, shit!" reverberated through the street as kids fell out laughing. I knew this would be the end. Like my longtime companion Kurtis Blow said, "These Are the Breaks."

Opposite:
Kurtis Blow
Mixed media on paper
14 x 17 in.
2011

MARLEY MARL

ANTHEMS REASSEMBLED

I remember listening to Marley Marl from way back when I was thirteen years old. He was the DJ for the "Rap Attack" radio show that aired on Saturday nights on WBLS, and was hosted by Mr. Magic. At the time, this was the only radio show playing hip hop all night long. I loved the show so much that I would break out of my girl's apartment (without getting "any"), just so that I could make it back home to catch Mr. Magic and Marley Marl on time. The crazy thing is that I never knew how important and pivotal Marley Marl was to hip hop; I just knew how important he was to me on Saturday nights.

Before Marley Marl, hip hop was essentially two turntables and a microphone. In the beginning, the DJs—Herc, Bambaataa, Flash—were the celebrities; they were the stars people were coming to see. In time, the DJ got moved to the back of the stage and the b-boy, who once ruled the limelight, got pushed off stage. Eventually it became all about the MC. The MC reigned supreme until Marley came along and changed the future of hip hop forever. Marley was the *first* person to sample break beats. Before him, producers looped records and used drum machines, but Marley would sample the drum from popular break beats and rearrange them. For example, he isolated the snare from James Brown's "Impeach the President" and was able to play with it by chopping it up and manipulating it. For hip hop, this technological innovation may as well have been Neil Armstrong landing on the moon. Marley became the new amalgamation of technician and musician. A hands-on genius, the soundboard became his instrument. He was one of the forefathers to use studio technology to transform old-school stock drum sounds into unlimited sampling possibilities. He opened the door for every hip-hop producer that followed.

But this was just one of his many contributions to the world of hip hop. His technical savvy, combined with a great ear and an uncanny ability to spot talent, led him to produce many of the greatest artists of rap's golden era, including Big Daddy Kane, Biz Markie, Roxanne Shanté, MC Shan (his cousin), Masta Ace, Kool G Rap and DJ Polo, and Craig G. Not only did he groom the local talent from his neighborhood in Queens, but he also made polished records with some of the biggest names, like LL Cool J and Lords of the Underground. A hit maker, he never made bad music.

Marley Marl is arguably the greatest producer in the *history* of hip hop. He certainly is its first super-producer. There's a well-known expression that goes, "Would you rather be the chump in the front or the mac in the back?" Today, most producers fiend for the spotlight and they revel in it. But Marley Marl was, and always will be, the mac in the back.

Opposite: *Marley Marl*, acrylic on paper, 11 x 17 in., 2011

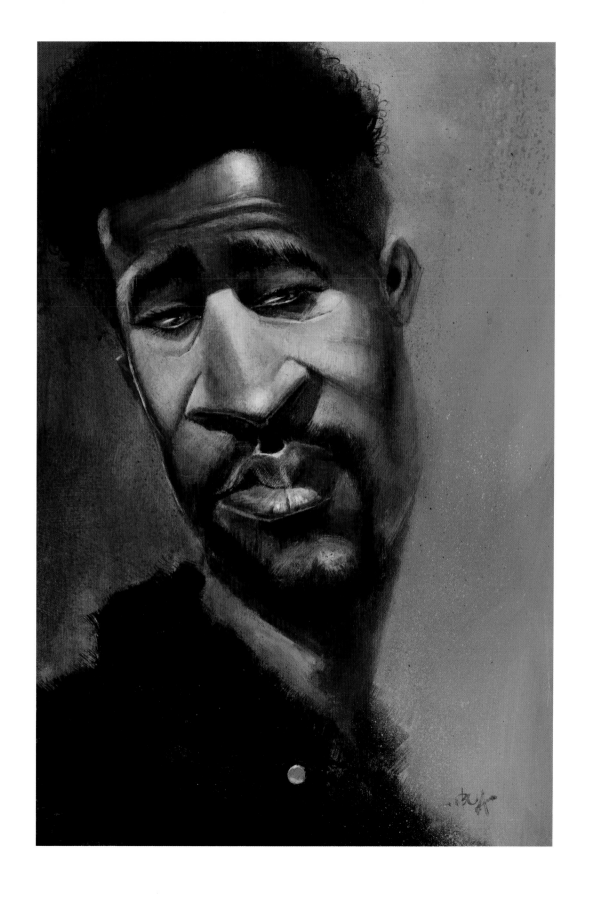

SHA-ROCK

SHE BOLDLY GOES

Talking in depth with various hip-hop icons like Ken Swift, DMC, Chuck D, Tracy 168, I asked them all the same question: Who are the female legends of hip hop? There was one name above all the others that came up again and again—Sha-Rock. The first time her name was mentioned, I admit it, I cocked my head to the side, looked off into space, and mentally searched the repository of my hip-hop memory banks. Then it clicked like an old-school tape deck. Flashback: dancin' to "Rappin and Rocking the House" at this party up in the Bronx, grindin' my Lee jeans against this fly Boriqua's Sergio Valentes. I recall that grind session going on forever...turns out that song clocks in at over fifteen minutes, arguably the longest hip-hop song ever. Hell, yeah. I remembered Sha-Rock from that group—Funky Four Plus One. Formed in 1976, they were the first hip-hop group to make it onto TV. They made their television debut performing their most well-known song, "That's the Joint," on *Saturday Night Live* in 1981.

Unlike the majority of today's female MCs, Sha-Rock wasn't selling sex nor was she looked upon as being a sex object. Simply put: She was a talented MC. She wasn't flashy, gimmicky, or cliché in any way, shape, or form. She was just a girl from the Bronx who loved to rap and was there first. There's something to be said about being the first. It's easy to look back and glorify the beginnings of a culture. The truth is, pioneers often suffer, creatively, personally, professionally, because not only are they are quickly forgotten, but they also don't get paid their due. It's easy to forget how hard it is to be ahead of the curve, to have your finger on the pulse before *everyone* else. Sha-Rock was the first female MC in the game and because of that she was scrutinized. Men were stepping to her and trying to battle her. But when they put her on the spot, they quickly realized her skill set was on par with the best. When MCs stepped to Sha, she served fools. As Grand Wizard Theodore said to me, "Sha would tell a story that we all could visualize. She was ridiculously intelligent; the way she flipped her words was profound. Sha-Rock was our generation's MC Lyte. She was the best of the era."

While Latifah is the Queen, Sha-Rock was the first to rule. She paved the way for all future female MCs, and for that, we should pay our respect.

Opposite: *Sha-Rock*, prisma on paper, 14 x 17 in., 2011

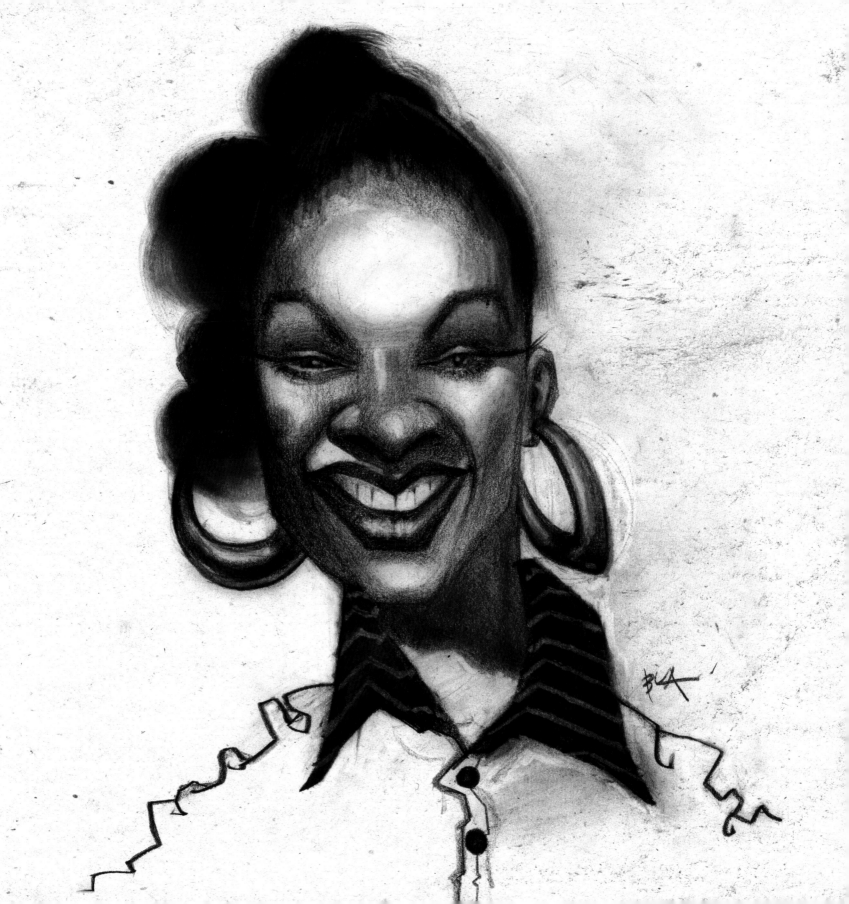

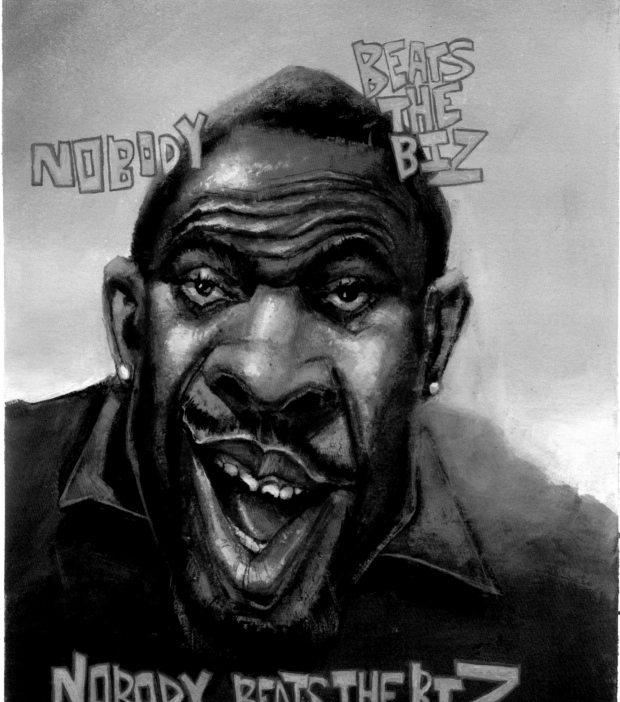

BIZ MARKIE

THE ELEVATION OF ARDOR

There are kings and queens of hip hop, but there's only one jester and that is Biz Markie. I consider Biz a legend by virtue of the fact that his bugged-out character is so interwoven into the history of the culture that he is true hip-hop royalty. Where would King Lear be without the fool? The fool is often the wisest man, and hip hop would be a different kingdom without Biz. He kept it real by not taking life too seriously. He wasn't a playboy, slickster, or a hard-rock type of MC. He was a jokester, a kid that would get up on stage and talk about picking his nose. He was funny, disgusting (in a silly way), and maybe a certifiable genius.

I started listening to Biz way back when he was beat-boxing, but I didn't pay much attention until he did "Nobody Beats the Biz" in 1988. That song was a play on the well-known advertising commercial and slogan, Nobody Beats the Wiz, for the New York/New Jersey electronics chain. There was a Wiz store on 97th Street and Broadway, close to my apartment and it seemed like every time the TV was on, that commercial played—"Nobody beats the Wiz. Nobody beats the Wiz." That store—and its accompanying jingle—symbolized the death of the neighborhood mom-and-pop stores, the places I grew up with, and represented the beginning of gentrification on the Upper West Side. From the early 1980s to the late 1980s, the neighborhood went from being economically and ethically diverse to being a home to yuppies, who could afford useless, expensive electronic shit. Biz's co-option of that jingle was akin to Robin Hood stealin' from the rich sayin', "Yo, we ain't goin' anywhere. In fact, we're still celebrating street life with your dumb-ass beats." I could be overanalyzing the shit outta this, but that's how it made me feel. *Nobody beats the Biz*? Genius.

Biz's music was uncanny—I'd be chillin' up in the Dyckman Projects with my boys and they would be playing "The Vapors" by Biz, and the next day I'd be hangin' with my mom's fortysomething-year-old intellectual friends and they'd be like, "Have you heard of this guy Biz Markie on the radio? He's really funny." Frat boys loved him, housewives, white girls, and dealers with pagers. He had mass appeal. He still does.

During the golden era of hip hop, there were giants like Rakim, BDP, Big Daddy Kane, and socially conscious/political rappers like Public Enemy, Queen Latifah, and N.W.A. Biz was an alternative for those who weren't deep in the scene and not able to assimilate political, social, and battle rap. Biz was likable to peeps in the scene and digestible to middle America. Eventually, he took his larger-than-life persona and brought it to TV and film, doing voice-over work among other gigs. In fact, just recently, I was reacquainted with his music by, strangely enough, watching him on the TV show *Yo Gaba Gaba* with my six-year-old daughter. What better way to seal his legacy as the big kid of hip hop? Some say he's hip hop's mascot. To me, he will always be the wise fool: Someone who knowingly comments on the world by bucking social convention, speaking his mind, and being imprudent in the most profound roundabout way possible. Legend!

Opposite:
Biz Markie
Acrylic on paper
8.75 x 15 in.
2010

SLICK RICK

THE NARRATOR

I went to the High School of Music and Art on 137th Street and Convent Avenue, in the heart of New York's Harlem. This institution birthed the careers of some of the most gifted artists, dancers, actors, and musicians the world has ever known: Billy Dee Williams, Liza Minnelli, Omar Epps, Wesley Snipes, Isaac Mizrahi, Desmond Richardson, Charles Bragg, and many more. I was fortunate enough to go to school with some of the greatest artists of our time, but my all-time favorite was Slick Rick, or Richard Walters, as he was known at the time.

My time on the hill was unforgettable—I was in a motley popping crew that I formed with two kids. One popper, who acquired his ill skills in L.A., was Ale Smith—a.k.a. Mechanical Puppet. (I have a VHS to prove he has some of the hardest-hitting pops the world has ever seen. On par with Taco.) My other dance partner was a living legend by the name of Mailbox. He was called Mailbox because of the shape of his head. Ale, Mailbox, and I would battle anyone and everyone we could. We danced for money, prestige, fame, and honor, but most important, we danced to get the girls. While we journeyed all over the city to burn wannabe boogiers, nothing was more rewarding than dancing at our school. At lunchtime, the tables would part like the Red Sea, and the atmosphere would transform from cafeteria to an insane block party. We danced while another group of kids—the Kangol Crew—rocked the mic. This crew was comprised of Dana Dane, Slick Rick, and a bunch of other kids of all races. Their rhymes were sick—while one kid banged out beats on the table, the rest rapped about their lives in the crazy City. My crew added to the entertainment in these intricate cyphers, a physical accompaniment to their genius. Sometimes, though, we simply listened as the rhymes unfolded.

I distinctly remember Rick's unique voice—there was no mistaking his tone, he had a cadence matched by a refined sense of humor and wit. Long before Slick Rick became a global superstar, I knew him as a ghetto celebrity, someone who inspired art and music and movement in the lives of the people he touched.

Slick Rick has been a part of my life for as long as I can remember: I listened to him spit raw rhymes in my high school cafeteria; I cranked him on my ghetto blaster in East Flatbush, Brooklyn, as a teenager; I played his cassettes in my car radio when I was in college and in my early thirties he became one of the first playlists on my iPod. Today, as I write this, his music is streaming from Pandora. As technology evolves, I will continue to listen to him in whatever format I can, for the rest of my life: Great music never gets old.

Opposite:
Slick Rick
Acrylic on canvas
12 x 24 in.
2010

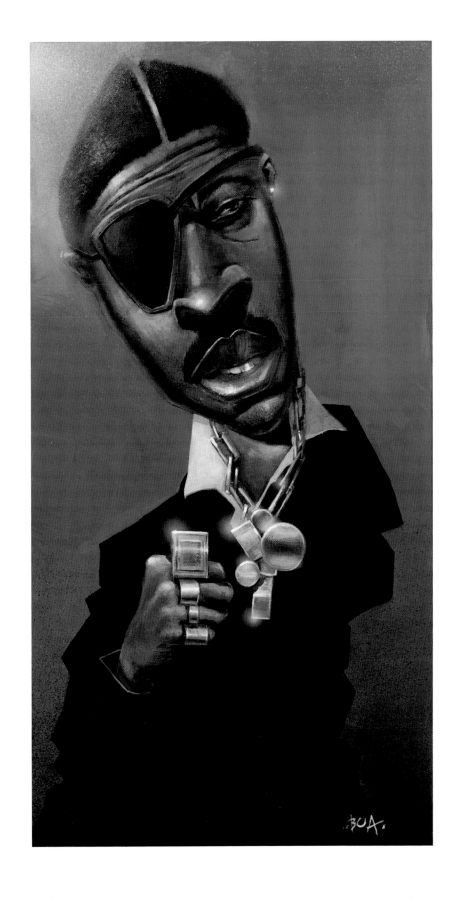

CRAZY LEGS

POETRY IN MOTION

The first time I saw Crazy Legs perform was in the majestic Rock Steady Park—98th Street and Amsterdam Avenue in New York City—where he was practicing some of the most beautiful footwork I had ever seen. *Ahh, that's what they mean by poetry in motion,* I remember thinking to myself. My jaw dropped. There he was. My idol: a living legend and the undisputed king of b-boying. The leader of the Rock Steady Crew, the greatest b-boy dance crew in the history of the world. As I reveled in this personal historic moment, he walked toward me.

Like all my friends in the neighborhood, I wanted more than anything to be in Rock Steady. When I was thirteen, I started hanging out at the projects on 103rd Street and was eventually taken under the wing of a mentor by the name of Ty Fly. He was down with Rock Steady, but not a main member. He had a crew called the Roc-Boys, which he said was junior Rock Steady. I was honored to be a part of the Roc-Boys, but I knew that they were second-string for anyone who wasn't good enough to be in Rock Steady. It was kind of like being on a D-league basketball team or in the minors in baseball, the only difference being that we had zero chance at making it into the majors. The Rock Steady guys were all-stars, the greatest dancers in the world. At the center of this greatness was Crazy Legs, who had adopted the crew from his home in the South Bronx.

Here he was, about to come up to me, and maybe, just maybe, ask me to show him some moves and—bam!—put me down in his crew. BUA in Rock Steady?! Oh shit, that would be fresh! Weirder shit could happen… why not? I smiled nervously. This was the moment of truth, a moment that, quite honestly, I had rehearsed over and over again in my mind for months. A once-in-a-lifetime opportunity to meet the one and only Crazy Legs. I had a kid smile so big it nearly split my cheeks in half. Here we go.

He looked me straight in my eyes and said, "What the fuck are you looking at?"

Shattered.

I froze. A deer in headlights. I don't even remember what happened after that. It was all just a blur. But I do recall the cold sweat of embarrassment and humiliation.

That was a long time ago, and thankfully, since then we've become friends. I never told him this story, although if he's reading this now, he probably isn't too shocked. Everyone who knows Crazy Legs has a story to follow mine—some positive, some negative, and probably all true. His persona transcends his personality. Crazy Legs is synonymous with b-boying, or, as the media calls it, break dancing. Without Legs, we might not have this culture that we love and honor. Love him or hate him, it doesn't make a difference in the context of history. That will all fade. What will remain is his legacy, the poetry of motion.

Opposite:
Crazy Legs
Acrylic on paper
11 x 14 in.
2010

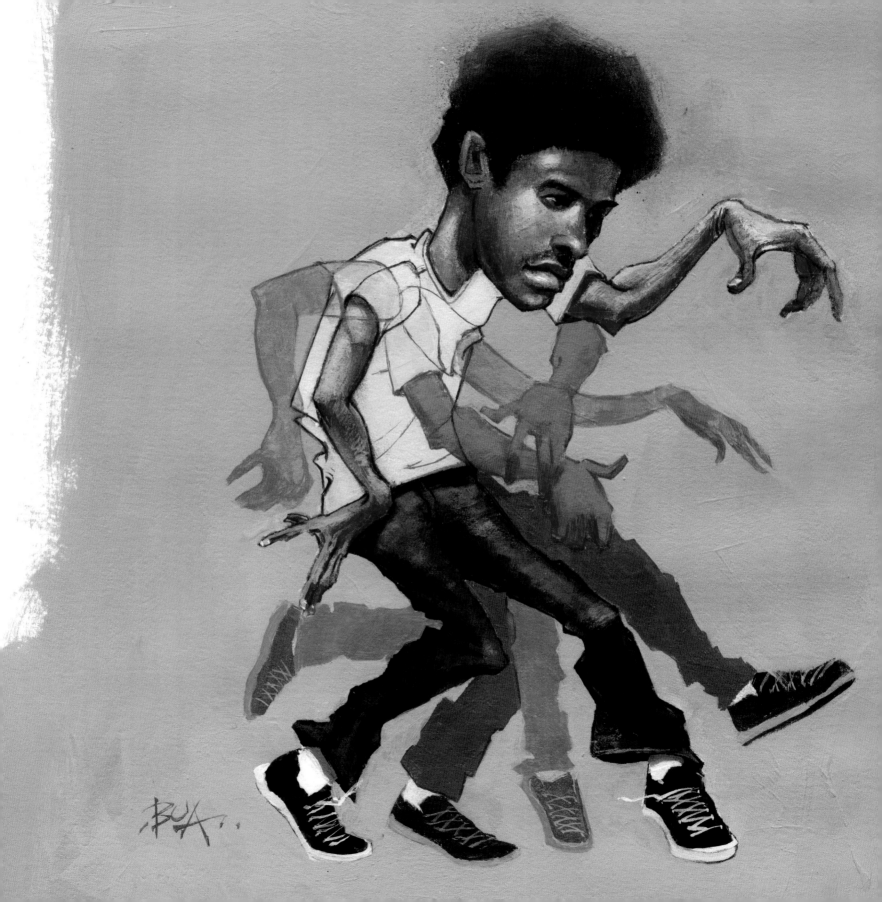

MR. WIGGLES

A MASTER AND THE JACK

Perfection. I really wanted to start and end this essay with that one word because hands down, Mr. Wiggles looms large as my favorite icon of hip hop. Born in the South Bronx, Steffan "Mr. Wiggles" Clemente grew up in the epicenter of hip hop, before the culture had a name. He is integral to hip-hop history because he was there from the beginning—as a graffiti writer, a rocker, a breaker, a b-boy, MC, popper, locker, and beat maker. His mind holds a library of our history. More than anyone I know, he has reached the far recesses of every element of hip hop in a deep, profound way and continues to "express his findings." He is *the* quintessential hip-hop icon. But what hits me the most, and what he is best known for, is his dancing. He has a pure and natural Boriqua rhythm that you cannot teach or be taught. You have to have been born and raised in the South Bronx in his specific era to have absorbed the culture like he did. It's in his pores, his breath, his blood. Wiggles is the greatest dancer alive on the planet today. He is *our* Baryshnikov.

His presence in the timeline of dance history was critical. In terms of dance technique, Wiggles combined his native New York flavor (tricks like Magazines, Characters, Floating, and Puzzles) with his b-boy skills and mixed the combination with moves he picked up from his West Coast compatriots—Boogaloo Sam, Poppin Pete, Sugar Pop, and Skeeter Rabbit. Mr. Wiggles is a master of his art, so much so that he's able to play and improvise on top of his technical virtuosity. He embodies a rare, hard-hitting grace, dancing with balletic elegance *and* street sensibility. The man has an unceasing work ethic and a love and understanding of hip hop that is unparalleled. These things have made for pure greatness.

I deeply appreciate the heights to which Wiggles has taken his dance. I recognize his incredible dedication to elevating his skills and continuing to evolve and reinvent over decades of time. I think that today, Wiggles is better than ever.

There have been thousands of great painters, but only one Rembrandt. Hundreds of amazing basketball players, yet only one Jordan. Pope Julius II believed that Michelangelo was the hand of God. There is no doubt in my mind that the same indescribable force that guided Michelangelo's art has also touched Mr. Wiggles. When I watch him dance, I am inspired beyond words. He has set a standard of greatness not just in dance, but also in art, music, theater, and life that we can all aspire to.

Today, there are countless dancers—on TV, in music videos, in competitions, some of them famous choreographers— that have stolen Mr. Wiggles's moves, without a modicum of acknowledgment, thieving his creations without reverence for their roots. Yet no one can *really* do what he does. It's easy to duplicate a move, but impossible to steal the soul of the movement. When I see Wiggles dance, I experience musicality at the deepest level. He understands the matrix of music. Mr. Wiggles doesn't dance to the beat, the beat dances to Mr. Wiggles. Perfection.

Pages 54–55:
Mr. Wiggles
Acrylic on board
20 x 12 in.
2011

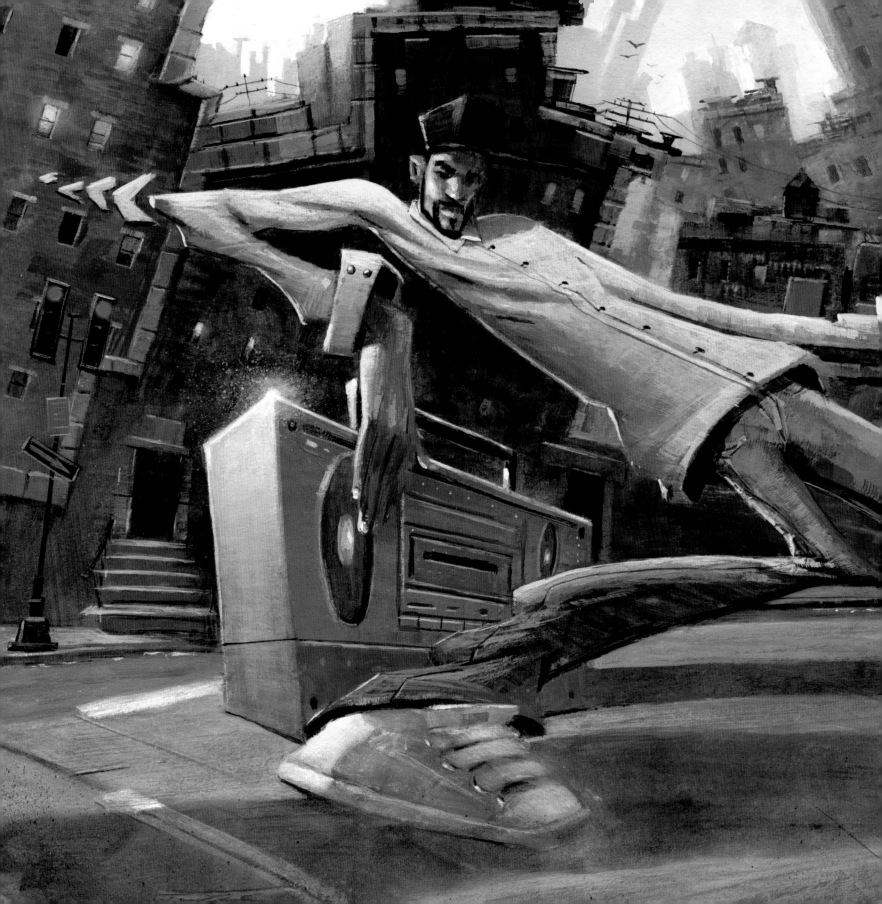

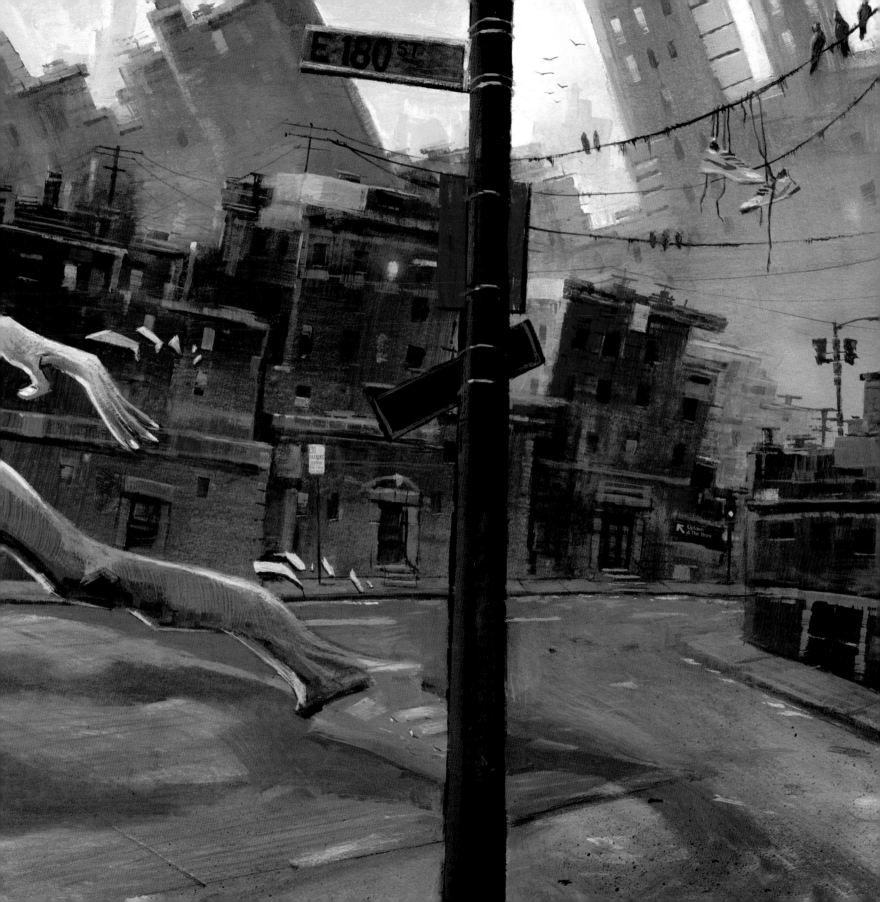

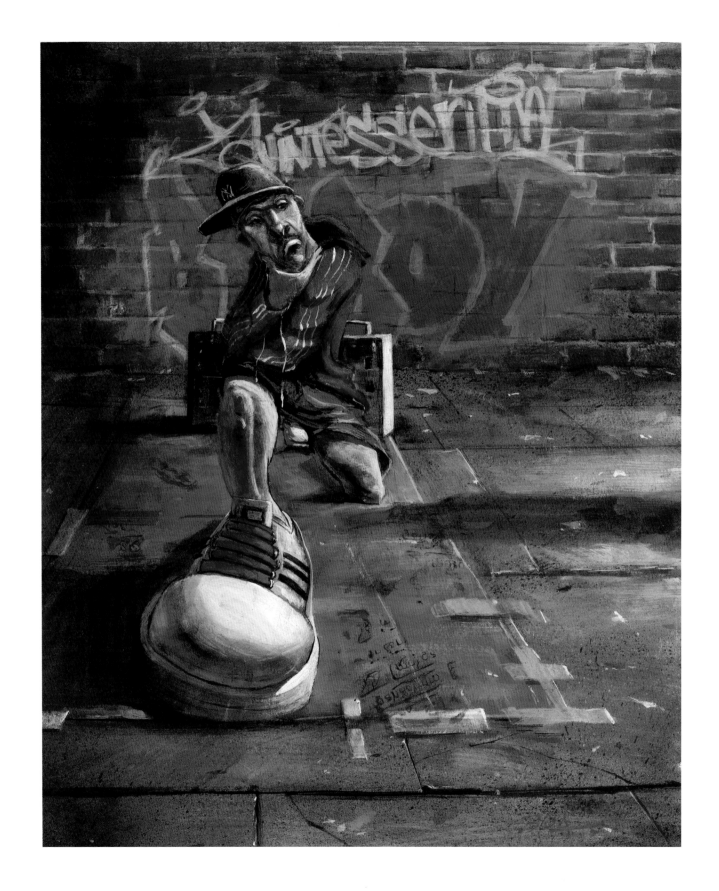

KEN SWIFT

RHYTHM EVOLVES

Ask any b-boy in the world, "Who is the greatest b-boy of all time?" and nine times out of ten they'll answer, "Prince Ken Swift."

Ken Swift grew up a few blocks away from me in New York City on the Upper West Side, a place I liked to call the "Upper Best Side." I used to watch him ditty bopping through the neighborhood streets as well as gettin' down in Rock Steady Park. Although he was only five foot five, he walked around like a giant. His larger-than-life persona resonated primarily through his swift footwork and quick moves. His baby swipes, backspins, and chair freezes were poetic and powerful, but they also had a flavor that no other dancer had. The trademark "mugsy" facial expression he wore, the way he pawed his hands as he top-rocked—he had a style all his own that was emulated by future b-boys.

Unlike most of the old-school cats in the scene, as the style of dance evolved, so did he. That's what makes him so special—his ability to grow, shift, and develop, all in an effort to master the moves. Most people plateau when they hit a certain level of greatness, but not Ken. He's always hungry for more. He is the last living viaduct between old-school and new-school b-boying. Not many remember the savoir faire of Spy, Sundance, and Shakie. Kenny does. It lives inside of him. He bore witness to it and continues the legacy of his ancestors as they pass through the lineage of his poetic steps.

After years of exchanging phone calls with Kenny, I was fortunate enough to have the almighty one attend an exhibition of mine in Bed-Stuy, Brooklyn, where he did an impromptu solo performance. Not only is he one of the most humble people that I have ever known, but he is also one of the most generous. In the game of hip hop, where there have been trillions made and billionaires born, it's important to honor those lone, brave souls who started it all. Ken Swift impacted the culture with his immeasurable greatness. Simply put: He is one of hip hop's fathers, a man who helped birth and shape the culture to positive effect. For that I am eternally grateful.

Opposite:
Ken Swift
Acrylic on board
10.75 x 13.5 in.
2010

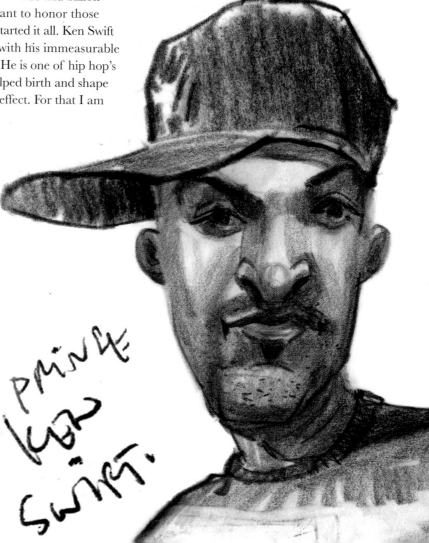

FUTURA 2000

THE ABSTRACT SCRIBE

Old reproductions of European painters—Hieronymus Bosch, Bruegel the Elder, and Kokoschka—hung on the walls of my childhood home. Although they were dark and often morbid, I loved their intensity and deeply appreciated the skill. But when I walked through New York City's streets in the 1970s, colorful graffiti paintings by artists like Revolt, Freedom, and Futura 2000 jumped off the concrete walls and made me see art in a whole new light. The most impressive art was on the giant, steel subway cars where artists could best showcase their work to the people. I would often wait at the 96th Street subway platform for the 2 train express to roll in just so I could see Futura's work. I didn't own a camera so I took quick mental snapshots while the train idled. Sometimes I would ride to the next stop just so I could dip out when the doors opened and look at the painting some more. Eventually, I would leave one portable canvas and jump onto another to get back home. If I was lucky, I got to ride a train with a LEE, a SEEN, a Dondi, or even another Futura painting on it, but usually the car was just "buffed up" or featured some bubble-lettered "toy."

As one of the pioneers of graffiti, Futura 2000 had a great name and an even greater style. He started writing back in 1970 and has been painting ever since. His graffiti challenged what graffiti was. As the legendary graff artist Mear One states, "In the subculture of graffiti there's a social norm—a standard model that graff writers expect each other to adhere to. Futura broke that mold by using tester tips, stock tips in unusual ways. His aesthetic concern was abstraction, free flow, and sacred street geometry. He is an innovator and his style transcends his genre."

Futura 2000 is a visionary. He's an artist who lives and creates work outside of the box, an explorer searching to redefine the boundaries of definition. As the legendary Tracy 168 said, "A lot of writers felt like they had to fill up the whole canvas, but he never believed that. When you're a master, you use less lines because you can make a powerful statement simply." Futura wasn't concerned with traditional 3-D letters, signing his crew's name, dates, or being too colorful. His art was more design-oriented and abstract like a futuristic vision of what art could be. His artistic voice was that of freedom fighter—an urban safari adventurer.

When I met Futura 2000 a few years ago, he was everything I expected him to be. He had an air of mystery about him, like he had been somewhere that no one else had, like he knew something important that we didn't. Maybe it was because he witnessed so much change over the years in a culture that he helped pioneer. Or maybe it was because he is still an artistic explorer, dedicated to an endless journey, searching for that elusive but sacred street geometry.

Opposite: *Futura 2000*, acrylic on paper, 3.25 x 6.75 in., 2010

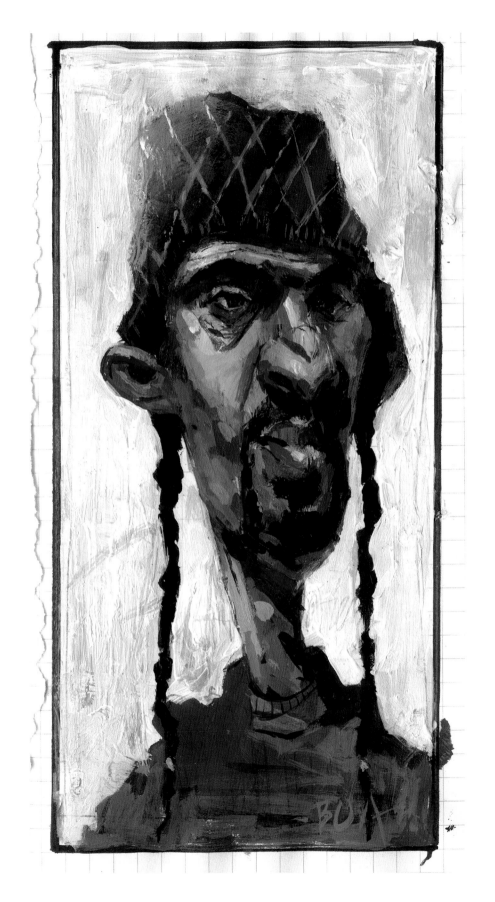

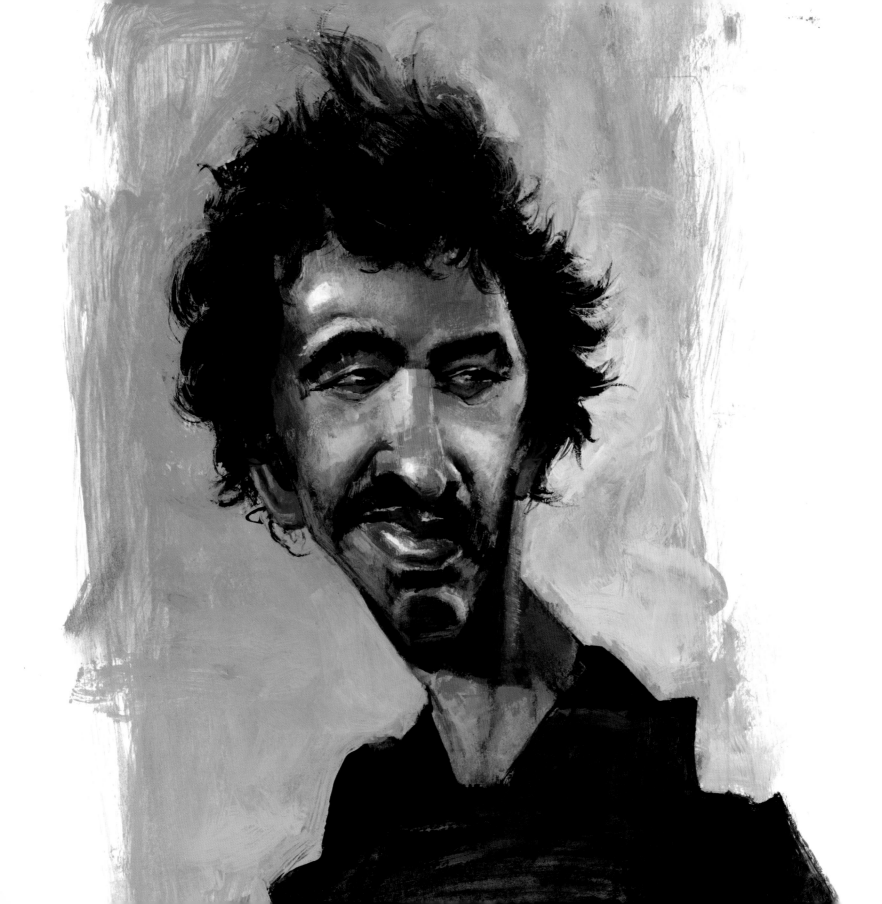

TRACY 168

MARKS OF AN UNTAMED MESSENGER

The saying "truth is stranger than fiction" best exemplifies my relationship with Michael Tracy, better known as the legendary Tracy 168, originator of the wildstyle form of graffiti.

We met a few years back; both of us were guests on a radio show and we were fans of each other's work. Let me further clarify: Tracy 168 was among my childhood heroes. The man was hitting up train yards from the beginnings of this great culture. I grew up watching him dominate the graffiti scene; he was featured in a variety of documentaries and books chronicling the infamous history of the Writer's Bench at 149th Street in New York City. As a young kid, it was an exciting moment to witness his works as they pulled into my platform on the trains I thought of as giant, steel panoramic canvases. His artwork was bold, audacious, and rhythmic—the visual incarnation of popping and b-boying. As I walked through the City, his letters popped off the walls with an energy that was alive with emotion, spiraling from one letter to the next then back again, keeping my eyes active. Tracy's burners were full of gesture like good figure drawings or mindful calligraphy.

Months after I first met Tracy, my assistant reported that I had received a strange phone call from a strange person with a heavy Bronx accent, someone who ended his cryptic message by exclaiming, "Whoo, whoo! Wildstyle, baby!" It had to be Tracy 168. Knowing him now, I appreciate his signature style of crazy and his wild stories. But when you're first getting to know the guy, his larger-than-life tales can leave you wondering if you're being had or not. Each exploit was bigger than the last. Over the course of our long-distance phone friendship, I've heard about the various times he's gone to court to fight a graffiti-related crime, narrowly avoiding jail time; the time he had his teeth broken by an undercover cop; the time that he was on the lamb from the FBI for reasons neither he nor I are at liberty to disclose (since I don't understand them myself). Our conversations were electrifying and I quickly became emotionally attached to this character, even worrying about his well-being and whereabouts. And as he's "gotten up" from the sooty walls of underground tunnels to the white-washed walls of the Brooklyn Museum—he is one of the only people on the planet that I can talk to about navigating the worlds of both street art and fine art. . .and Tracy's got *a lot* to say on the subject.

Even though Tracy's life is somewhat of a mystery to me, I consider him a kindred spirit. I relate to his drive and respect that every time I speak with him, he has a pen in hand. I truly think that Tracy would die defending the right to write. He is a true artist with an utterly unique vision of the world. With the soul of an outlaw, Tracy is the physical embodiment of graffiti. He lives for it, walks it, and breathes it. Tracy 168 is a character of epic proportions, the stuff that legends are made of. Whoo, whoo! Wildstyle, baby!

Opposite:
Tracy 168
Acrylic on paper
10 x 14 in.
2011

LADY PINK

MS. MIDNIGHT MAVERICK

In the 1970s, New York street art was both a visual inspiration for our generation as well as a reflection of the times. Graffiti's gigantic letters were abstract expressions that mirrored the social climate of the city—poverty, crime, and the economic uncertainty of Reaganomics. The angular letters spelled peril. The drips and splatters symbolized the unsettled, teenage angst of the unknown. Graffiti allowed the kids in my hood to take back the streets and define their space, giving them a sense of purpose.

You had to be rugged and tough with big brass balls if you wanted to be a graffiti writer. To go into the train yards, you had to have an extra sense of fearlessness. Electric third rails, transit cops, barbed-wire fences, and attack dogs—just some of the obstacles you had to get through in order to "bomb" a train. The yards were a male-dominated kingdom full of testosterone-driven boys jockeying to be the best. There was no place for a woman. Or was there?

Lady Pink was the first girl I knew in the game. There were women before Pink—Barbara 62, Eva 62, and Lil Love 2, but Pink was the most known *and* the most stylish. She navigated a world dominated by men. She hit up the yards—the 2, 5, and CC trains—and competed neck and neck with the boys. Pink brought femininity to the trains. Her art was passionate; she painted with elegance. She's wasn't just in the game to vandalize or go all-city. She was in it because she was an artist.

Pink was able to flourish in a man's world without much female support. Not only was she talented, she was beautiful, too, with cherub lips, a heart-shaped face, and long black hair. Her palette reflected her beauty and featured a range of light cerulean blues, warm pinks, and soft colors. Her work was uplifting and feminine; an urban Georgia O'Keefe. Mear One says, "She's like the Rosa Parks of graffiti. She's the first woman that made it to the social discussion—everyone noticed her. She opened the door for a lot of women. She's a major inspiration for people like Miss Maggs, Blue, and Claw. She's been an incredible influence on them. She is a pioneer who inspires other women around the world who would not have gotten into the game without her. It was her courage, bravery, and passion that is inspiring to women—*and* men. I was inspired by her."

To this day, Lady Pink is still the most well-known, enduring, and accomplished woman in the history of graffiti and for that, her name is engraved in the holy grail of hip hop.

"LADY PINK GETS RESPECT. THE MIDNIGHT YARDS WERE NO JOKE BACK IN THE DAYS, AND SHE HELD HER OWN. HER STYLE WAS ALWAYS RAW AND UNIQUE—WITH HER OWN FLAVOR, LADY PINK IS A TRUE ARTIST."

—TRACY 168

Opposite:
Lady Pink
Acrylic on canvas
14 x 18 in.
2010

BIG DADDY KANE

It was the summer of 1988 and I was on break from college. I was working the kind of crappy summer job you never forget—busboy at an upscale bistro called Julia's on 79th Street and Broadway. The two other busboys, Victor and Franco, didn't speak a word of English. The head waiter-slash-actor was rude, obnoxious, and arrogant. I mean, this guy was such an asshole that whenever he took an order, he would whisper under his breath to Victor, Franco, and me, "Waiter with a *real* job coming through. Out of my way." Since I was the only busboy who knew what he was saying, his arrogance stung me the most. But Victor and Franco weren't dummies. They got the picture, too. I wanted to sock this guy in his pouty little wasp of a mouth, but I needed the money, so I just grinned and bore it. The only saving grace of those long, hard working days was Big Daddy Kane's music.

On breaks, the busboys and I would huddle around the radio, drink the morning's fresh squeezed orange juice, and listen to our favorite single, "Raw" by Big Daddy Kane. His music transcended the language barrier and did the talking for us. "Raw" didn't just get me through the day, it helped me become a man. Full of skillful bravado, it was an anthem of cool—and since I *wasn't* cool, I reveled in the possibilities of Kane's words. Even though we were the same age, Kane offered an example of what a grown-ass man should be: articulate, wise, confident, and strong. I listened to the multilayered, complex rhymes over and over and memorized every lyric frontward, backward, and sideways. The funny thing is that Victor and Franco also learned the lyrics. To this day, I can recite the song verbatim.

Kane pushed hip hop to another level. His voice set him apart—he was just faster, nastier, and rhythmically cleaner than anyone I had heard. He spat lyrics at hyperspeed with powerful precision; his battle-ready voice became the standard as he tore through his opponents into the next millennium.

It's amazing to think that at one time Big Daddy Kane's "hype man" was Jay-Z. The King of New York being hyped up by the future King of New York. Back then, Big Daddy Kane was more than the king in my eyes, he was my deliverance.

Opposite: *Big Daddy Kane*, acrylic on board, 14 x 15 in., 2011

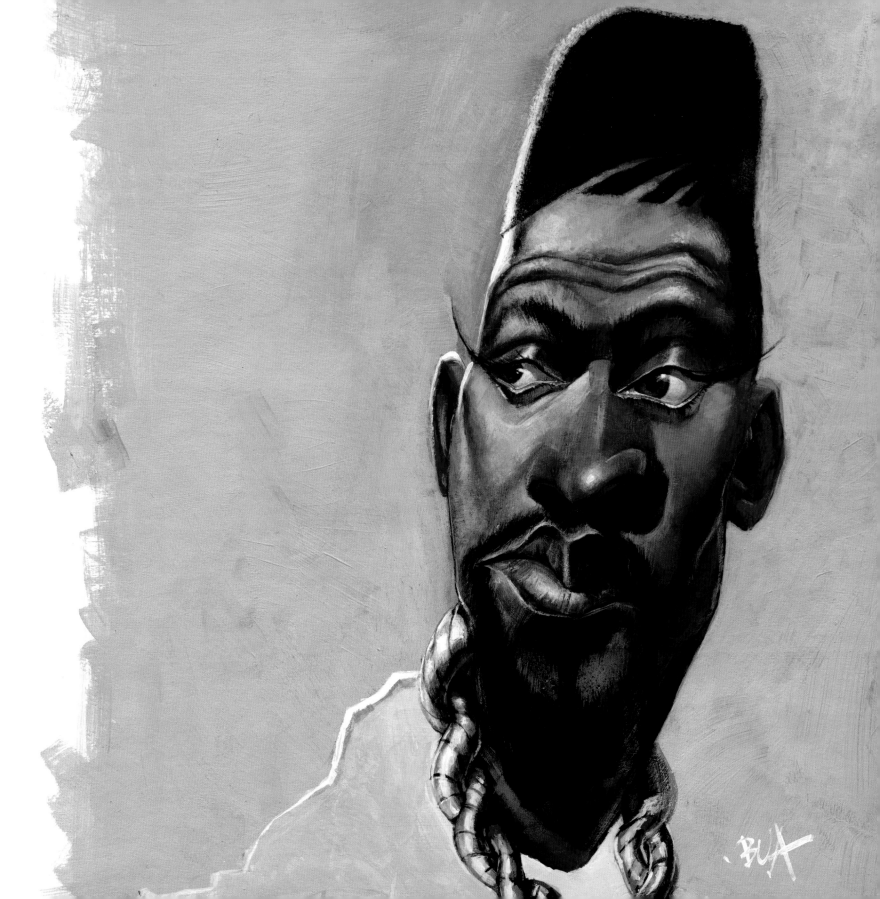

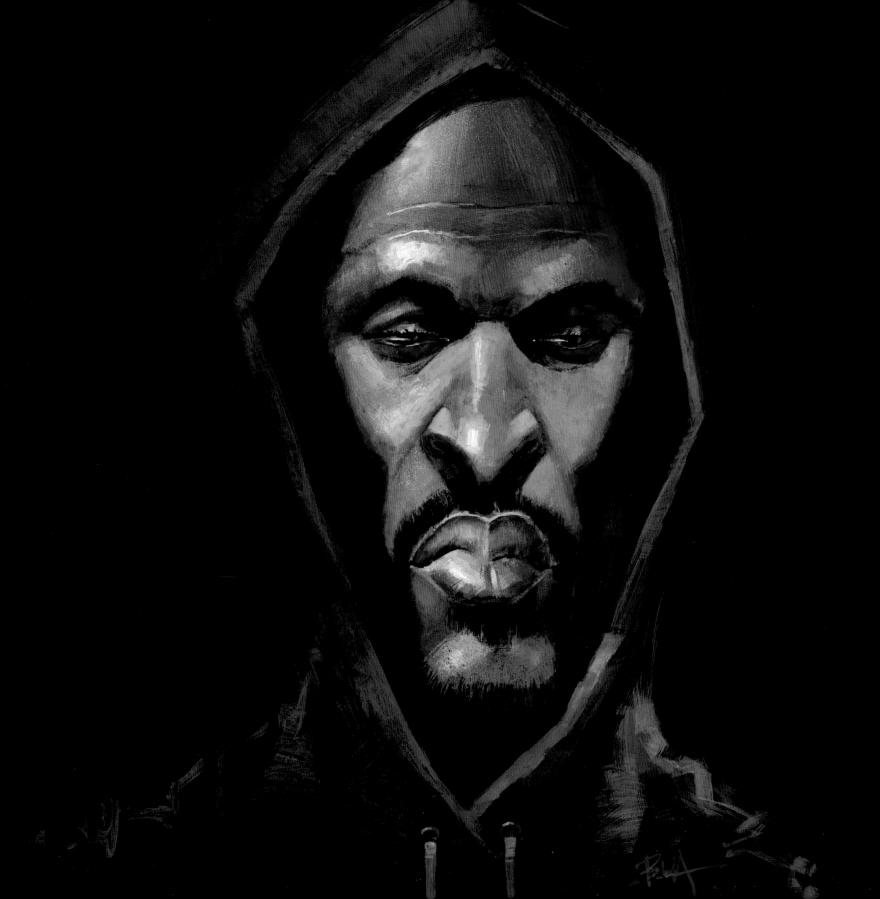

RAKIM

THE SECOND COMING

Pablo Picasso said, "Art is the elimination of the unnecessary," and that's how Rakim puts it down. Clean, cut, lean, and hard. No extra-fluffy, bullshit vocab. Nothing corny. His shit hits you. Rakim's deep voice and powerful, laid-back delivery are pure perfection. His verbal agility is second to none. But it isn't just his technique; it's his lyrics. He is the Bob Dylan of hip hop. Like Dylan, his lyrics take center stage; the layered complexities of his wordplay showcase his technical skills and are reflective of real street life. Christopher Walken takes a script and crosses out all the punctuation, then reads the script as he feels it. Rakim spits in the same way and controls the tempo of the music with his words.

When I first heard Rakim's voice in concert with Eric B's genius cuts and beats, it was one of those feelings that was almost impossible to articulate. It was like the first time I saw b-boying—it changed the way I saw hip hop and opened a whole new dimension to the culture. There was a maudlin idea of hip hop before Rakim stepped up, and then the second coming of the MCs was upon us. I think of the William Butler Yeats line, "The ceremony of innocence is drowned," when I think of Rakim's appearance on the scene. With Rakim, virtue no longer exists; he delivers lyrical truisms full of darkness. He killed the naiveté of rap, murdered it with words, and in the process has both changed everything we've ever thought of rap and influenced a generation of future greats. Everyone from Tupac to Biggie and Jay-Z to Eminem all reference the "R" in their music.

The great poet Saul Williams said, "You haven't heard hip hop unless you've listened to Rakim on a rocky mountain." I think everyone in the game would agree that if you haven't listened to Rakim, you haven't listened to hip hop. Rakim is *the master.*

Opposite: *Rakim*, acrylic on paper, 14 x 17 in., 2011

KRS-ONE

KEEPING THE RECORD STRAIGHT

It was 1987 and two of my b-boy dance partners invited me up to their neighborhood in the South Bronx. That hot summer night was most memorable.

The fire hydrants cooled the streets and the cart vendors, slangin' coconut icies, cooled the kids. Shaft told me we were going on a trip to get out of the heat and handed me a hit of acid called mescaline. The tab was so small, it looked harmless. I asked if it was at all possible to have a "bad trip"? He said, and I quote, that it was "impossible." Confident of his words, I took the hit. For the first hour, the only thing I felt was the hot summer breeze. Then, all of a sudden, I got really tingly and extremely blazed. I went into another dimension of time and space. My eyes closed as I felt my new body. I was tripping.

Everything became a cinematic vignette:

Int. Shaft's apartment. Plates strewn about, TV blarring, baby in diapers poltergiested in front of it. Loud sound of television snow then silence.

Int. Shaft's lobby. Two Puerto Rican girls arguing, cocking their heads from side to side. Lips pursed. "No me mires, no me grites."

Ext. Playground. My body flips onto the concrete. My playground in Riverside Park is made of hard black rubber that you can fit together like a puzzle. But this is real cement. I am doing suicides from the jungle gym—front flips, landing on my back. I'm six feet up in the air flipping onto the concrete. It feels good!

"Give him another hit," Shaft shouts. "This mothafucka's fucking craaazy! Ha-ha-ha!"

I look down at rusted steel pipes and I realize that I'm sitting on red monkey bars. Monkey bars aren't red? I'm bleeding from the elbow. The music drifts out of the gargantuan ghetto blaster speakers and into my pores. My pores are wide open. I can smell the music and taste the mescaline in my mouth.

KRS-ONE raps. The song is "The South Bronx." Everyone loves that song, but to be in the South Bronx, with kids from the South Bronx, adds another dimension to the song. KRS-ONE is so good. His voice, his words—he's smart. Everyone is singing his song like it's their anthem. I love it. Singing the praises of the South Bronx, talking about the real birthplace of hip hop. Referencing Rock Steady Crew, Herc, Bam, Flash—KRS is telling it like it is. I'm trippin' but I'm open to his genius flow. Scott La Rock is such a dope DJ. Boogie Down Productions, or BPD, as they were called.

I haven't done *any* drugs in almost seventeen years. But that night, mescaline opened up my mind to a deeper level of hip hop. In the song "The South Bronx," KRS-ONE stands up for his borough with passionate love. He is the ultimate Bronx zen-warrior. The lesson learned? It's the first time I realized how powerful words could be to fight without violence. Maybe that's why KRS-ONE is known as "The Teacher." In the words of Mr. Wiggles, "Everything KRS-ONE spits is word to the mother, he doesn't hide behind his lines with slang." A social commentator, he's hip hop's ear to the streets and he's still reporting live from KRS1 radio.

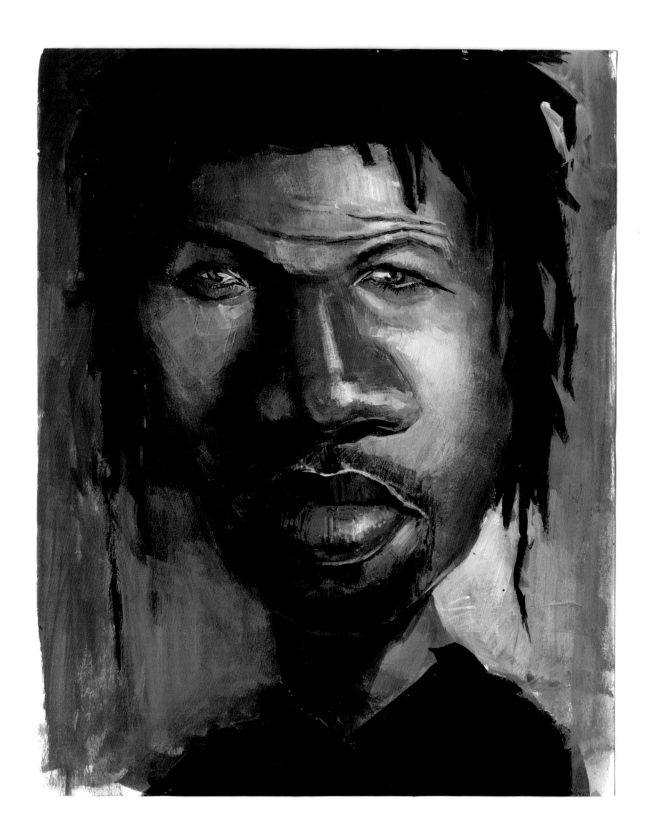

"KRS-ONE IS THE CONSUMMATE PARTY-ROCKER AND EDUCATOR WHO UNDERSTANDS HOW TO SEAMLESSLY ROCK A CROWD WHILE DROPPING SCIENCE."
—BIG DADDY KANE

Opposite:
KRS-ONE
Acrylic on canvas
16 x 20 in.
2010

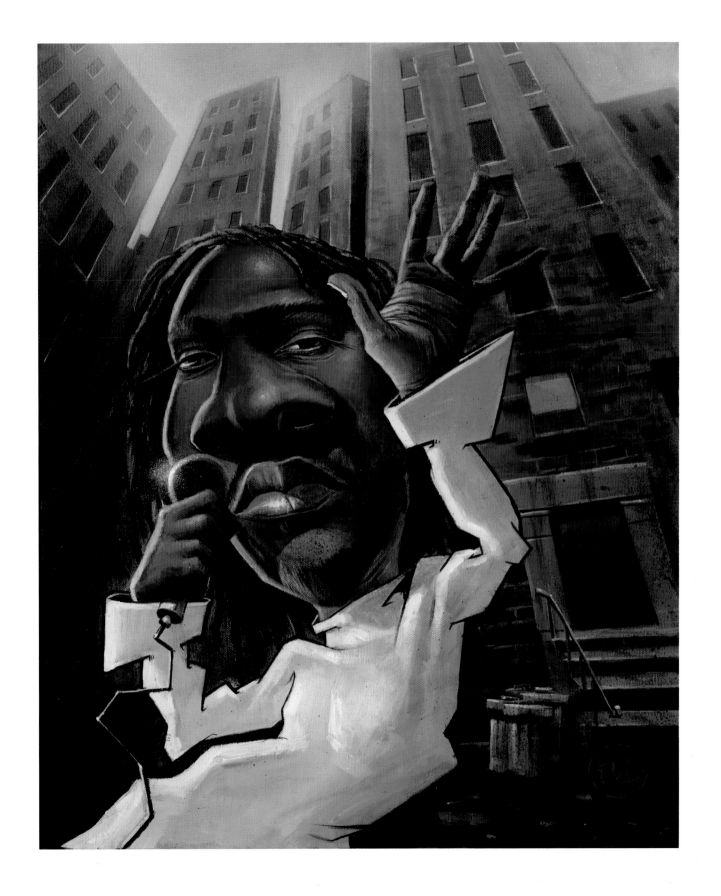

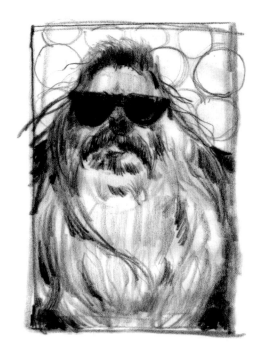

RICK RUBIN

THE BLACKSMITH

I was sitting at dinner with some potential clients at an upscale L.A. restaurant discussing a mural project I was up for. All of a sudden, in walks a hefty, hippie-looking Santa Claus with big sunglasses, a dirty white T-shirt, torn jeans, and flip-flops. I mean, I didn't get to eat out at five-star restaurants every day, but maybe this was status quo for shi-shi L.A. restaurants? L.A. was more casual than I thought. The dirty Santa passed my table and I almost pissed myself silly.

Holy shit, that's Rick Rubin! I thought. I was trying to pay attention to my clients but this realization was taking precedence at the moment. I mean, this man was one of the greatest producers in the history of hip hop—if not *the greatest*. The one responsible for bringing us LL Cool J, Run-D.M.C., the Beastie Boys, and Public Enemy, not to mention countless other artists like Red Hot Chili Peppers, and too many others to name.

The client said, "We were thinking it would be great if you rocked a mural. . ."

Rocked, I said to myself, drifting off into fond memories of "Rock Box," "Walk This Way," "Sabotage," "Fight for Your Right to Party," and all of the other rock-inspired anthems that Rubin helped to bring to hip hop. I wanted to go up to Rick's table because I had always wanted to meet him. I am pretty outgoing, but this was Rick motherfuckin'

Rubin! I mean the same Rick Rubin whose music blasted from my boom box while I battled Carlos in the Douglass projects, smoldered as I puffed weed at the Roxy, and even drowned out the disturbing fights my mom and her boyfriends had.

As my client continued to explain his vision of the mural, I excused myself. . .I couldn't help it. This was a once-in-a-lifetime opportunity that may never come again.

"Where are you going?" they asked.

"I'm *so* sorry, I'll be right back. Please don't go anywhere." Before my shyness stopped me short, I was in front of Rick.

"Hey, man. My name is BUA, I'm an artist and a very *big* fan."

"I know your work, you're the artist that did *The DJ*. I love that."

I was in awe. He was very down-to-earth, humble, and real—especially for someone in the music business whose repertoire of hits is so extensive. *What a saint,* I thought.

With such a great experience of Rick in mind, I painted him amid a never ending row of platinum albums, with one gold glowing record emitting a halo like the one in Masaccio's *Holy Trinity*. With his trademark sunglasses, beard, and long, flowing gray-blond hair, he looks as unique as the music he makes. It was an honor to paint one of the pioneers of hip hop.

Opposite:
Rick Rubin
Acrylic on paper
7.5 x 13.75 in.
2010

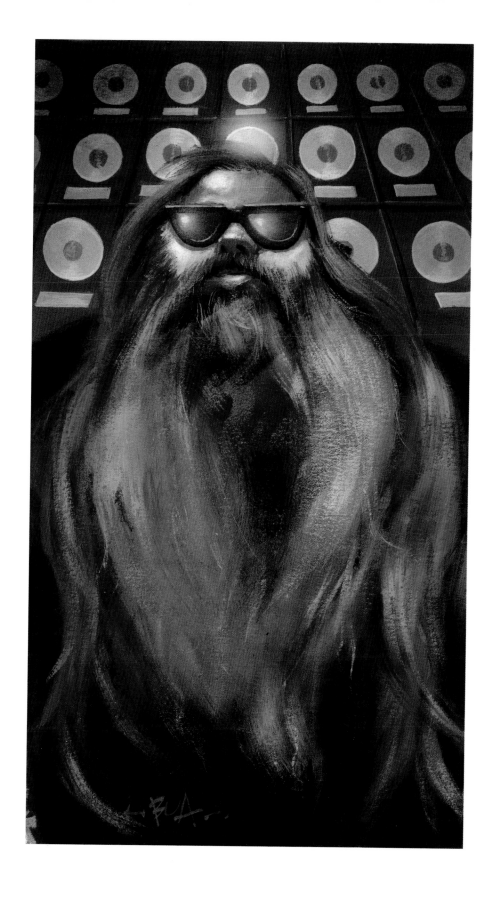

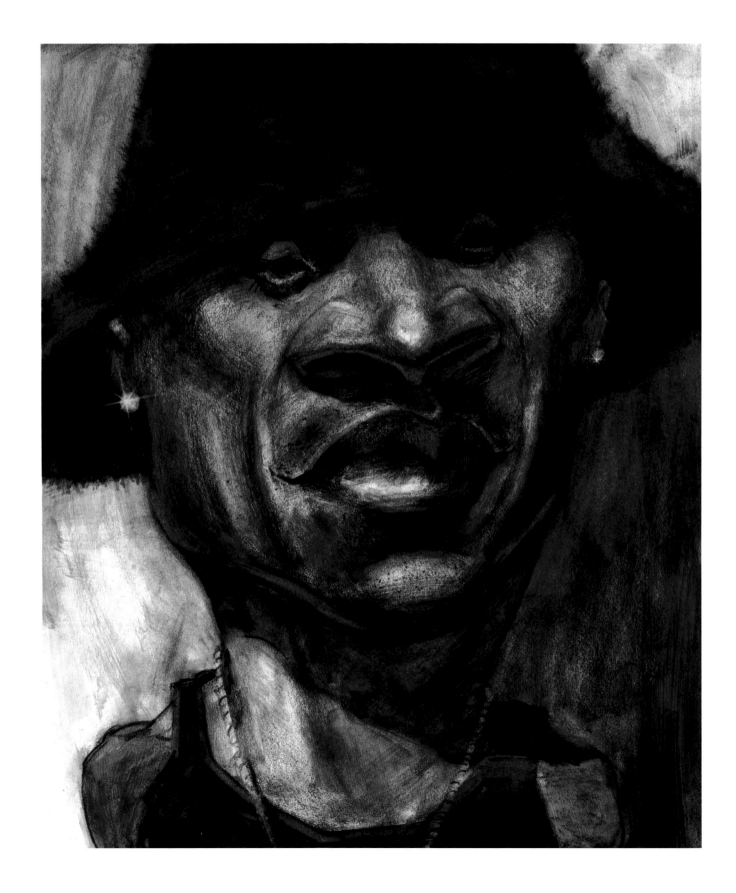

LL COOL J

ADONIS'S MELTED WORDS

All of my friends love LL Cool J. From "Radio" to "Mama Says Knock You Out," he crushes it. LL has the rare ability to appeal to hardknocks and soft girls alike. His distinctive hard-hitting voice, bravado, youthful energy, and, let's face it, sex appeal provide something for everyone. LL was Queens born and bred, an early draft pick for Def Jam. His raw talent was sculpted by two of the greatest artisans of the era—Russell Simmons and Rick Rubin. Once LL hit the airwaves, his music was part of my everyday life—from battling b-boys in the Bronx to kickin' boots in Brooklyn.

As decades passed and LL became more of a romantic ballad MC, I still liked him, but I found myself gravitating toward more hardcore hip-hop music. I didn't tune back into him until the 2000s when I made a shocking discovery: One of my very good friends had appeared in LL Cool J's music video "Going Back to Cali" at the age of fifteen. She was *that* girl. You know, the girl wearing the black miniskirt, shot from below? Being a minor, her mother contacted a lawyer once the video aired on MTV, and within *hours* my friend's panties were covered up on MTV with a black censor box. I liked "Going Back to Cali" before my friend told me this story; now, I love it. It is undoubtedly one of hip hop's best songs, fusing jazz

and hip hop, and the video is cooler than cool, with its black-and-white shots of L.A. landmarks. "Going Back to Cali" is a classic, just like the man himself. The great thing about LL is that he is still one-of-a-kind after all these years. In March 2011, my boy Qbert, who had just performed with LL at the South by Southwest music festival, said, "When LL came out on stage, all of us, including De La Soul and Jazzy Jeff looked on in awe. LL is still the shit. He tore it up like it was the early 1980s. He's still 'the GOAT'—the Greatest Of All Time." I loved hearing this. While his career has evolved, LL remains true to himself—he is still the raw and impressive, Kangol-wearing, shirtless MC he was back in the day, still boastfully rocking crowds.

LL is a lot like the great Muhammad Ali in that while he is the epitome of bravado, he transcends narcissism because he brings the audience along on an empowered call-and-response journey. To the effect of Ali's two word poem "Me, We," many of LL's lyrics lead the audience to repeat empowering words about themselves. His positive affirmations became anthems that we could all draw inspiration from. It has been our good fortune that an eager teenager from Queens who loved to rock the mic rose to become a full-fledged legend.

Opposite:
LL Cool J
Prisma on paper
14 x 17 in.
2011

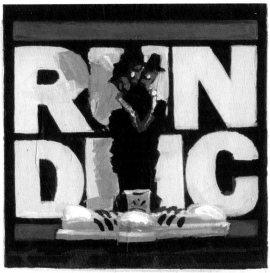

RUN-D.M.C.

KINGS OF A NEW KINGDOM

Run-D.M.C. is my *favorite* group from back in the day. As a kid, I spent every morning before school ironing my Lee's, Le Tigre shirt, and fat laces while listening to their music. Their story was my story, our story. They were the first group to dress like we did (every other group's attire reflected the funk and disco era). They rapped about the social and political climate of the time. Their songs were about how *we were all* living: trying to make ends meet, working hard against the competition, being underpaid and falling behind on bills, but they didn't just paint a picture of obstacles. They also gave us positive words of wisdom and uplifted us with their message without being corny. They were original. They represented everything I wanted to be: a cool, stylish, intelligent man. I followed their shows like a hip-hop deadhead.

One of my greatest memories is Run-D.M.C.'s performance of their album *King of Rock* at the 1985 "Live at the Beacon" concert. Shit was slammin'. They had just finished performing "Sucker MC's," the crowd was going bananas, and Run asked, "Is Brooklyn in the house?" The crowd exploded with electricity. Then, out of nowhere, a bunch of roughneck kids bum-rushed the stage, and the electricity turned into a violent assault. Security couldn't control the feral crowd. D.M.C. tried to peace out the crowd but, by this time, chairs were launching. The balcony, where I was sitting, erupted with violence. Kids were trying to throw one another over the edge. Fights broke out to the left and right of me. It was complete pandemonium. Then gunshots popped off—*cap, cap, cap, cap!* Run-D.M.C. screamed, "Oh, shit!" dropped their mics, and ran off the stage. My friends, West and Zulu, and I jetted out the back door, and ran down the fire escape to Amsterdam Avenue. But the insanity had spilled into the streets. Amid the insurrection, we dipped in and out of the chaos. The night reminded me of the cult-classic film *The Warriors*, as we witnessed robberies, beatdowns, and fights trying to make our way back home.

You'd think I'd remember all the violence, and I did, but I couldn't get over the fact that I had just seen Run-D.M.C. perform. They made such a lasting impression on me that the shock of all the violence took a backseat.

While I was in the process of finishing my painting of Run-D.M.C., I had the amazing opportunity to hang out with D.M.C. one-on-one. I was incredibly proud to be able to show him the piece. I was overcome with emotion as we stood in front of the canvas; he said it was the most iconic image of Run-D.M.C. that he had ever seen. I told him how I was a huge fan when I was a kid, but I really couldn't explain just how big a part of my childhood they were. To this day, I can recite "Sucker MCs" and "It's Like That" word for word, like it's 1985 and I'm rockin' it at the Beacon Theater.

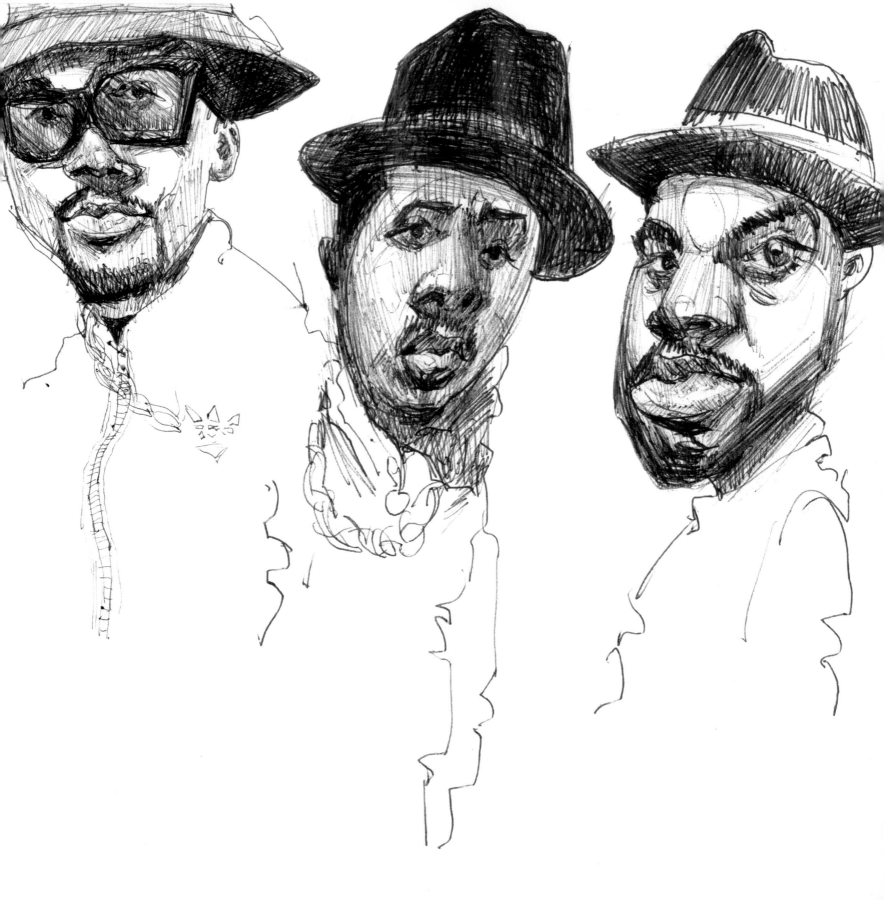

"RUN-D.M.C. REPRESENTED THE FIRST CHANGING OF THE GUARD IN HIP HOP. THEY TOOK THE ESSENCE OF HIP HOP— TWO TURNTABLES AND A MICROPHONE— DEFINED AN UNDENIABLE STYLE, AND BROUGHT RAP MUSIC INTO THE LIVING ROOMS OF THE WORLD. THEY ARE UNDOUBTEDLY THE MOST INFLUENTIAL RAP GROUP OF ALL TIME."

—GRANDMASTER CAZ

Opposite:
Run-D.M.C.
Acrylic on canvas
48 x 40 in.
2010

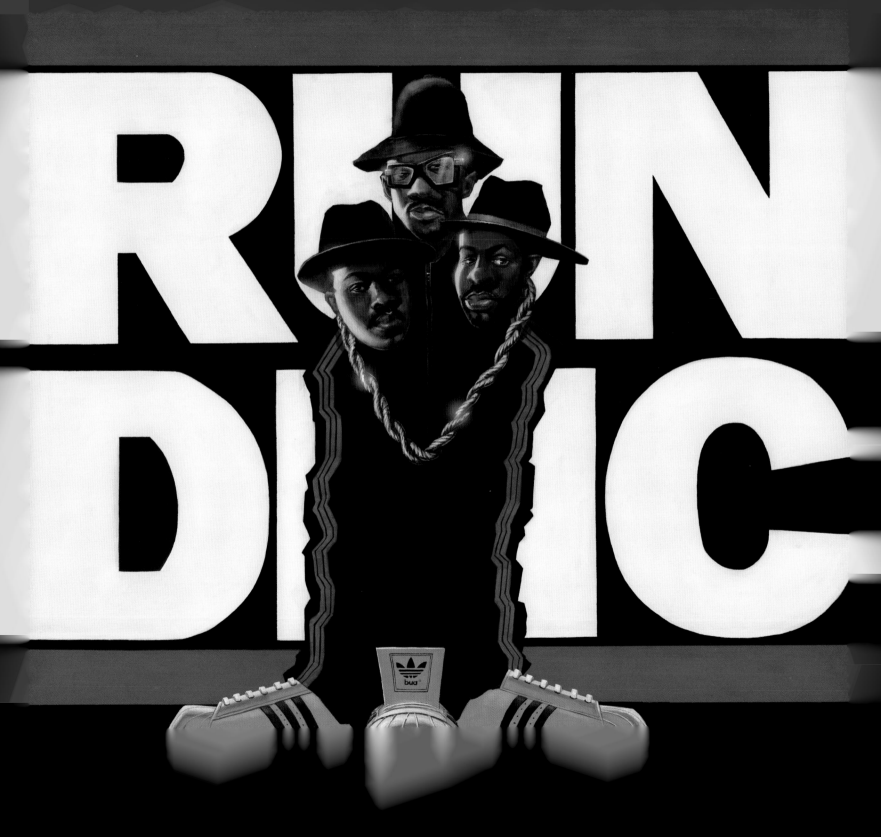

THE BEASTIE BOYS

...AND THEN *PAUL'S BOUTIQUE* CHANGED MY LIFE

In 1982, my boy Trev handed me a cassette tape of a band playing punk rock: the Beastie Boys. I hated it. A few years later when I found out that these punk rockers were on the same bill, piggybacking on one of my favorite groups—Run-D.M.C.—I was perplexed, to say the least. I remember thinking, what kind of frat-boy rap is this shit? Rapping over heavy-metal riffs, screaming about their right to party?

All of my friends were bugging out, infuriated by the chutzpah of these Jewish kids. No one knew what to make of them—they were "toys," "biters," and "wannabes." Me? I didn't understand their off-kilter syncopation; they seemed to be lampooning rapping. I was used to hard-hitting flows like Rakim, Big Daddy Kane, and Kool Moe Dee or laid-back, smooth storytellers like Slick Rick or Biz Markie. Even the way they dressed seemed to be a parody of our style. Were they mocking our culture?

When their second album, *Paul's Boutique*, came out, I was in college. I was so blown away by the complexity and musicality that I instantaneously transformed from a hater to an appreciator. *Paul's Boutique* was a landmark in the art of sampling and made me rethink what hip hop could be. Miles Davis said that *Paul's Boutique* was the greatest album of the decade, and I agreed. I was a die-hard fan, and they soon became my favorite group to listen to while I painted. Songs like "Sabotage" and "Brass Monkey" gave me chills up my spine. Their music was charged, intense, and *fun!*

My first celebrity spotting in Silverlake, Los Angeles, was the great Mike D—the *D* is for Diamond, you know. I was standing in the checkout line at Rite Aid and he was in front of me. I freaked out. While I don't recall exactly what I said, I do remember that it was a jumbled mess, something like, "Yo, Mike, I'm a big, big, big fan." Then I mixed in some of his lyrics into my monologue and, without realizing it, I was spitting, "Your cash and your jewelry is what I expect, so I grabbed the piano player and I punched him in the face." What? Insane. We walked out together—well, he walked out and I followed after him, blabbering incessantly. Like a bat out of hell, Mike D ran across Hyperion Avenue so fast, he almost got hit by a car. I was elated and bewildered, completely stoked that I just met one of the legends of hip hop—from one of the greatest groups of all time.

I know I'm going out on a limb when I say this, but shiiiiit, this is *my* book, so here it goes: There are ripples in *The Legends of Hip Hop*, and there are waves, but the Beastie Boys are a tsunami. Kick it!

Opposite:
The Beastie Boys
Acrylic on masonite
11 x 14 in.
2010

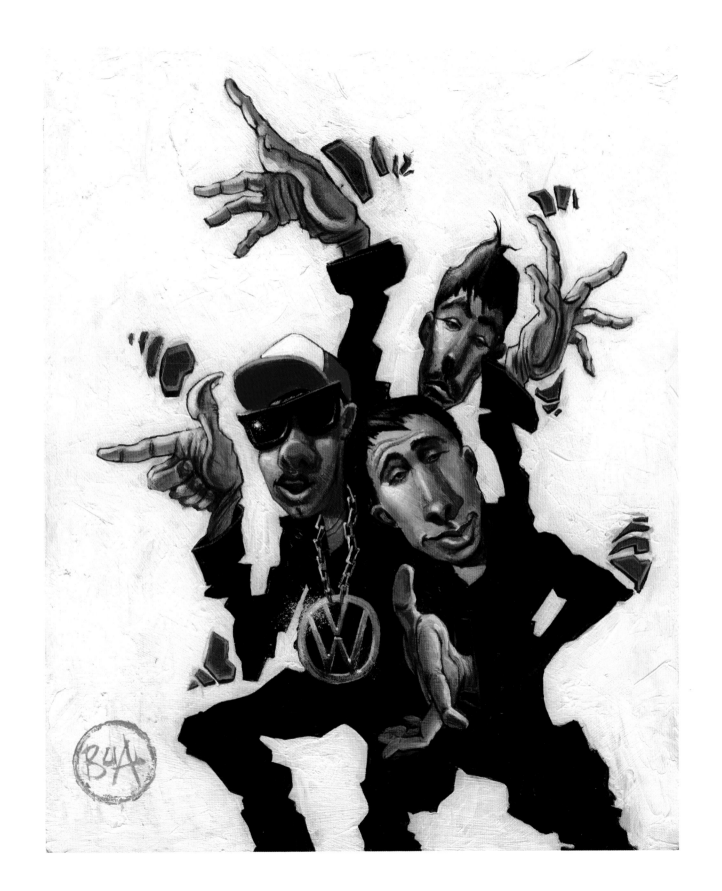

PUBLIC ENEMY

FROM THE REVOLUTION'S PULPIT

The year was 1986 when I applied to college. My first choice was the acclaimed Cooper Union. My grades and SAT scores were not reflective of my creativity, but according to the Cooper Union, neither was my art.

When the Cooper Union rejected me along with other notable art schools, my mom and I decided it would be best to go to *any* school that accepted me. Enter Hampshire College, a superhippified school better known by the students as "Camp Hamp." Camp Hamp was full of hippies who listened to the Grateful Dead and protested affluence. They might have looked destitute with their torn jeans and worn-out Birkenstocks, but many were driving BMW 5 series. These kids had money. Since I needed money, I worked as an RA (resident assistant) for the dorms, responsible for my hallmates' well-being.

One night I was woken by a girl complaining she couldn't sleep because of the loud music in one of the rooms. Aggravated, I stormed over to the suspected noisemaker and banged on the door. The door swung open, a trail of smoke billowing out. The room was filled with crunchy tree huggers stoned out of their minds, sitting around a stereo like a campfire, transfixed by the music. The music was strong, forceful, political, and different than anything I had ever heard in my life. It was Malcolm X militant. How in the world did they get ahold of this music? I asked who they were listening to and they said, "Public Enemy." I hung out and danced all night long.

Chuck D's voice was already living inside of me, before I ever heard him rap. A latchkey kid, raised by a single, working mom, I had a lifetime of anger welled up inside of me. I was upset at the schools that rejected me, disturbed at the teachers at Camp Hamp who didn't think I was "good enough," and I definitely could have skipped being an RA for a bunch of rich kids. Could we possibly share the same rage? It was ironic: Here were these black militant musicians talking about "fighting the power" while these white kids, who *had* power, were singing along to the lyrics. Maybe they had as much reason to fight the power because their CEO fathers and executive mothers were the power? My background didn't make me more qualified to relate to Public Enemy's words. Public Enemy stirred a riot in everyone. Everyone connected to Public Enemy for their own reasons. Music, if nothing else, is the great equalizer.

I recently had the pleasure of working with Chuck D on a project. He was incredibly humble, open, and real. We spoke about life, basketball, and art. I was actually taken aback by the range of Chuck D's artistic knowledge. He referenced obscure artists that few professional artists are aware of. His knowledge was deep. He quickly lived up to *all* of my expectations—he's in one of the greatest hip-hop groups of all time, has one of the greatest voices ever, and is an able, articulate dialectician who understands hip hop inside out.

I'm glad that I was rejected by all of those pompous art schools. They sidelined me to Camp Hamp where I was introduced to Public Enemy and learned that hip hop transcended stereotypes and could be a voice for everyone.

Opposite: *Public Enemy*, acrylic on paper, 10 x 10 in., 2011

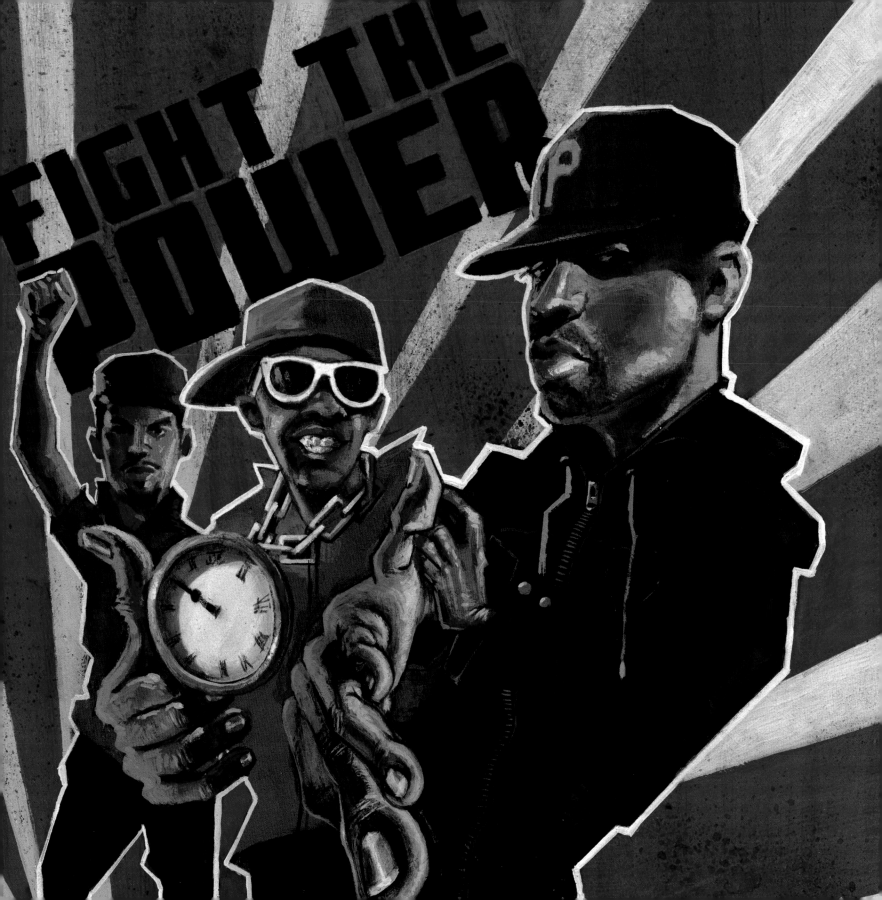

QUEEN LATIFAH

ALL HAIL, MAKE WAY

In the male-dominated world of hip hop, Queen Latifah is an admirable example of a woman who didn't wear booty shorts or strip half-naked to get fame and fortune. From the moment she busted onto the scene, back in the day, she was running at the front of the pack, right up there with the men. If the men could anoint themselves "grandmaster" this and "King" that, Dana Elaine Owens could change her name, too, and become royalty. Not only did Latifah take on the title of Queen, she transcended it, paving the way for future female MCs to carve their own path in hip hop and cross over into television, film, and fashion.

Before Queen Latifah became one of the biggest success stories in Hollywood, she was reppin' women on the real. When I saw the video for "Ladies First" in 1989 (featuring Monie Love, another great female MC), I knew the game had evolved. I remember their African garb, Afrocentric images of slavery and apartheid. These were strong black women. Queen's Latifah's songs were anthems for all the women in my neighborhood. It didn't matter if they were Puerto Rican, Italian, or African American; it was all about unity.

If Latifah came to the game now, as an unknown, I don't think the industry would know what to do with her. I think that in today's watered-down, bubblegum, hip-hop culture, a strong, politically-minded black woman like Latifah wouldn't fit in. She might be, as Malcolm X said, "Too black. Too strong." To this day, there is no one in hip hop like her. That's why she will always be the Queen.

Pages 88–89: Queen Latifah, acrylic on board, 9.5 x 5 in., 2011

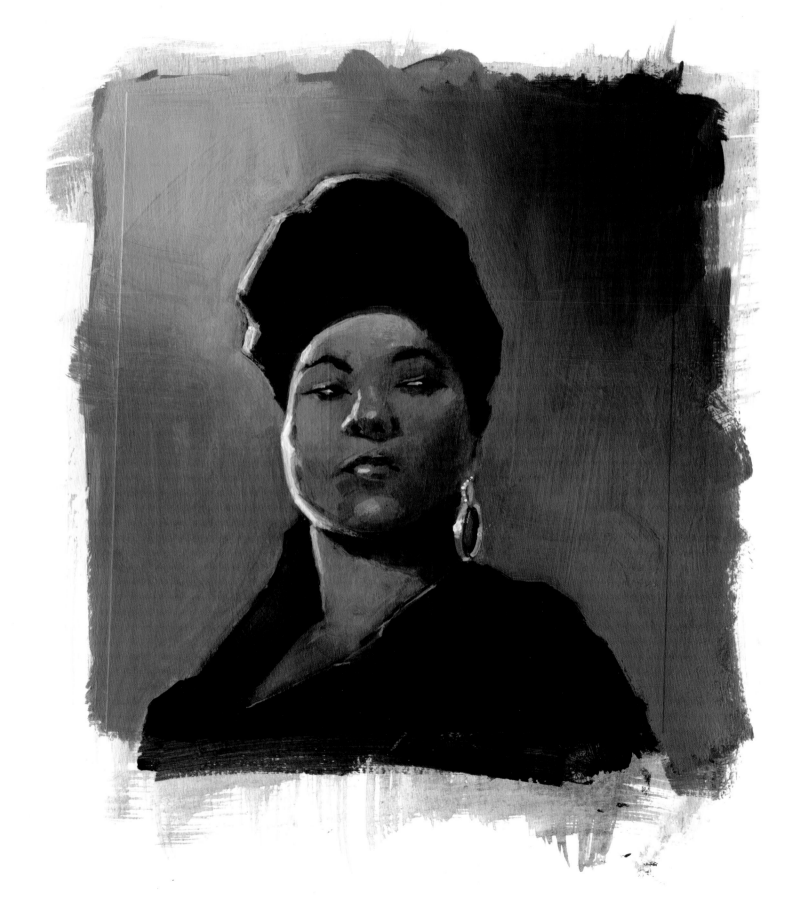

IP HOP

UNITY

L1970

Q E N

RST

1

A TRIBE CALLED QUEST

THE HALCYON DAYS

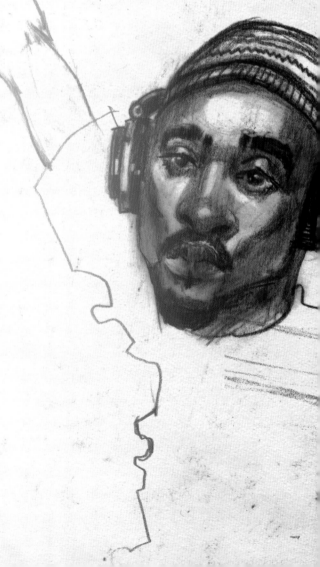

In the summer of 1990, New Yorkers were experiencing a heat wave of urban fatigue. People were tired of the hardships of city life. A few years back my mom and I had moved from Manhattan to East Flatbush Brooklyn in search of a better life. However, in Brooklyn, the crack problem was so severe that you couldn't leave a geranium, a hose, or a plastic chair on the porch without getting them stolen. At twenty-five cents each, you had to sell only twelve geraniums and you could buy a hit. My mom avoided sidewalks and walked in the streets so she didn't get robbed by a crackhead hiding out in the bushes.

One night, we noticed cop cars surrounding our neighbor's home. Wendell was a good friend, a hardworking man from Jamaica. Along with his wife and child, he had been tied up and robbed at gunpoint of everything he owned. A week later Wendell packed up and moved his family back to Jamaica. Everyone had a story of the hardships they were experiencing at that time—and New York MCs were reporting it through the radio. They rapped about crack, robberies, street life, and the ensuing darkness of living in the city. In contrast, A Tribe Called Quest was a breath of fresh air. They were positive, uplifting, and fun. I spent the summer of 1990 painting, relaxing, and dancing to Tribe. They sang odes of a New York City I wanted to live in. Their rhymes were celebratory and fantastical. Tribe felt like my New York family. I never met them personally, but through their music, we spent the entire summer together. Even when Q-Tip rapped about leaving his wallet in

"El Segundo," it *still* hit home. Their feel-good lyrics gave many city kids a feeling of inner peace. Not many musicians can take you away on a journey of love, peace, and togetherness without sounding corny. That is what makes Tribe so great.

I painted them as a unit, literally cut from the same cloth. One does not exist without the other and each man is bound by the colors they wear. They sport the same red, green, and black on multiple albums, including *Midnight Marauders* and *The Low End Theory*. The graffiti-esque green and red designs are the abstract life force of this brilliant quartet. Q-Tip—the genius—is lost in translation, leading the way on one end, and Fife—raw, gifted, and unafraid to speak his spirit—on the other. Ali Shaheed Muhammad, centered, calls Tribe's collected unconscious to action, his fist clenched as he salutes. Jarobi—the glue of the group—keeps the crew bonded by love, understanding, and friendship. Even though they work as a unit, Phife and Tip drive the energy of the band. Friends since first grade, it is their deep, intertwined understanding of each other's best and worst qualities that make them truly remarkable as a music duo. Phife's high-pitch sound and raw-style rhymes plus Tip's low-pitch, distinct flavor make the perfect yin and yang. Like Simon and Garfunkel, with all of their ego and personality conflicts aside, they make great music. Or better yet, they're like Paul McCartney and John Lennon—the heart and soul of the Beatles. And like the Beatles, A Tribe Called Quest has never made a bad song.

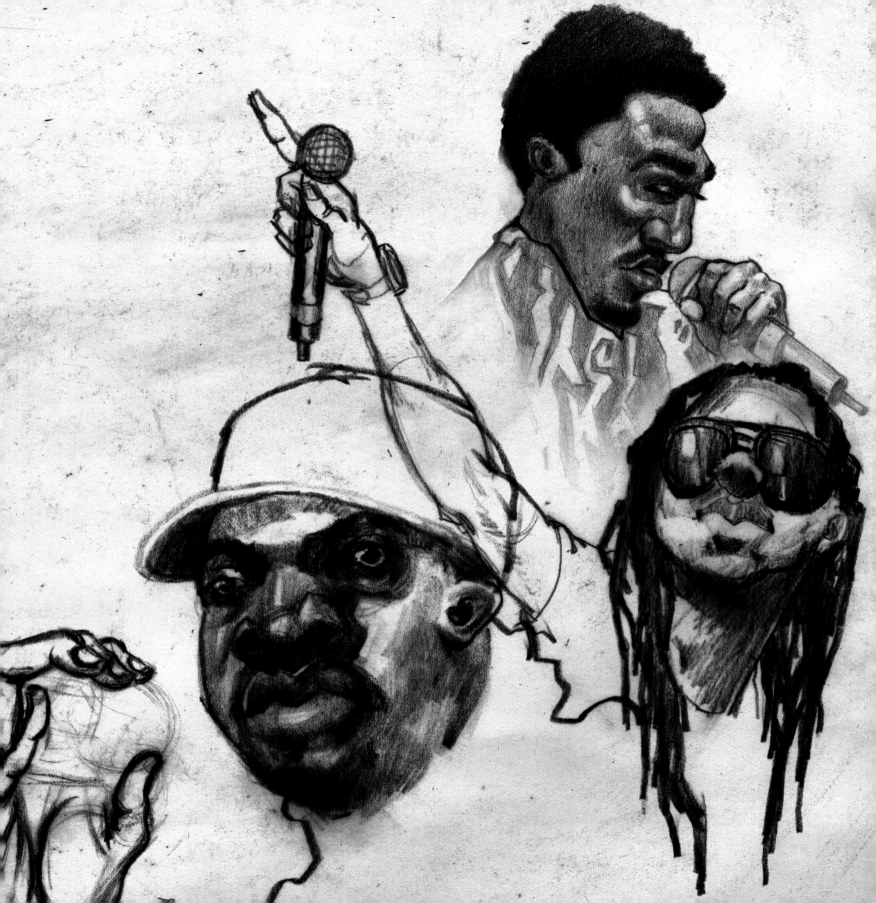

"TRIBE PUSHED THE BARRIERS AND BROKE THE MOLD. THEY HELPED HIP HOP SHED ITS HARD-CORE IMAGE AND FINALLY SPOKE FOR A GENERATION OF HIP-HOP HEADS THAT WERE AWAITING THEIR REPRESENTATIVE."

—MC LYTE

Opposite:
A Tribe Called Quest
Acrylic on board
15 x 20 in.
2010

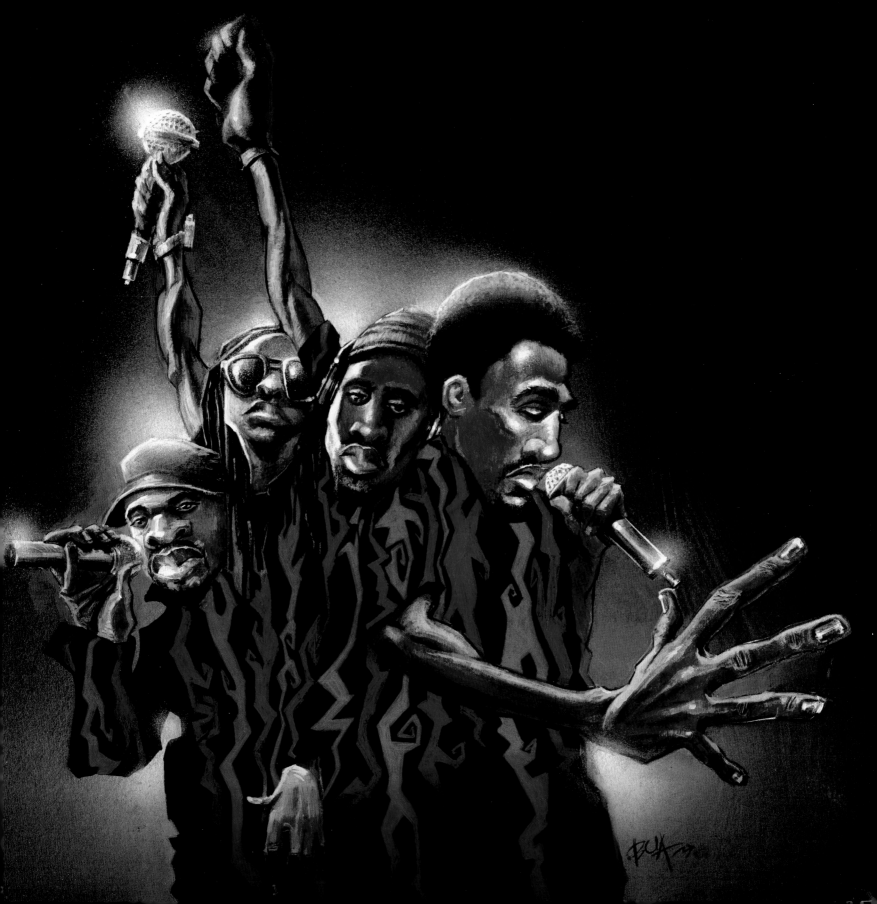

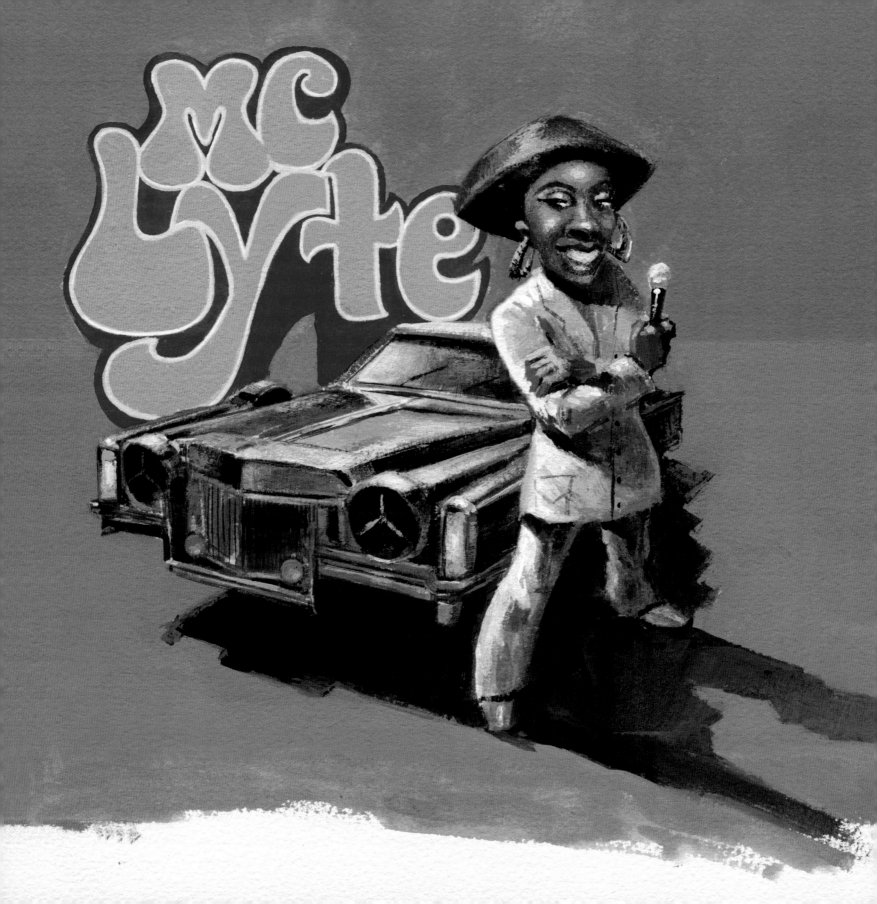

MC LYTE

SISTER COMES CORRECT

Today there are scholars, academics, and experts in the field of hip hop. There are hip-hop classes, seminars, conferences, and panels full of intellectuals with Ph.D.s, all designed to dissect and discuss the social relevancy of hip hop on culture and its implications on gender and race roles. But I personally guarantee that most of these so-called hip-hop scholars don't know how to bust a wave, uprock, top-rock, six-step, scratch, freestyle, or have any kind of can control with aerosol. This distinction—the difference between the knowing and the doing—is important to me. The real experts are those individuals who were on the streets making history, not in the schoolroom dissecting hip hop's greater meaning. Back in the day, hip hop wasn't under a microscope getting analyzed. It just was.

One of the main topics of discussion in hip-hop academia is the role of the "Femcee"—and MC Lyte is frequently studied as an example. Minorities in the male-dominated arena of hip hop, female MCs represent the intersection of gender, race, and sexuality. And then there are the related fallout issues: consumerism, marketing, capitalism—the analysis is endless. Don't get me wrong. I love reading history and someone has got to analyze it to write it.

Hip hop, created by both men and women, is an important culture to add to the canon of American history. And a true account of history can only arise from multiple voices and perspectives. But here's the deal: I loved MC Lyte because she was a great rapper—not because she's a woman, or because she's a "feminist," or because she may or may not have had to be either sexual or rugged to sell records, or anything else the academics say about her. More than many other rappers out there—men included—MC Lyte represents authenticity. Born Lana Michele Moorer, MC Lyte's appearance on the scene was organic; there was no act or marketing package in place. A Brooklyn girl, she grew up surrounded by hip hop, and quickly rose to the top because she's talented and brought something unique to the game. Her content was strong, witty, funny, and insightful, and she told clever narratives. Like Slick Rick, she was able to relate stories about her hood with humor and sarcasm, all the while keeping the listener engaged. When you listen to her, all the academic psychobabble goes up in smoke. It just doesn't matter. When you're good, you're good, and you don't need a panel of intellectuals to give you the nod of approval. MC Lyte was beyond good; she remains one of the best MCs period, male or female.

Opposite:
MC Lyte
Acrylic on paper
9.25 x 9.5 in.
2011

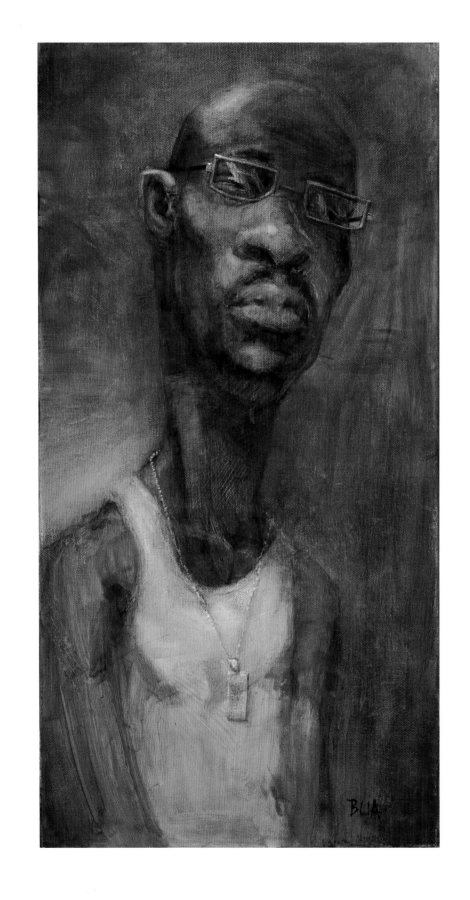

GURU

RED-HOT AND COOL

I first heard Gang Starr on Spike Lee's legendary *Mo' Better Blues* soundtrack in 1990. I really liked painting to Guru's voice on that track "Jazz Thing," but I fiended for more. When I graduated from Art Center in 1994, Guru appeared on the Red Hot Organization's compilation album, *Stolen Moments: Red Hot and Cool.* That's when I started to paint to him on the regular.

It was easy during my painting career to work with Guru playing in the background. He wasn't an abrasive, in-your-face type of MC, nor was he was one of those MCs that followed a predictable tempo when he rapped. His cadence felt conversational, like he was talking to me. Sometimes lyric-heavy MCs can distract me if I'm doing something that requires concentration, like designing compositions or figuring out a color scheme. But I lost myself in the zone when Guru's music played.

Picasso said, "Inspiration exists, but it has to find us working." But sometimes even getting to work is difficult unless you have a tool to get you there. For some, that tool can be drugs or alcohol. For others, the stillness of meditation. For me, great music puts me to work. I have had many a session painting to Guru and DJ Premiere.

Growing up in a hip-hop-centric neighborhood, I didn't discover jazz artists like Thelonius Monk, John Coltrane, or Miles Davis until my late teens. Jazz and hip hop (especially freestyling) are similar to each other in the sense that they're both improvisational art forms that play off each member of the group. Both have Afrocentric roots, but were born and bred in the streets of America. Even though they are generations apart, both genres speak the language of the streets and tell the stories of the social and political unrest of the city.

I relate to Guru's music because he, too, derived his art from a fusion of jazz and hip-hop rhythms. Listening to his tracks, I imagine he absorbed the soul of an old saxophonist playing on the street, or a young poet spitting rhymes on a corner—just as my inspiration comes from soaking up graffiti, the geometry of popping, and jazz.

Guru was revolutionary in creating a new genre of music. Up until that point, many people in the game were using samples of the great jazz musicians, but Guru went out and got the *actual* musicians they were sampling from and brought them into the studio to play over hip-hop beats. Guru worked with outstanding jazz artists, like Roy Ayers, Branford Marsalis, and Donald Byrd. Because of my appreciation for the masters of jazz, it makes sense that I loved to paint along with Guru's music. The acronym his name stands for is true: Gifted Unlimited Rhymes Universal. He was a game changer and took rap to a place where the new generation could explore the old, with reverence and ingenuity.

Opposite: *Guru*, oil on canvas, 12 x 24 in., 2010

LAURYN HILL

TURN OF A TENDER SONG

Like Tupac, Lauryn Hill could have done anything she put her mind to and like an angel falling from heaven, she blessed all of us in the world of hip hop with her divine voice—maybe the greatest singing voice that the hip hop has ever known. She was both rapper and singer—a combination rarely heard at such a high level of expertise and confidence. Sure, there were some MCs that could sing, but none like her. She was *extra-ordinary*, unparalleled in her craft.

A legend is someone whose contributions change the landscape of a culture, someone without whom we wouldn't have a history of hip hop. Lauryn Hill is a revolutionary. A movement. While the East and West Coasts were warring, she gave us hope that things were going to be different. . .better. Both with the Fugees and as a solo artist, her music made waves. She inspired us to be better. She asked us to believe, if not in a higher power, then in ourselves.

I painted Lauryn on a page in my sketchbook. I didn't plan out the portrait with compositional studies, value, or color keys. I kept the process spontaneous so that I could capture the raw emotion that she exudes. When she performs, she lays everything on the table; she breaks out in tears during a performance and elicits the same from her audience. I've always been moved by any artist's willingness to expose their soul. Lauryn does it fearlessly and with no reservations. She willingly reveals the most intimate aspects of her life through her music, and we are the better for it.

She means so much to hip hop. She is an important voice for our generation and will be for generations to come. What Lauryn Hill gave to hip hop is the most beautiful gift that one could give in any relationship: She gave us her true self.

While most often we glimpse merely a sliver of an artist's totality, Lauryn Hill gave us her whole person—emotional, uninhibited, and human.

Opposite: *Lauryn Hill*, acrylic on paper, 5.5 x 8.25 in., 2011

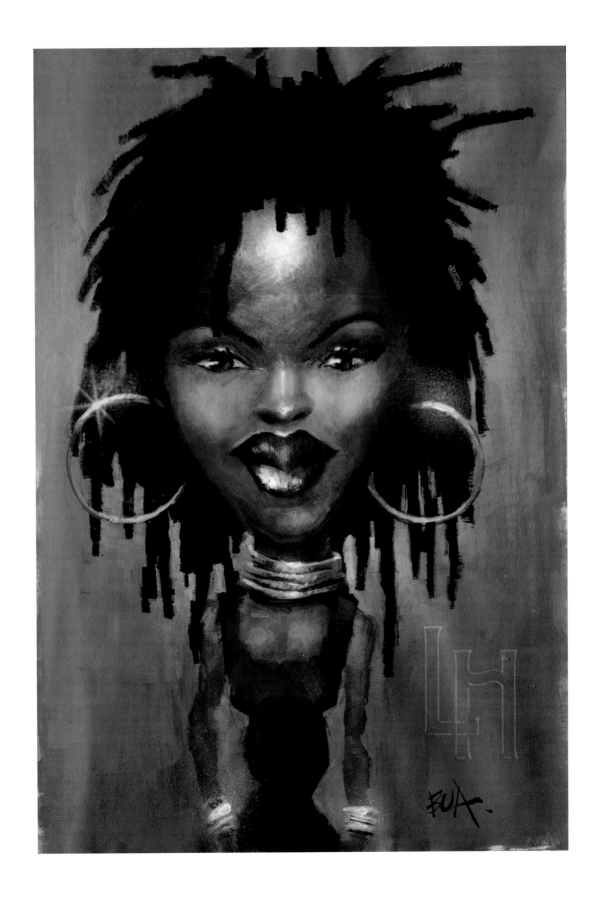

NAS

INAUGURATION OF A POET LAUREATE

I may have been born in Manhattan and raised between the City and East Flatbush, Brooklyn, but I had an unspoken love for Queens despite the bad rap it had in my hood. It's not like people hated it, it's just that, like the saying goes, most people thought "Queens was the whack." My mom was born and raised in Manhattan and my absent father was born and raised in Queens. I made many trips to that enormous suburb to visit my paternal grandparents, who attempted to have a relationship with me throughout my youth. I never saw my father on those visits, but I had good times and created history and memories with my grandparents. Those many trips on the F train built more than a bond between family. It built a bond between Queens and me. Queens—and the culture that thrived there—was my extended family.

Hip hop may have been born in the Boogie Down Bronx, but Queens raised some of the most brilliant MCs the boroughs have ever known. I don't know what was going on over there, but there must have been something in that water. Queens was a mecca for rappers—Run-D.M.C., LL Cool J, Roxanne, Craig G, Kool G Rap, and many, many, more. However, after the golden era had passed, the spotlight on the great borough faded. West Coast MCs stepped onto the world's stage.

In the early 1990s, there was something brewing in hip hop that would shift the focus back on to Queens. Nas (real name Nasir bin Olu Dara Jones) was a young MC born in the rough Queensridge Projects. His mother, Fannie Ann Jones, was a postal worker, and his father, Olu Dara, a vocalist and multi-instrumental jazz musician. Nas, writing rhymes when he was ten years old, dropped out of the school system before he reached the ninth grade. Nas saw the world from outside the box and documented it from a window inside the Queensbridge Projects. His words emit a colorless, disconnected sense of being as he earnestly chronicled life around him. Nas was a ghetto documentarian that inked words and made you feel as if you were witnessing his life and surroundings firsthand. He was a poet.

Eventually, young Nas created a classic album that took every hip-hop head by surprise—*Illmatic*. Like a wizard brewing a magic potion, Nas conjured up the dopest producers around—Pete-Rock, DJ Premiere, Q-Tip, LES, and Large Professor all had his back. They treated each song like a work of art. Each track was masterful individually, but as a whole, the project was a *masterpiece*. *Illmatic* stepped up the lyrics, taking the legacy of Queens hip hop to the next level. No one had heard anything like this album before. When Nas's lyrics came over the airways, he raised the bar for all rappers. His album did what everyone said it would do. It went gold, and in the 1990s, that was a big deal. He was legit, he was underground, and he sold albums.

I have always been a fan of great poets like Yeats, Wordsworth, Keats, and Shakespeare. I have also looked to many of hip hop's lyricists to inspire me with their words—Biggie, Pun, Tupac, and Melle Mel. However, today, it's Nas that many consider to be the poet laureate of hip hop.

Opposite: *Nas*, prisma on paper, 18 x 24 in., 2010

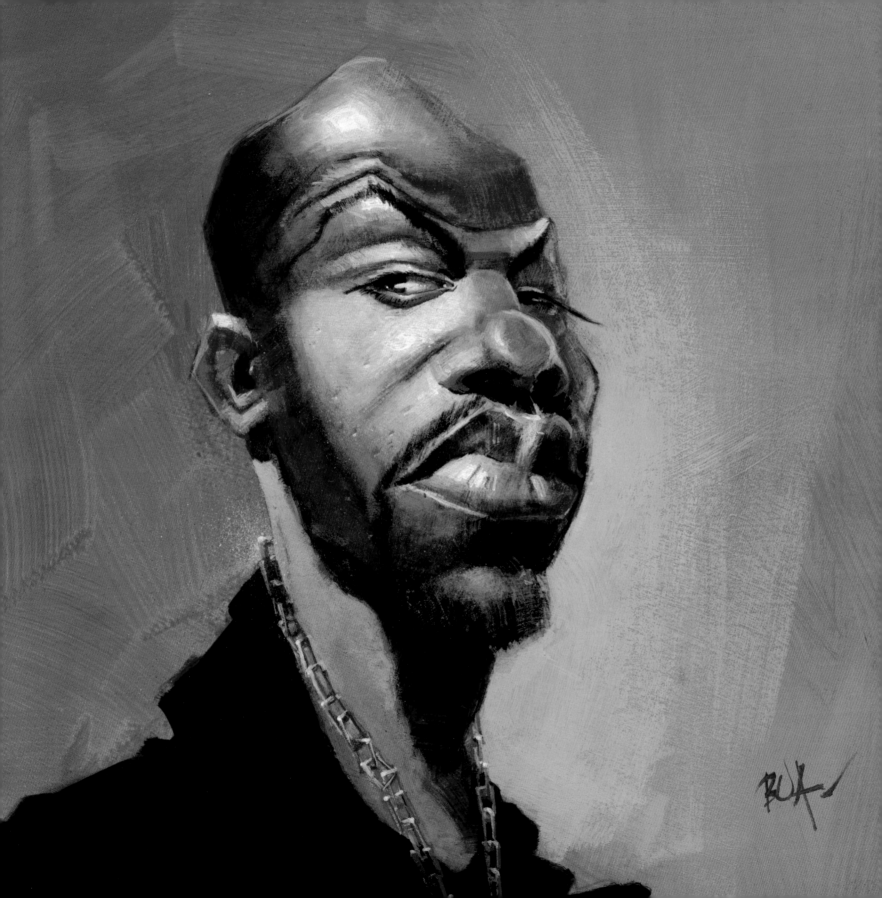

TOO SHORT

ENTER THE PLAYER

In the early 1980s Too Short was hustlin' the hoods of Oakland, California, trying to get his mix-tapes heard. Word on the street was that his raps were good—*so* good that a local pimp asked to be mentioned in Short's next song. Before long, Too Short was getting paid a few bucks here and there to customize his songs to include different pimps and players from around the way. He would hang with the hustler in question, find out what they were about, how they rolled, and what kind of ride they had, and return home to get to work. He rapped over instrumentals on the flip sides of vinyls, like Vaughn Mason's "Bounce, Rock, Skate, Roll."

Then one day, one of the biggest and baddest pimps approached Too Short. He had heard what Short was up to and wanted a royal shout-out of his own. "Put me into one of your songs or you're dead," he demanded. Besides the threat, it must have been an honor—no good pimp would want in on something that wasn't cool, or barely getting heard. Too Short was official.

Short's whole rap game was telling stories. In many ways, he documented the crazy shit going down in Oakland—on the streets and behind closed doors—from the escapades of neighborhood criminals to his own sexual antics. His tapes became folklore around the Bay area, with creative titles like, "Cuss Words" and "Invasion of the Flat Booty Bitches," which referred to the influx of white girls to Berkeley. These became underground staples of music for kids from the streets.

In 1982, my great friend and world-renowned DJ, CJ Flash, got a hold of an old Too Short "and friends" mix-tape. Too Shorts's verse was called "Jiggle Jenny." The lyrics were explicitly raunchy but comedic. As Flash says, "Listening to that song changed my world. In 1982, we only had access to our parents comedy albums—Red Foxx, Richard Pryor, Dolemite, and Blow Fly. Too Short was hip hop's comedian. He created a whole style that the Bay area embraced. A slow rhyming pimp-swagger type of music that was never done before."

If Schooly D is the architect of gangster rap, then Too Short is the architect of hustler rap. He even coined many of today's common slang expressions like "B-Town" for Berkeley, and of course the infamous shout-out, "Biiiiiatch!" But its not just the fact that Short was a pioneer of style and genre that makes him a legend in my eyes. The man works haaaard and has never slowed down. How many other old-school legends around today are still touring with a tenacity that could only be matched by a young, hungry artist just comin' up in the rap game? The hard work and dedication he has committed to his career is extraordinary. The message? If you work every day and you put your heart into something, and stick with it, you *will* have success. It seems that artists these days just do what sells. Most are just a flash in the pan, but Short stands the test of time. He's the guy who is going to hit singles and doubles his whole life and doesn't have to be a home-run hitter. He's going to still make it into the hall of fame, like Cal Ripkin Jr., who was a great player, the iron man of baseball. He's still performing at least three shows a month and has only missed a couple of shows in the last ten years. Since his eager/humble beginnings, Too Short has stood the test of time. He *is* the iron man of rap.

Opposite: *Too Short*, acrylic on paper, 14.75 x 16.5 in., 2011

Bbs Compton Landmares?

EAZY-E
THE TITAN OF THE RAW

Being from New York City, I always felt like I was on the pulse of the latest, dopest, and freshest music from the streets. So you can imagine the shock I got when I was first introduced to Eazy-E and NWA. They fucked up my East Coast paradigm because I didn't find them on my own. It took someone else—a kid from Cali—to school me.

When I moved from New York to California, I befriended Ruben, a stoner, punk rocker, who later became a great artist and my best friend. My friendship was strategic: I knew *he knew* some beautiful women and being F.O.B. from the East Coast, I needed a calling card to California girls. He was down with the whole Northern California punk rock scene, and listened to bands like Primus, Rancid, and Operation Ivy. Ruben thought he knew everything there was to know about music. I thought his musical taste sucked; it all sounded like noise. Being the hip-hop connoisseur that I was, I wanted to open his eyes. So I turned him on to artists like Slick Rick and A Tribe Called Quest. As expected, he dissed the shit out of these artists, calling them "soft and corny." He told me that I didn't know what *real* hip hop was and pulled out a cassette tape with "Niggaz With Attitude" inked across it. "Is this a joke?" I thought to myself but when that shit played, I found myself transported to another dimension, a place I had never been to before.

Eazy-E's voice was high-pitched and sounded nasty, and hoodish. At that time, I hadn't been to a West Coast hood, but Eazy's words painted Compton with theatrically outlandish lyrics. I felt how Malcolm McDowell's character—Alex Delarge—looked in Kubrick's classic *A Clockwork Orange:* eyes forced wide open. I thought to myself, *Whhhhhat the fuck is this shit?* But in a good way. The closest I've gotten to replicating that "what-the-fuck" experience was when I heard Public Enemy for the first time, or when Mr. Magic played "The Message" on WBLS for the first time. Ice Cube's powerful voice, Dre's earth-shattering beats, and Eazy-E's unusual hard-hitting, high-pitched sound were monumental.

When Eazy-E started Ruthless Records and formed NWA, he changed the hip-hop game. With Eazy at the helm, NWA targeted the government, the police, and telegraphed the conditions of L.A.'s hard-core inner-cities to the world. Eazy-E changed the way the world saw America. He even changed the way I viewed my boy's musical taste. I thought to myself, "Maybe he's on to something. Maybe he knows what good music is?" After listening to more of his favorite groups, I came to the conclusion that he got lucky with Eazy-E; the rest of his choice in music still sucked. But he did spot genius in Eazy, a man responsible not only for founding "gangsta rap," but for leading a new culture of resistance to oppression.

Opposite:
Eazy-E
Acrylic on paper
9.5 x 11 in.
2011

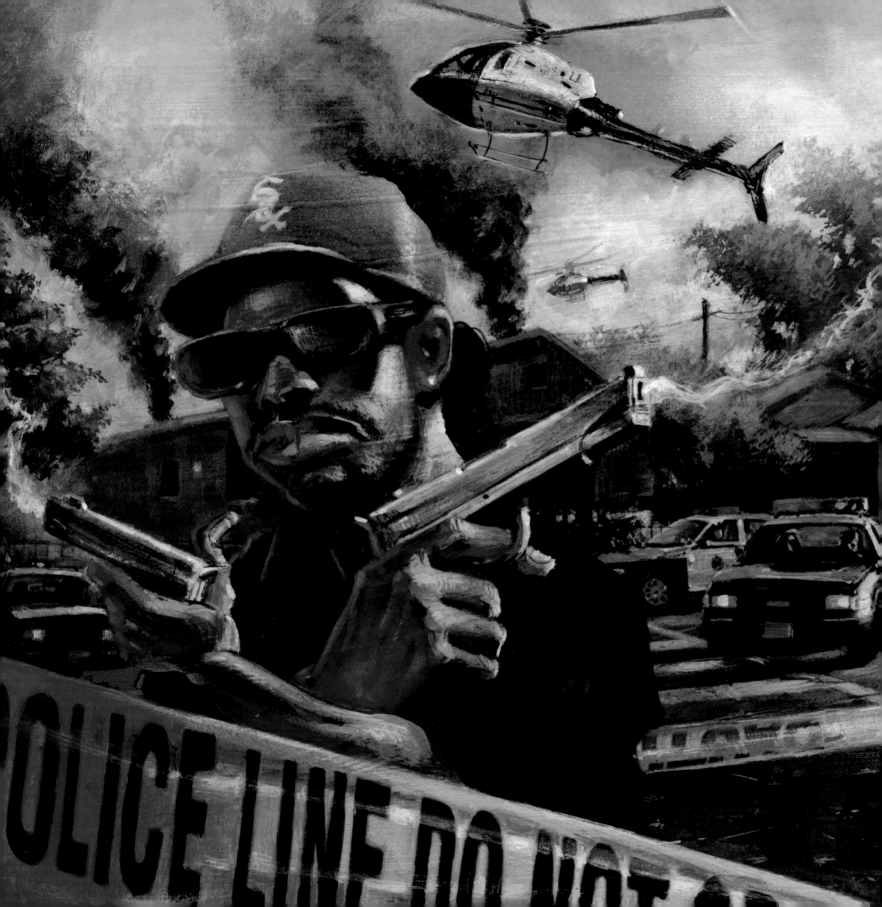

ICE-T

DOWN BY OUTLAW

As a kid in college, I listened to Ice-T religiously. I was obsessed with his music, especially the album *O.G. Original Gangster*. I imagined myself inhabiting an Ice-T music video, but one night the fantasy became all too real.

I was driving home from Art Center College blasting "New Jack Hustler" from my car stereo. Lost in Ice-T's thumping, gritty world, I didn't register that I was pulling 85 m.p.h in a 40 m.p.h zone. Unaware that I sped past an LAPD car, I started climbing the California hills, breaking into record speed. I put my baby into fifth gear and floored it. I knew the South Pasadena terrain like the back of my hand and took the tight corners at 70 m.p.h plus. Ice-T pressing me on, I owned the road.

Then, the sirens started. Keep in mind that this little escapade of mine was pre–Rodney King and pre–O. J. Simpson. There was no precedent for pulling a stunt like this; so my perspective was all fucked up. I could make out police lights in my rearview mirror. I hit the gas and cut the curb at hyper speed. But the faster I drove, the faster the police seemed to close in on me. Sirens were *blaring*. A helicopter swarmed overhead; its propeller sounded like machine-gun fire. I came to my senses and pulled over.

The cops pushed me facedown in the middle of the street and pointed their guns at my head. I struggled to look around and saw a group of white suburbanites staring at me with disapproving eyes. They must have thought I was a murderer and why not? Cop cars, helicopter: It was a scene. The female cop shined her flashlight in my eyes and shouted, "What are you on?"

"I don't do drugs," I replied.

"I'll let you go if you let us search your car," she said and I knew she expected to find drugs. I didn't have any drugs on me, no weed. Nothing, but—and this is a big but—I did have a gun. It was an incredibly realistic toy gun—but that's a whole other story. I knew I wasn't breaking any law owning it, though, so I let them search my car.

The female cop found the gun immediately. She waved it in my face and exclaimed, "Got you!" The other cop—a brother—took the gun from her and said, "That shit's fake." He went on, "This kid's an artist. Look: He's got a smock with fresh paint on it, paintings in the back of the car, and Ice-T playing on the deck. Anybody who likes Ice-T is okay with me."

"Arrest him!" the female cop yelled. "He was evading us."

"Actually," I said, "I didn't hear the sirens because my music was playing so loud. If I had, I would've pulled over. I am so sorry and I apologize. I didn't realize I was going so fast." And that was almost the God's honest truth. When I listened to Ice-T, I was in another world.

The male cop quoted Ice-T, saying, "You are a nightmare walking, psychopath stalking."

"Nope, I'm just a painter." We both laughed.

How ironic that a man who wrote "Cop Killer" could unite people from all walks of life. Maybe everyone has a little gangster in them. Through Ice-T, we could live vicariously without getting into too much trouble. After all, if I didn't have Ice-T in that tape deck, who *knows* what could have happened to me that night? I'm just saying. . .

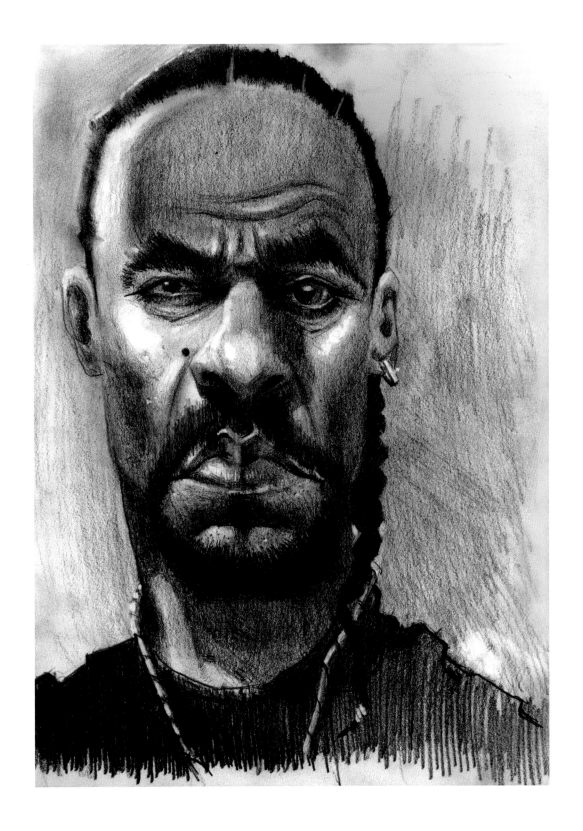

"MY DEFINITION OF O.G. IS ICE-T. IMITATED BUT NEVER DUPLICATED, HE INVENTED WEST COAST GANGSTA SWAG."

—D.M.C.

Opposite:
Ice-T
Mixed media
12 x 12 in.
1993

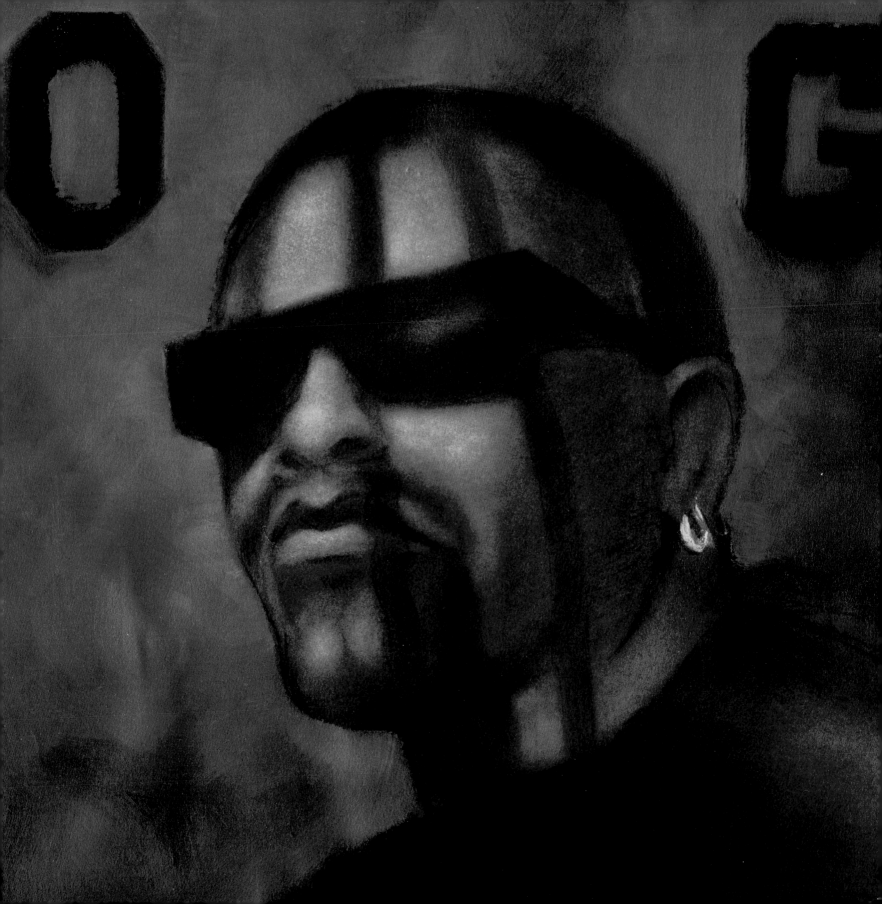

ICE CUBE

AN IRON VOICE RESOUNDS

During my childhood in New York, I spent a lot of time hanging out in the projects—I was very familiar with the insurmountable cement high-rises. Didn't matter if you were visiting Douglass, Bronx River, or Queens borough projects, they all felt the same—cold and hard. Even the color palette consisted only of tertiary colors, sickly grays, and muddy browns. There was little to no greenery, never a yellow flower or a red rose. Primary colors only showed up in the hood as yellow spray paint splattered on the walls or the red blood of a homicide. Most of my friends that lived in the projects dreamed about getting out.

In 1991, I was still new to Los Angeles. I was cruising around with my friend Ruben, blasting Ice Cube from the car, attempting to acquaint ourselves with the surroundings. Los Angeles was connected by a capillary of manic highways and freeways that seemed to take you to any corner of this dry desert. We took the 110 South Freeway to the 101 North to the 134 East to the 405 South to the 105 East. One thing led to another and we were smack dab in the middle of Compton. We had watched the movie *Boys in the Hood*—gangs, crack, AK-47s. Ice Cube rapped all about it. But as we drove around more and more in *the hood*, all I thought about was how beautiful everything was. There were houses, yards, patio furniture, green lawns with red and yellow flowers. The neighborhood looked like the complete antithesis of the ghettos of my New York. I was surprised and now I was questioning the authenticity of Ice Cube's lyrics. As we drove off we made jokes about how soft L.A. was.

On our exit out of Compton, I accidentally spilled some coffee, so we pulled over at a gas station to get some paper towels. It was completely empty. We walked up to the front window to ask the attendant for help. He was standing behind bulletproof glass with several bullet holes already in it. It was no more than thirty seconds before we were descended upon by a homeless guy in a wheelchair, two balding crack-whores, and a skinny, limping man. They were all talking simultaneously, offering to either pump our gas or tell us directions (for a fee). It was getting scary and the longer we were there, the more we attracted attention, and the more the homeless started to swarm. It was like *Dawn of the Dead*. Then we saw two grown-ass men riding toward us, on kid-size BMX bikes, hard looks on their faces. We jumped in the car and locked the doors. As we drove off, we looked in the rearview and noticed a swarm of Comptonites chasing us. Brothers chillin' on the porches with 40s were mad-doggin' us from all sides. Ice Cube was on the real. We might not have seen it at first, but this Los Angeles shit was no joke.

Compton had green lawns and flower beds, but it struggled with the same economic and social hardships that we had in the projects back East. Oppression is a shape-shifting motherfucker and comes in all different shapes and forms. Those who have never experienced its weight have something to learn from Ice Cube. With his powerful voice and his prolific and revealing lyrics, Ice Cube put the story of a small neighborhood called Compton on the world's stage for all to confront.

Opposite: *Ice Cube*, acrylic on paper, 10 x 10 in., 2011

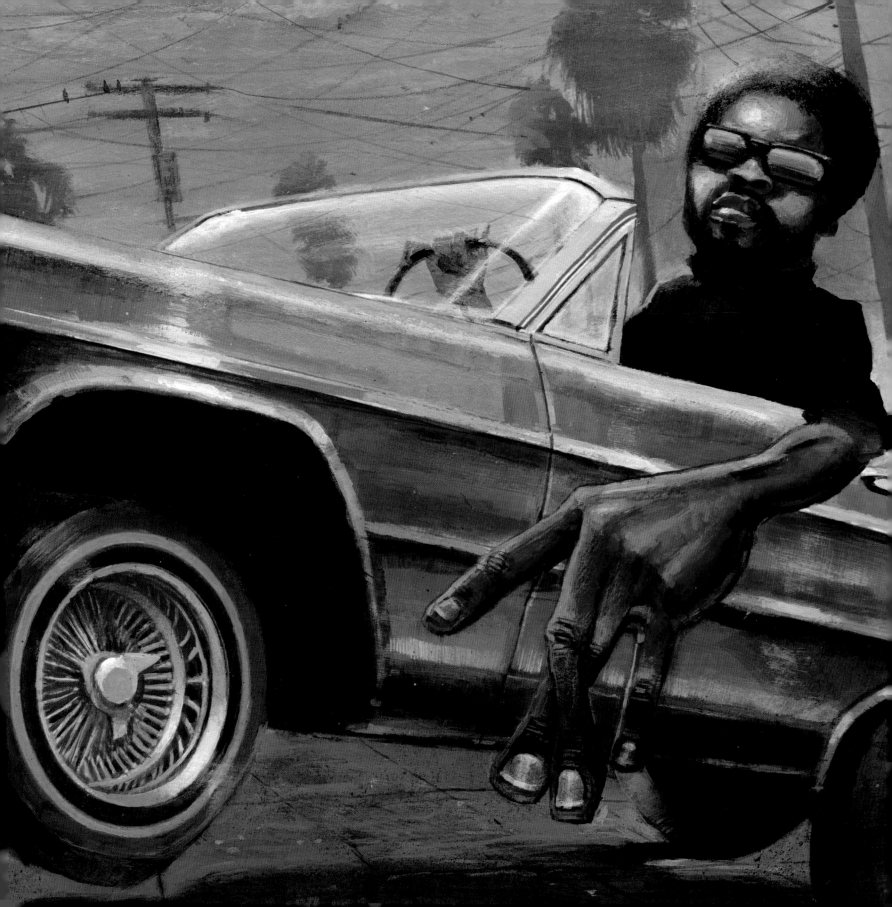

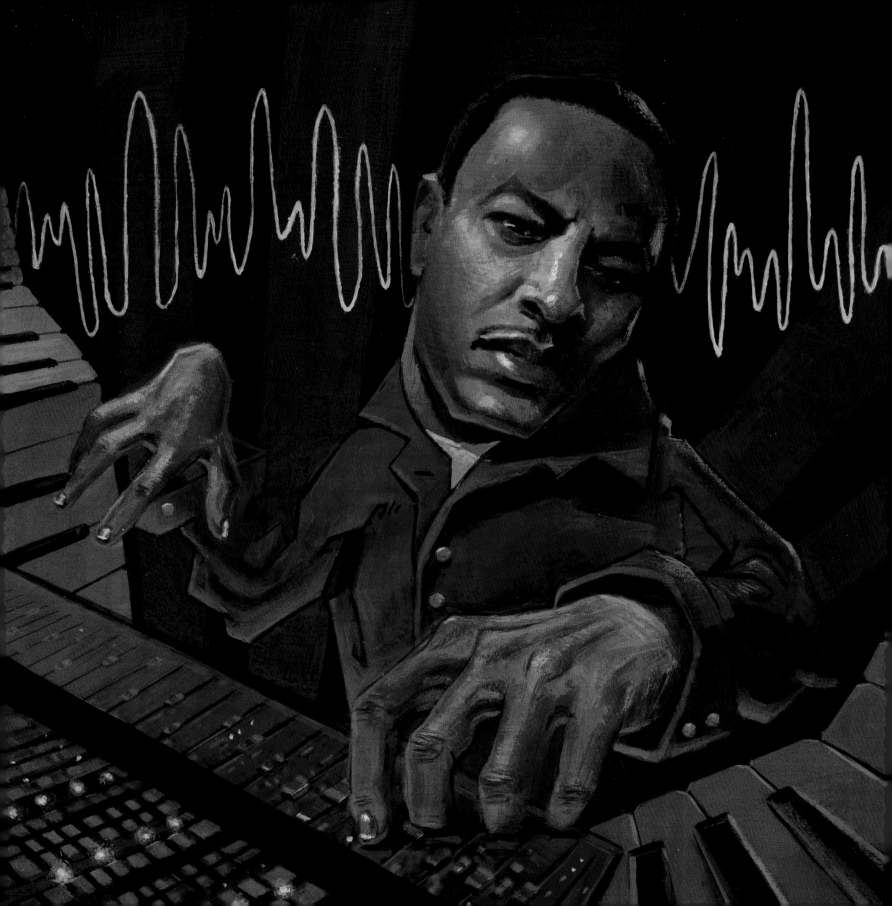

DR. DRE
THE DELIVERANCE

It was 1993. I had recently graduated from Art Center College of Design and was trying to eek out a living as a painter in Los Angeles. On a Saturday night, after a hard day's work of painting, I was chillin' with my best friend and painting partner, Ruben, along with our girlfriends at the roach motel apartment I called home.

Ruben and I were self-ordained weed connoisseurs. On this night, Ruben brought over a baggie of this new supergreen, hydroponic marijuana with gigantic crystal boulders dangling off the green leaves. It was called the "chronic." This shit looked like it was from another planet. In New York City, I hadn't grown up with the extensive repertoire of weed that Cali offered. I had never seen anything like this in my life. We passed around a joint, each taking a hit.

"Let me get it one more time," I said.

"Why are you bogarting? You just hit it ten times!" Ruben told me. That was one of my last coherent moments of the evening.

Ruben proceeded to put on this new CD by Dr. Dre called *The Chronic*. I knew that Dre was the beat-making architect behind NWA, one of my all-time favorites groups, but I couldn't believe what I was hearing. This sound—a laid-back West Coast style—was different from anything else I'd ever heard. As Dr. Dre took us on a narrative journey about girls, weed, murder, and theatrical gangsta life, I lost all sense of time. When the THC really hit my bloodstream, though, I stopped hearing the music. Paralyzed and cold, I felt like I was on a bad acid trip. Suddenly, my girlfriend was crying. I tried to console her, but she looked me in the eyes and started laughing hysterically. I went to find Ruben for some reassurance.

"Do you think this weed is okay?" I asked. He was staring at my latest jazz painting.

"Hmmm," he said, "it could be better." I realized he was referring to my painting—not the weed. Ruben was one of the best painters I knew and I valued his opinions. I felt an overwhelming surge of insecurity. Ruben's girlfriend pushed past me.

"Let's go babe," she told Ruben, "I'm too high!"

"Wait!" I say. Ruben is my anchor to the real world. If he leaves I might go off the deep end.

"I gotta go, sorry," Ruben said. "Try to fix that painting. You have a lot of drawing problems."

At that moment I felt the ceiling close in on me. The kitchen clock looked as though it were melting. I felt stuck in Dali's *Persistence of Memory*. In a fit of panic, I put *The Chronic* back on and sat in front of the speakers, focusing all of my attention on the prophetic words of "Lil' Ghetto Boy." The music took me deep into the genius of Dr. Dre, and out of my high. The song's narrative kept my mind occupied in a profound way, shepherding me back into reality. I sat alone, contending with the giant talent that is Dr. Dre. I listened to the album over and over again until I found sobriety. That was the last time I ever smoked weed. But to this day, *The Chronic* still gets me high.

Opposite: *Dr. Dre*, acrylic on paper, 10.5 x 10.5 in., 2011

SNOOP DOGG

THE BELOVED

What can I say about Snoop? What *can't* I say about Snoop? He may be the biggest contradiction in the history of hip hop; he certainly is its biggest anomaly. A family-man, he's also a playboy, a Crip, and a kids' football coach. He's a rapper and a producer; a writer and a poet; an advertising spokesperson and a convicted felon; an actor, in both film and TV; a pimp, a husband, and a hustler; a porn star, a drug dealer, and an ex-drug dealer; a wake-and-bake marijuana smoker, and a role model. Snoop transcends definition, and everyone—from soccer moms to gang bangers—*loves* him. I love Snoop, and not because his namesake is a loveable Charlie Brown character. I love him because he's so forthright with who he is. As he says, "I have never hidden anything from my kids. . . .They know I am an ex-banger, drug-dealer, wanna-be pimp. They know about how I cheated on their mother and wanted to get a divorce because they heard it from me directly. . ." Snoop walks the walk and talks the talk.

If any other celebrity in the world had a fraction of those negative titles on their resume—drug dealer, gangbanger, wannabe pimp—you would have never heard of them again. Yet Snoop's career and reputation remain virtually unscathed: a testimony to the man and his talent.

The first time I heard *The Chronic*, it blew my mind. Dre's beats were genius, and Snoop's laid-back, relaxed drawl was unlike anything I'd heard before. I painted a lot while listening to that album. To me, it is a seminal album in the canon of hip hop. It was a game changer, and to this day, it remains one of my top three all-time favorite hip-hop albums.

With his Doberman pinscher-like features and his cool, calm, and collected demeanor, Snoop is the embodiment of the West Coast style: always smooth. And while he defines the cool factor in hip hop today, he is so much more than that. Today, most rappers have a built-in, showbiz persona. Snoop blurs the line between this pimped-out persona and his real identity. His act never feels fraudulent because he's 100 percent real. He wears his heart on his sleeve and always gives it to us straight. His music is a direct reflection of himself: honest, real, and unique. Not only has he added great music to the cipher, but he has also humanized hip hop by allowing us to see behind the veil to who he really is. There's no act. There's just Snoop, the legend.

Page 119:
Snoop Dogg
Acrylic on canvas
24 x 36 in.
2010

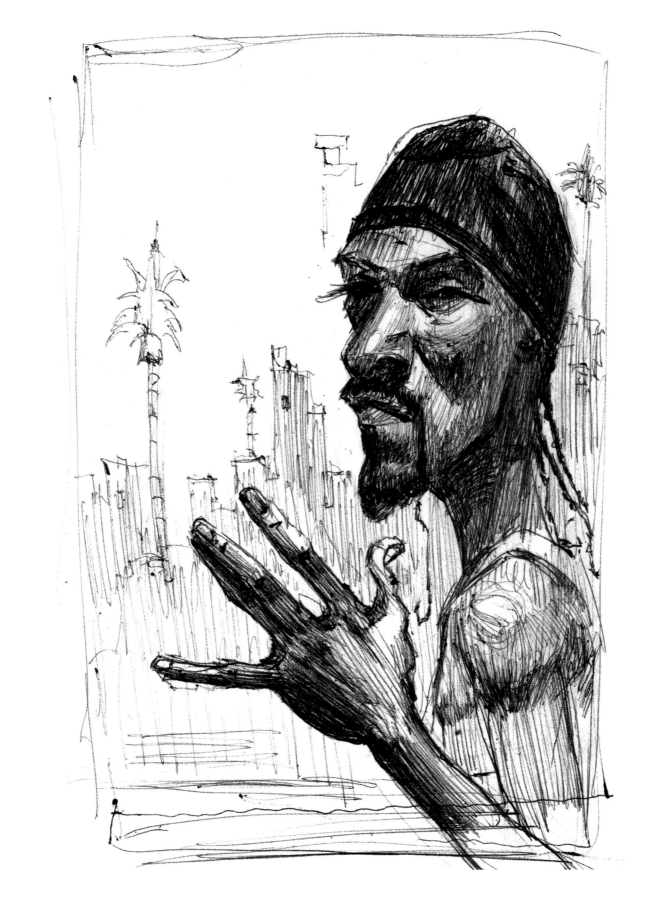

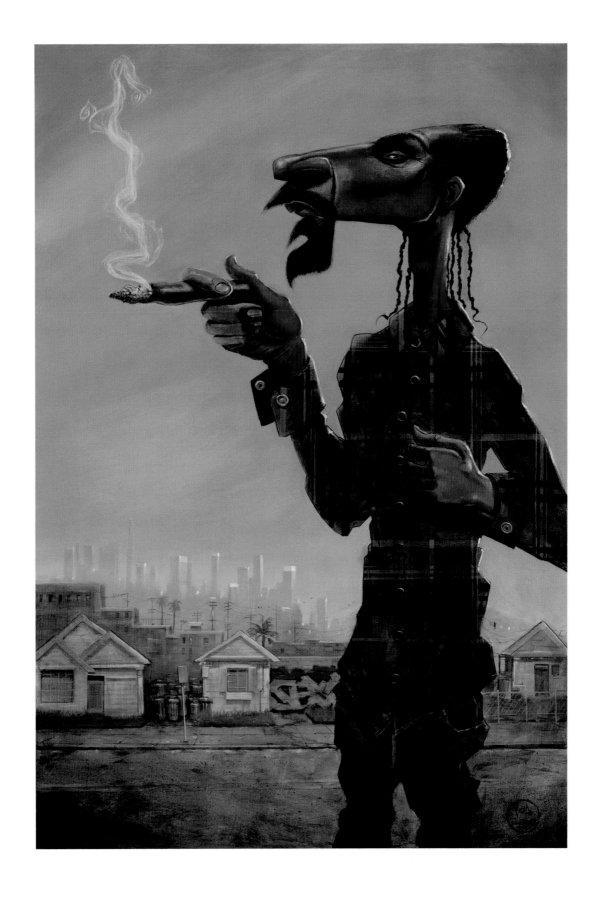

TUPAC

A TERRIBLE BEAUTY IS BORN

Like Leonardo da Vinci, Tupac Shakur was a Renaissance man, one of those rare talents who could have done anything and been anyone—musician, model, poet, social activist, record producer, writer, actor, or philosopher. Somehow, he was able to be all of them, all at the same time. He transcended that status of being an icon and became a legend. At twenty-five, he was dead way before his time, yet he left behind seven albums, which sold millions, seven movies, countless television appearances. Beyond all of that, he possessed an apotheistic persona that spoke to the people.

Even though I never met Tupac, I felt he was a kindred spirit. Like him, I was born in Manhattan, New York. We were both raised by single, working moms; we both went to performing arts schools, and ran with thugs, hustlers, and drug dealers as well as with the "artsy crowd." Pac's open contradictions of hard and soft and good and evil made him human to me. He wore his heart on his sleeve, whether he was rapping about inequalities or "killing Biggie," flipping off a news camera, or singing loving songs about his momma. There was truth in his gaze, a devilishness in his smile. It doesn't matter if you are a man or a woman, you can't deny that Pac's unique beauty went deeper than the surface. I think of the line in William Butler Yeats's poem *Easter 1916* when I think of the legacy of Tupac Shakur: "A terrible beauty is born." We miss you, Pac.

Opposite: *Tupac*, oil on canvas, 9 x 12 in., 2010

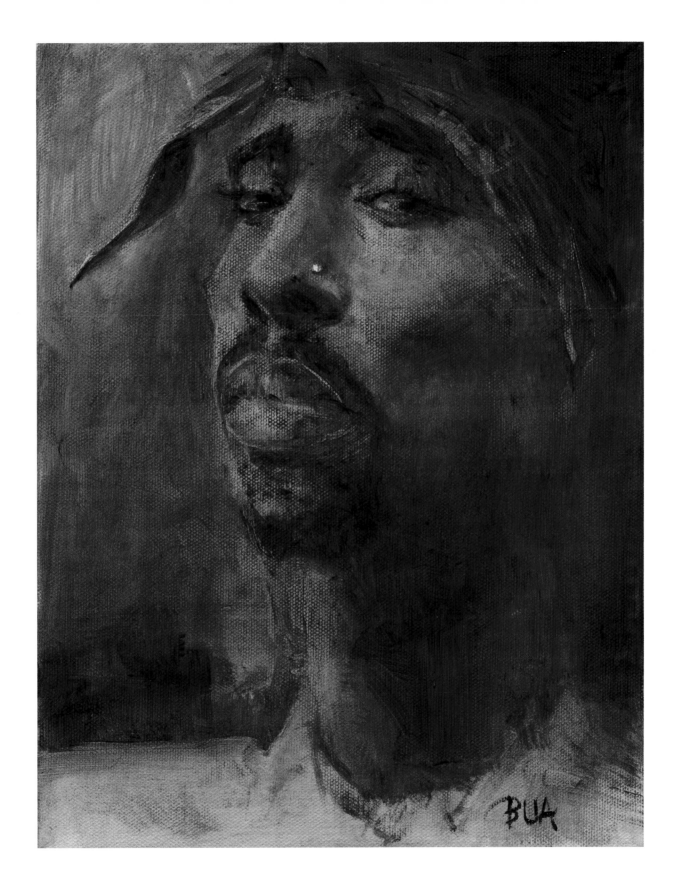

NOTORIOUS B.I.G.

IT'S LIKE COMING HOME

Afrika Bambaataa's song "Planet Rock" represented true New York City flavor in the 1980s, before Giuliani cleaned up the city with his dirty mop in the mid-1990s. Let me be clear: Manhattan in the 1990s was *not* the New York that I grew up in. Although it was still a great city, by that time, it had lost its edge. Full of prosperous transplants from Westchester County; Greenwich, Connecticut; and Montclair, New Jersey talking about, "Yeah, I'm from NYC." But the truth is you're *not* from NYC unless you've been jumped by eight Dominicans, then stomped down with Timberlands in the dead of winter and left for dead. So, I'm projecting my childhood. The deal was this: When Manhattan got overrun with rich wannabes in the 1990s and lost its flavor, there was one last bastion of realness—Brooklyn.

My mom moved us to East Flatbush, Brooklyn, toward the end of the 1980s. At first, I cursed her for moving us out of "the City" and into the depths of hell. A skinny, scared-to-fight, one-hundred-pound artist, I wasn't made for Brooklyn's "realness." I encountered getting held up at gunpoint, scary late-night rides on the D train, and our house being burglarized on five different occasions. These experiences did one thing: They transformed me from being a pussy to being a smart pussy. I learned how to get out of life-threatening situations using my wits. As horrible as it sounds, today, I look back on those times with longing. To me, they were the good ol' days and Biggie was the vocal embodiment of that era. As much as Howard Stern was the voice of the City during the 1980s and 1990s and Woody Allen and Martin Scorsese were the cinematic image-makers during that period, Biggie Smalls was the City's musical counterpart, a consummate New York storyteller.

Biggie waxed about ghetto life and nostalgic street hustle in Brooklyn. How hard and tough you had to be (or try to be in my case) when you walked its streets. How you were a survivor if you came out of it alive. When you heard Biggie at a Brooklyn club—that was heroin. You felt not only at home, but also larger than life, superhuman. His rich, smooth voice is full of volume. His flow is impeccable. At the same time, his voice is bent toward a strong NYC diacritic. A Brooklyn wordsmith, he stretches, compresses, and emphasizes syllables; his cadence so skillful, he plays with words like a mischievous cat chasing a helpless mouse. He could own a club without ever having to enter it.

I wanted to paint Biggie classically to pay homage to him as "the master." I used sepias to keep my palette somber. In the spirit of the masters, I painted him in oils (one of the few oil paintings I did for this book). In order for Biggie to come to life, it was important for me to dig into the canvas, losing and finding edges to create atmosphere along the planes of his face. His left eye to scale, his right eye, watchful, as if he knows something we don't. When Biggie died, he took a piece of NYC with him—a time we can only relive through his music.

Opposite: *Biggie*, oil on canvas, 11 x 14 in., 2010

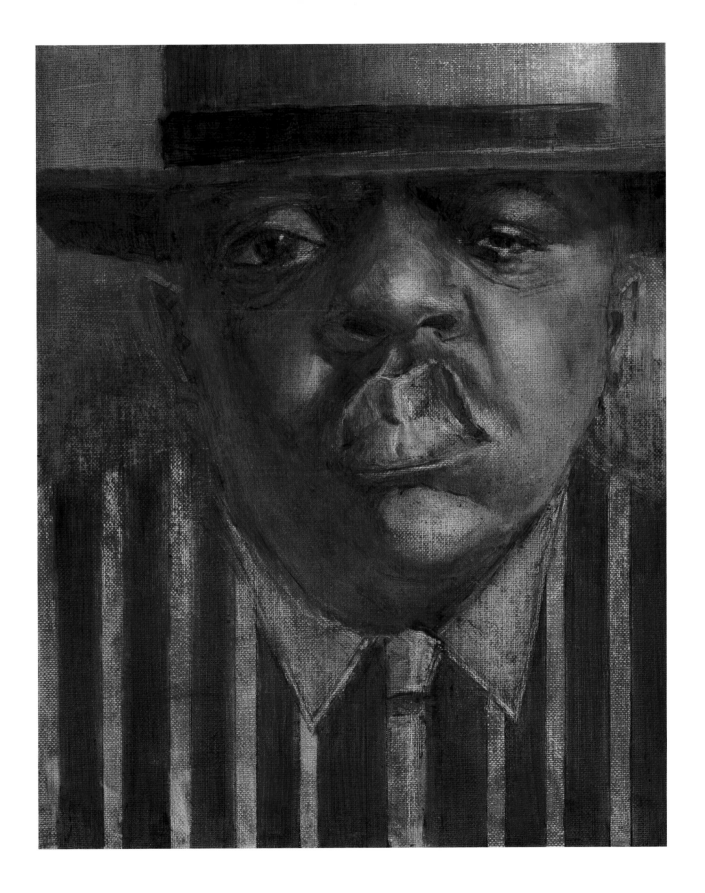

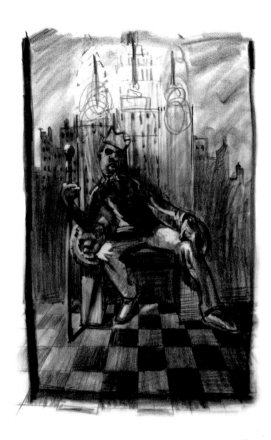

JAY-Z

AFTER THE PILLARS CAME THE CASTLE

I never paid much attention to the hype surrounding Jay-Z's music while he was blowing up. Everyone was telling me, "Yo, Jay-Z is the shiznit! You gotta listen to him." The more that people tried to get me to listen, the more reluctant I became—just my typical rebellious personality at play. Truth be told, I was skeptical of anything deemed new hip hop. At the time, I was listening to Run-D.M.C., Melle Mel, Fearless Four, and Afrika Bambaataa; I wasn't into embracing any rap past the golden era of hip hop.

Prompted by nothing in particular—but maybe, just maybe, in an effort to get everyone off my back—I decided to own up, face the hype, and listen to Jay-Z. As mental preparation, I did a little bullshit Northern California meditation to "open my heart." Sufficiently prepped, I put on *Reasonable Doubt*. And I waited, the revelation pouring over me slowly at first. "This is good," I thought. "Wait. This is really good. No, not just good, but fuckin' like, Tony-the-Tiger-Great good!" So this is what the hype was about: He's smart, witty, lyrical, and poignant. I started

playing so much Jay around the studio while I was painting, that the "Jay converters" were jonesing for the old-school stuff. So, while I don't know the man, I do know his music.

As I set out to paint Jay-Z, I faced a challenge: How do I portray today's greatest living MC? Unlike some of the great legends in the canon of hip-hop history, Jay-Z's accomplishments are by no means over. I can paint Guru, Rakim, Tupac, and Biggie with 20-20 hindsight, but Jay is still goin', flowin', and growin'. In the world of hip hop, there have been many street kings, ghetto celebrities, princes, dukes, earls, and bishops, but there's *never* been a king as mighty as Jay-Z. He is hip hop's modern-day king; his throne might be in New York but it extends around the world. What I most appreciate is that, like all great kings, he pays homage to the past and to the people who built the world he made his own. In "Empire State of Mind" he says, "Afrika Bambaataa, home of the hip hop." I can tell he is grateful and humbled by the legends that came before him, for it is they who have allowed him to be so mighty. Respect.

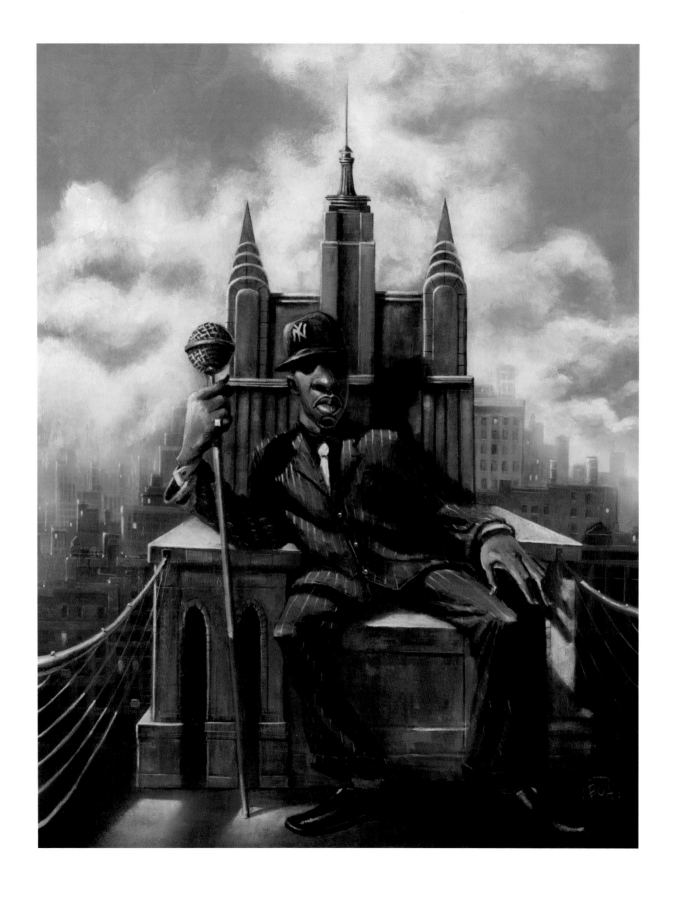

"RESPECT TO THE LYRICAL ABILITIES
OF THE LEGEND JAY-Z,
WHO TRANSFORMED STREET HUSTLE
INTO ENTREPRENEURSHIP—
DECIPHERING THE CODE AND
MASTERING THE GAME."

—AFRIKA BAMBAATAA

Opposite:
Jay-Z
Acrylic on canvas
18 x 24 in.
2010

MISSY ELLIOT

JOURNEY TO A FOURTH DIMENSION

Missy Elliott is one of the most unique artists to enter the realm of hip hop. She seems to exist in a parallel universe, a fourth dimension, untouchable by other mortals. Like Afrika Bambaataa, Prince, and George Clinton, she explores identity and image: Not only does she embrace different roles, she also telegraphs them. With no hesitation, she explores and expresses herself as the hardrock, the hoochie, the dunce, the distorted freak, and the diva. She toys with the notion of femininity, wearing outrageous, androgynous-looking outfits. It's not uncommon for her to be clad in bedazzled, old-school, masculine, hip-hop regalia mixed with punk rock studs and space-age futuristic fabrics. Unabashed, she gets away with it all because her music is great and her courageous spirit speaks volumes. Strip away the fashion, glitz, and glam and she's still a solid, well-rounded, skillful rapper. The best part is she's not West Coast, dirty South, gangsta, or R&B. There's no box for Missy. To me, she is a true original—musically, visually, and philosophically.

Missy Elliott seems to see the world as I like to paint it—a highly distorted, heightened reality, the kind of place that's populated by *Wizard of Oz*— or *Alice in Wonderland*—like characters that succumb to crazy adventures, but with a hip-hop twist. Ever mindful of her predecessors and her part in the great hip-hop story, Missy has featured true dancers like Mr. Wiggles, Flow-master, and Sweat Pea, among others, in her videos. At the same time, she calls out hip hop's current stars. In Missy's view, hip hop is a multicultural, multiethnic landscape that showcases people of all ages and races. Her vision for hip hop is a world of oneness.

Opposite:
Missy Elliot
Acrylic on paper
10.625 x 11 in.
2011

QBERT
UNIVERSAL CONTACT

I've known Qbert for many years now and he is one of the most entertaining individuals I've ever met. He is ridiculously inquisitive and genuinely interested in the world—so much so that sometimes I can't tell if he is truly so spellbound by the minute details of my artistic process, for example, or if his fascination is facetious and he's just fucking with me. After all these years, I've realized that he is in fact actually interested, not just in me, but life in general. That's why he's a genius DJ—his curious nature has led him to reach deep into music's abyss where he has continually developed and honed his stellar skill set.

At five foot two and a half, Qbert is a giant talent. He and his crew, which featured the great Mix Master Mike, were the 1992, 1993, and 1994 DMC champions. A musical genius, Qbert is regarded as a virtuoso of scratchin'—one of the greatest scratchers ever. While other DJs were showboatin' their skills, scratchin' in handcuffs, or with their feet, or while spinning basketballs, Qbert was playing the turntables like a musical instrument. As he says, "While every guy was doing body-tricks I was about skills." The sound he produces from a turntable is nothing short of being a siren song of hip hop. He explains his technique, saying, "When I'm in a zone it's like a prayer. I'm just having fun. My spirit is free. You become one with God. This is my meditation."

While one of Qbert's greatest gifts is his sense of musicality, when he puts his hands on pause and his mouth into motion, he waxes poetic, exploring every angle of the universe, no matter how abstract, crazy, or conspiratorial. The last time I called him, he launched into questions: "Why do you think Picasso is a great painter?" After I explained, Qbert changed subjects, asking, "Have you seen the pyramid in Bosnia? It's hidden in grass and there's a city at the bottom that the government is hiding from us." He continued, "You know, if you ever get a sickness in your throat from a government chem-trail, the best way to get rid of the sickness, is to put a hair dryer in your mouth, so that it can kill off the virus." I didn't know what to say. After a pause, he said, "I found out what the Iraqi war was for. There's a colony of two hundred thousand humans living on Mars and they travel from a Stargate based in Iraq. There are bases on the moon, too, I think."

I am continually captivated by the mind of Qbert. I take his theories with a grain of salt, but it does seem that he converses with the hip-hop cosmos. His abilities as a DJ are so intuitive and deep, who knows? Maybe he *is* communicating with creatures in a parallel universe and channeling their energy into his music. He might know something that we don't. He certainly has a skill set that is not of this world. In any case, it doesn't really matter. The Filipino brother is bona fide. Not only is he a living legend of hip hop, but he's also brethren that I consider family.

Opposite: *DJ Qbert*, acrylic on board, 7 x 9.5 in., 2010

BIG PUN

A HERO FOR LA GENTE

In the 1970s, the Bronx, once home to a thriving community of Jewish and Irish families, was a waste-land of political wreckage left behind by the erection of Robert Moses's Cross Bronx Expressway, white flight, and slumlord arsonists. Big Pun was born in this aftermath. He was only six years old when, in 1977, the Bronx was burning, people were looting, and blackouts were at their peak.

Growing up in this environment, Big Pun's future promised nothing but economic gridlock. After getting kicked out of high school, he had to start thinking about sheer survival. Big Pun solved his problems by selling drugs and carrying guns, but ultimately, by being creative. Like his South Bronx forefathers—Melle Mel, KRS-ONE, and Mr. Wiggles—Pun drew inspiration from the streets and grew to become a legend of hip hop. Big Pun is well respected by everyone in the rap game, but to the Boricuas, he is royalty.

New York City has always been a mecca for Nuevo Ricans, who had little representation during hip hop's beginnings. Prince Whipper Whip, the first Puerto Rican MC, and Tito from the Fearless Four opened the doors for other Latino MCs to walk through. Big Pun didn't just walk through the door, he ripped off its hinges. When Big Pun came along, Puerto Ricans received him with arms open wide. However, what made Big Pun great wasn't that he was Puerto Rican or that he was the best of the Latino rappers. It's that when it came to MCing, he was cream of the crop, period. Black MCs marveled at the Puerto Rican flow-master's abilities. No one else had his sound.

Even though Big Pun was funny, he rapped like he wasn't fuckin' around. He took rhyming seriously, like any great artist does with his art. His machine-gun style of rapid-fire rapping was both nasty and controlled and, for a man of his size, his breath control was supreme. He spit complex double-syllable rhymes that cascaded like water. His style seemed to complement his native tongue—being bilingual, his words seemed to flow with the greatest of ease.

Big Pun was a lyrical virtuoso, spitting rhymes like a master painter glazes with oils. He was fast, intelligent, intricate, and smooth. He had it all. When you look at his rhymes on paper, whether you like him or not, you can't deny that he was a consummate craftsman. There are some painters out there whose work I don't necessarily connect to emotionally, but because of their high skills, I respect them for the level they've taken their craft to. You might have to be a rapper to fully appreciate Big Pun's talents. Or, if you're like me, you might have to slow the music down and play it back ten times to fully grasp the layering and complexity. Listen carefully: On the tenth time around, you'll understand why Big Pun gets respect on all levels. Sadly, he left us all too soon. *Siempre pensamos en tí*, Big Pun.

Pages 136–137: *Big Pun*, acrylic on paper, 17 x 14 in., 2011

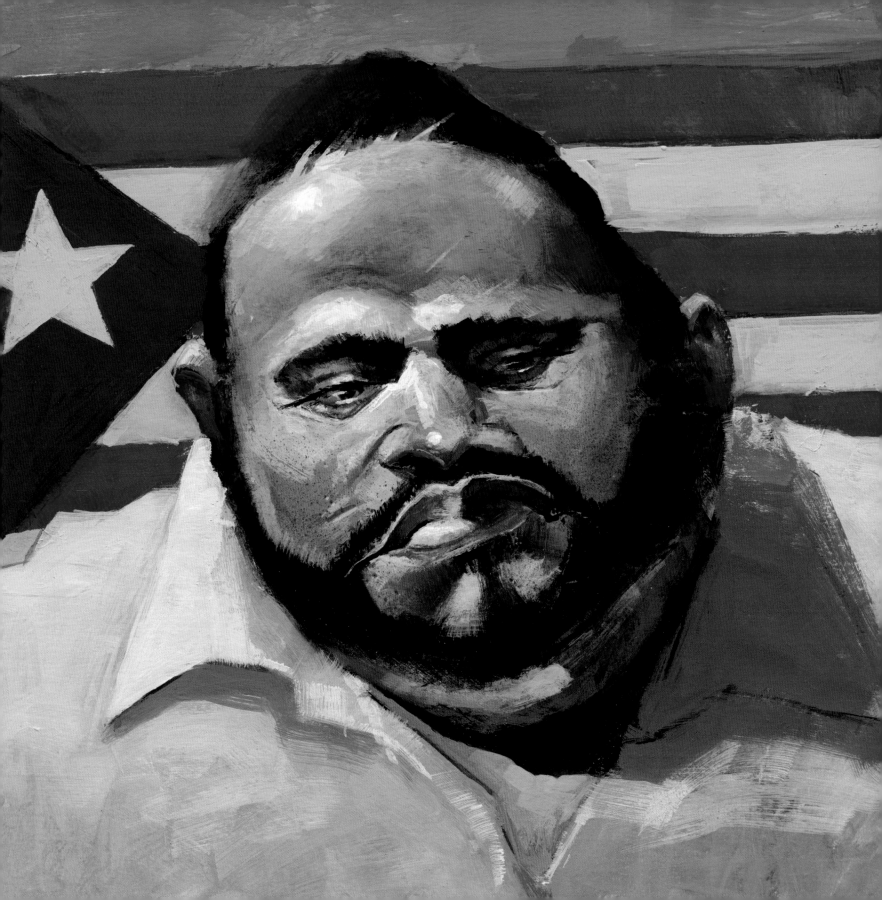

J DILLA

THE QUIET STORM

J Dilla was the soundtrack of Detroit hip hop. He gave us beats that a whole generation of hip-hop heads fell in love with. Whether his beats were crafted for Slum Village, the Pharcyde, Common, Talib Kweli, Q-Tip, Busta Rhymes, or De La Soul, he forged a unique sound that hip-hop artists adored. As Qbert says, "J Dilla's choice of beats were different. He hunted for abstract sounds and turned them into drumbeats. He was an engineering master and knew how to make beats explode. He defined cool with beats."

The way that I discovered J Dilla was bizarre. He was in no way in my top fifty legends list, not even close to my top one thousand of all time. I mean, how could he be? I didn't even know who he was. I know what all of you hip-hop aficionados out there are thinking: "What the fuck, BUA? How do you not know Dilla?" Well, here's the story. . .

The year was 2008 and I was researching all the legends of hip hop that I was planning on painting.

My friends kept inquiring, "You're painting Dilla, right?" The first few times this happened, I didn't pay any attention. But it kept happening, over and over again. "Yo, BUA, you painting Dilla or not?"

Finally, I posted on my Facebook page, "Is Dilla a legend? Yes or no?" The response was overwhelmingly *yes*. I got so many comments I was shocked.

Finally, my friend said, "BUA. You know Dilla. Remember the 'Tainted' Slum Village video you did?"

"Yeah. . ."

"Well, Dilla produced it." He went on, "What's your favorite Pharcyde song?"

"'Runnin',' " I replied.

"Dilla," he said.

After doing my homework, I was admittedly embarrassed. I had worked with, listened to, and loved Dilla's work, yet I never knew his name. But that's how the best producers work: You can sense their handiwork in every song they do, even though they're behind the scenes.

J Dilla died young. I wanted my portrait to honor not only his memory, but also his contributions to the world of hip hop. His music made the world a better place. The process of painting J Dilla was an emotional experience, and it awoke my sense of spirit. To enliven the soul of a man through a portrait, one has to be inspired by his subject. I was more than inspired. I was uplifted.

Opposite: *J Dilla*, acrylic on paper, 6.5 x 14.25 in., 2010

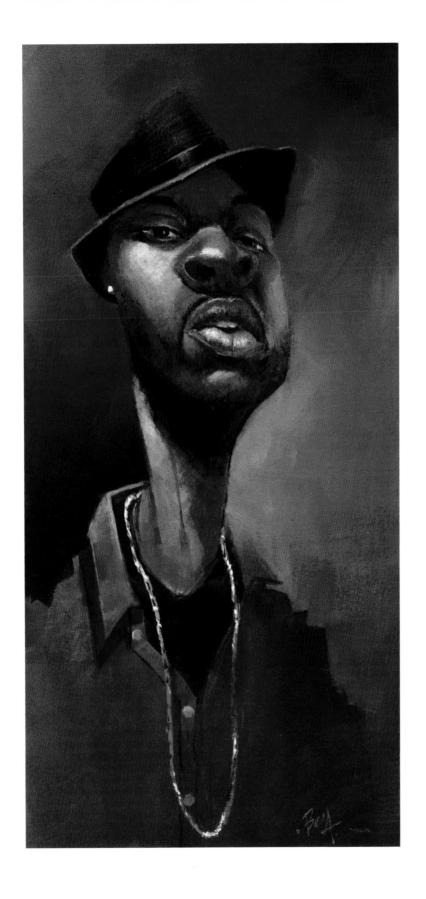

EMINEM

TRUE ID

Some legends, like Afrika Bambaataa, Kool Herc, Tupac, and Biggie Smalls, are undisputable. Their lives and accomplishments have been written about and celebrated for years; many university classes even include discussions of these legends and their impact on society at large. Contributions by newer hip-hops stars might be as worthy, but many of these individuals haven't been around long enough for us to realize the sum of their worth. Hip hop, as big as it is, is still a relatively young movement.

While I was planning out my Eminem portrait in a sketchbook at a local coffee shop, a woman leaned over my shoulder and asked me, "Why him?" I told her I was including Shady in my book *The Legends of Hip Hop*. She exclaimed, "He is *not* a legend!" Another woman joined the conversation, saying, "Doesn't matter what you think, honey. There are millions of people that think he is and I'm one of them." *Very telling*, I thought. Like it or not, Eminem is undoubtedly written into the collective consciousness of the *people*.

Every old-school legend I've spoken to has no hesitation about calling Eminem a legend. Why? When I asked D.M.C. about him, he said, "Eminem is authentic. He reminds me of the Beastie Boys. They weren't Cazal-wearing, Kangol-sportin' parodies, rappin' about their Adidas. They were legit because they made references to things they knew–from Led Zeppelin to skate decks to Picasso. They shared their unique world. That's like Eminem. He isn't a white rapper trying to be a black MC. Like the Beasties, he revealed his own existence and personality and *that's* why we accepted him. He's controversial, honest, and not afraid to be silly."

D.M.C. is right. Eminem doesn't pretend to be anyone he isn't. He rhymes about his life. His hardships run parallel to those of his pioneering predecessors. Fatherless and raised by his single mom, he dropped out of school and got into drugs amid his family's poverty. But his world wasn't the South Bronx in the 1970s. His world was the trailer parks of Detroit's famed 8 Mile in the1980s. He rhymed about the rugged and crime-ridden conditions of his youth; MCing became a way to escape his unhappy life.

In the underground world of MC battles, he gained respect from MCs by pushing his way up the ranks. He proved himself a legitimate, underground battle rapper by tearing through his adversaries with skill, humor, and intellect. Inevitably he rose to the top and was noticed by the industry. He attracted the attention of business mogul Jimmy Iovine and genius legendary producer Dr. Dre, and the rest, as they say, is history. Eminem's rapping style is different; it's nasal and slightly cartoonish, lending itself to a Dr. Seussian brand of wordplays and riddles. The visuals of his words captivate my imagination like a clever M.C. Escher drawing—his rhymes trip and tumble and loop back in on themselves like one of Escher's staircases that simultaneously go everywhere and nowhere. His rhymes have a chiaroscuro-like appeal, whimsical lights to almost murderous darks. His lyrical layering achieves what the poet William Wordsworth encouraged of all writers: "Fill your paper with the breathings of your heart."

Opposite: *Eminem*, acrylic on board, 4 x 5.5 in., 2011

WU-TANG CLAN

ALL FOR ONE, ENTER THE DRAGON

When I was a kid, I was like a stray cat wandering the alleyways of the city streets. I did so much crazy shit back in the day, I'm surprised that I'm alive to write about it. My friends and I roof-jumped, risking death with every step, and train-surfed, ducking through tunnels to avoid decapitation. Jumping on the back of the bus was not as much of a thrill as it was a practical way to travel the city when we didn't have money. One of my favorite things to do was gather the crew, cut school, and go down to the Deuce—42nd Street before it was transformed into Japan's interpretation of Disney world—back when that shit was still raw and flavorful.

We weren't as interested in the peep shows or the triple-X movies as we were in the Kung Fu flicks. We snuck into movies all day long, hopping from one theater to the next, grabbing street-vendor hot dogs and vicking Yoo-hoos at the local grocery store in between shows. Afterward, we'd ditty-bop down Broadway's night streets acting out martial arts moves, using everything in our path as props: We'd jump on grocery store awnings, and backflip off cars with our break-dance/Crane-style hybrid sets. Our city-style moves like Drunken Homeless and Crackhead Leopard kept us busy until we passed out to fight another day.

When Wu-Tang Clan came on the scene, I felt as if they were the vocal embodiment of our childhood Kung Fu shenanigans: They were both humorous *and* serious. They were viciously dope lyricists—hard, strong, and full of hooligan energy. Woven into their names and rhymes was a Shaolin-style of martial art madness—and it felt right. Wu-Tang opened up and explored the parallels of hip hop and martial arts and integrated the cultures. Sure, poppers and b-boys had integrated martial arts moves into their moves and steps before, but Wu-Tang created a cultural synergy, melding East and West under the rising sun of hip hop.

For me, the appeal of Wu-Tang Clan is that they feel like characters from a book of hip-hop folklore, a gang of madcap renegade ninjas, spreading morals with their stories. East Coast Staten Island brothers singing about Eastern Zen Shaolin culture? But it makes sense. The virtues of warriors who train to be the greatest, match those of the MC who strives to be the best. The battle is in the discipline. In order to win, you have to come to combat prepared. Training in any field requires discipline, routine, and inner strength, whether you practice with nunchucks or with words. This is the message Wu-Tang embodies, as each member with his own unique sound, works as a unit toward victory—spiritual, physical, psychological, and lyrical. The Clan used this camaraderie to pull themselves out of the ghetto and conquer the world. They wrote a new chapter in the history of hip hop. They are brilliance unleashed.

Pages 146–147:
Wu-Tang Clan
Acrylic on board
18 x 9.25 in.
2011

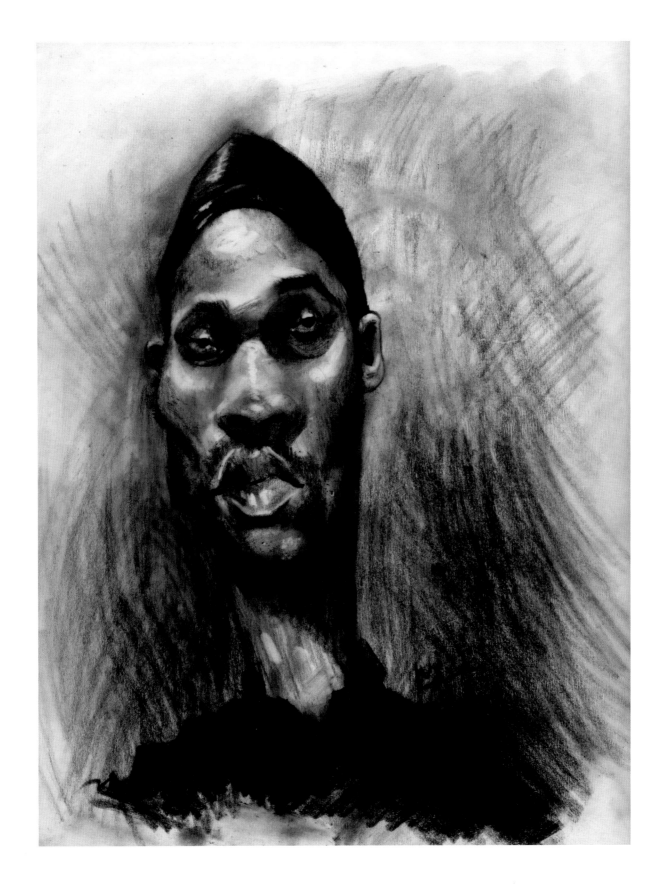

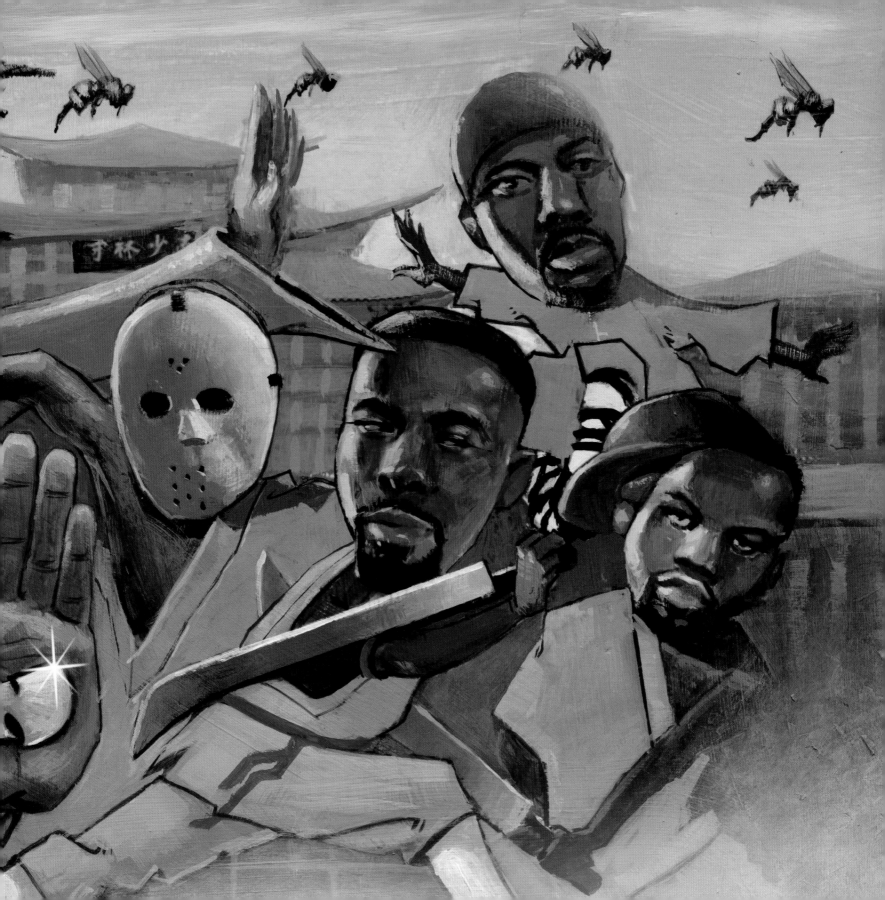

PRESIDENT OBAMA

THE HEIR OF A GENERATION'S INFLUENCE

When Barack Obama appeared on the scene as Hillary Clinton's competition for the 2008 democratic candidacy, I was ambivalent. I mean, we knew the Clintons—Bill, our *first* "black" president, a jazz musician, and Hillary, a strong and brilliant woman. With their many years of experience (not to mention the fact that they collect my work), I wanted to see the Clintons back in office. Having a black man in the running was amazing, but just because he was black was not reason enough alone. As Dr. Martin Luther King Jr. said, judge not by the color of one's skin, but by the content of one's character.

When Hillary fell out of the race, I got behind Obama with conviction, and, along with a group of graffiti and street artists, rolled up my sleeves and got to work, creating art posters and prints to rally the people behind the potential president. A true grassroots movement, we "posterized" subway cars, bus benches, city walls, and billboards with murals, stickers, posters, and stencils—our goal was to get Obama's face out there into the consciousness of the American people. Street artist Shepard Fairey's iconic "Hope" poster was the most recognizable image of Obama, even more iconic than the man himself. As Napoleon Bonaparte once said, "A leader is a dealer in hope." I painted Obama as a beacon of oneness, a symbol of a new generation that was multicultural and ethnically diverse.

Barack Obama, a jazz fan throughout his life, was in his early twenties during the golden era of hip hop. Twenty-some years later, he used his connection to urban American culture in a way that would culminate in one of the greatest triumphs not only for the United States, but also for hip hop. Obama shouted us out through his entire campaign as the cameras caught him dapping Michelle, as he "brushed his shoulders off" during a speech, as he gave the quintessential hip-hop head nod. Without words, Obama gave simple gestural nods to hip hop that more or less slipped under the radar of white America. Most audiences wouldn't even catch the references. But those who did were hit in the heart. We were the golden tickets—the minds that every politician dreams of winning over. Obama effectively won over the most influential demographic in America—*people raised on hip hop.* The hip-hop generation elected Obama. Crowds exploded for him. Like an MC rocking a crowd, he reached out to us like no other nominee had before. This made him not just a *black* candidate, but hip hop's candidate.

Opposite: *Obama ONE*, acrylic on canvas, 24 x 30 in., 2008

BIOGRAPHIES

AFRIKA BAMBAATAA (page 28)
Kevin Donovan, b. 1957, South Bronx, NY
- AKA Godfather of Universal Hip Hop Culture; titled the movement "hip hop."
- Warlord of largest NY gang, Black Spades.
- After life-changing trip to Africa, formed Bronx River Organization, a peaceful alternative to gangs.
- Early 1970s: Hosted parties; used arts and culture to inspire youth; founded Universal Zulu Nation (grass-roots hip-hop organization).
- 1982: "Planet Rock" inspired electro-boogie sound.
- Organized hip hop's first European tour with Rock Steady Crew, Fab 5 Freddy, Futura 2000, and Dondi.
- 1983: Released "Looking for the Perfect Beat," "Renegades of Funk," and "Wildstyle."
- 1990: One of *Life* magazine's "Most Important Americans of the 20th Century."

BIG DADDY KANE (page 66)
Antonio Hardy, b. 1968, Brooklyn, NY
- Considered one of the most influential, skilled, and trendsetting MCs for technique and style.
- 1986: Member of Juice Crew, formed by Marley Marl.
- 1987: Released debut single "Raw," followed by the album *Long Live the Kane*.
- 1989: Released album *It's a Big Daddy Thing*.
- 1993: Acting debut in *Posse*.
- 1990s: Featured in *Playgirl* and Madonna's book *Sex*.
- 1990s: Collaborations with multiple artists such as MC Hammer, Tupac, and Jurrasic 5.
- 2005: Honored at the VH1 Hip Hop Honors.
- 2010: Continues to tour while working on a new album.

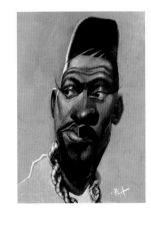

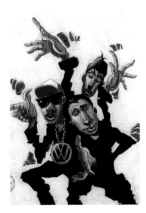

THE BEASTIE BOYS (page 82)
Mike D (Michael Diamond), MCA (Adam Yauch), and Ad-Rock (Adam Horovitz), b. 1960s, NY
- First prominent white rap group; known for fusion of punk rock, hip hop, and pop-cultural lyrics.
- 1979: Formed hardcore punk group.
- 1985: Signed to Def Jam by Rick Rubin.
- 1985: Performed in film *Krush Groove*.
- 1986: Released groundbreaking debut album *Licensed to Ill*, including "Fight for Your Right to Party," marking crossover into mainstream. As of 2010, 40 million albums sold worldwide.
- 1989: Recorded *Paul's Boutique* (produced by the Dust Brothers).
- 2007: First nomination into the Rock and Roll Hall of Fame.

BIG PUN (page 134)
Christopher Rios, b. 1971, South Bronx, NY; d. 2000
- AKA Big Punisher.
- Rapper; celebrated Puerto Rican figure.
- 1995: Commercial debut on Fat Joe's album *Jealous One's Envy*.
- 1997: "I'm Not a Player" became his first major mainstream hit.
- 1998: Became a member of the Terror Squad.

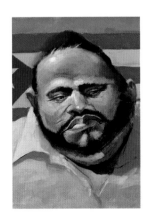

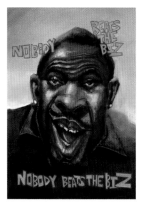

BIZ MARKIE (page 46)

Marcel Hall, b. 1964, Harlem, NY

- Rapper, DJ, comedian, and actor.
- Late 1970s: Gained notoriety in Long Island for his beatboxing and rhyming skills.
- 1985: Beatboxed for Roxanne Shanté of the Juice Crew.
- 1989: Released his most well known single "Just a Friend," which became a *Billboard* Top 10 hit.
- 2006: Creator and regular guest on the hit children's TV show *Yo Gabba Gabba*.
- Currently DJing at high profile parties and events all over the world.
- Known to have one of the largest record collections in the world.

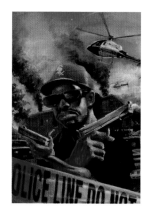

EAZY-E (page 104)

Eric Wright, b. 1963, Compton, CA; d. 1995

- Rapper, producer; known for major impact on West Coast hip hop.
- 1983: Cofounded Ruthless Records with profits earned as a drug dealer.
- 1986: Formed N.W.A., benchmark group known for inner-city point of view, explicit lyrics, and significant social commentary.
- 1987: Released gold album *N.W.A. and the Posse*.
- 1988: Released debut studio album *Straight Outta Compton*.
- 1988: Released debut solo album *Eazy Duz It*.
- 1991: Began an infamous feud with Dr. Dre.
- 1995: Album *Str8 off tha Streetz of Muthaphukkin Compton* released right after his death.

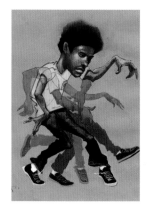

CRAZY LEGS (page 50)

Richard Colón, b. 1966, Bronx, NY

- B-boy pioneer; inventor of standard moves like the backspin, continuous backspin, and the "1990."
- 1979: Became member of Rock Steady Crew.
- 1981: RSC battled Dynamic Rockers at Lincoln Center. Event covered by *National Geographic*, bringing break dancing to mainstream.
- 1983: Film debut in *Wild Style*; became president of the RSC.
- 1983: Performed in *Flashdance*, bringing RSC national attention.
- 1983: RSC performed for the Queen of England.
- 1984: Performed in *Beat Street*.
- 1992: Won Bessie Award for choreography.
- 1994: Hip Hop Pioneer Award from *The Source*.
- 2011: Current president of RSC.

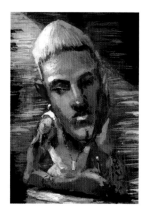

EMINEM (page 142)

Marshall Mathers, b. 1972, Saint Joseph, MO

- One of best-selling music artist worldwide; known for controversial lyrics and freestyle.
- Raised in Detroit, MI.
- 1997: Placed second in Rap Olympics; won *Wake Up Show*'s Freestyle Performer of the Year.
- 1999: *The Slim Shady LP* with Dr. Dre's Aftermath Entertainment went triple platinum within year; won Grammy for Best Rap Album.
- 2000: *The Marshall Mathers LP* became one of fastest selling albums in history.
- 2002: Starred in the film *8 Mile*.
- 2003: Won Academy Award for Best Original Song, "Lose Yourself," from *8 Mile*.
- 2010: Named "Hottest MC in the Game" by MTV.

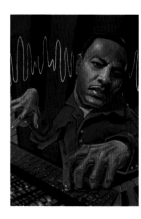

DR. DRE (page 114)

Andre Young, b. 1965, Compton, CA

- Rapper, mega-producer, actor.
- 1984: Member World Class Wreckin' Cru.
- 1986: Collaborated with Ice-Cube for Ruthless Records, owned by Eazy-E; member of N.W.A., known for their gangsta rap, explicit lyrics, and social commentary.
- 1991: Cofounded Death Row Records with Suge Knight.
- 1992: Released Grammy Award–winning platinum debut solo album *The Chronic*, introducing Snoop Dogg to mass audience.
- 1996: Founded Aftermath Entertainment.
- 1996: Major acting debut in *Set It Off*.
- 1998: Signed Eminem, produced *The Slim Shady LP*.
- 2000: Won Grammy for Producer of the Year.

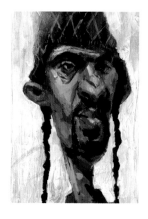

FUTURA 2000 (page 58)

Leonard McGurr, b. 1955, NY

- Pioneer graffiti artist; known for futuristic style.
- 1970: Took the name Futura 2000 from Stanley Kubrick's film, *2001*.
- Early 1970s: While other graffiti artists focused on lettering, Futura developed unconventional imagery and lines.
- 1981: Painted live as on-stage backdrop for the Clash's European tour.
- Early 1980s: Exhibited work at Fun Gallery with Patti Astor, Keith Haring, and Jean-Michel Basquiat.
- 2005: Appeared in documentary *Just for Kicks* about sneaker culture.
- Since 1980, shown in over 100 exhibits in galleries and museums worldwide.
- Currently a graphic designer and gallery artist.

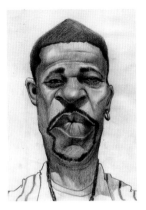

GRANDMASTER CAZ (page 38)

Curtis Brown, AKA DJ Casanova Fly, b. 1960, Bronx, NY

- Pioneer DJ/MC combo, songwriter; revered for his groundbreaking lyrics.
- 1974: Went to his first Kool Herc party.
- 1979: Big Bank Hank of Sugar Hill Gang used Caz's lyrics for "Rapper's Delight" without credit.
- 1980: Joined Cold Crush Brothers.
- 1983: Appeared in *Wild Style*.
- Late 1980s: Began solo career.
- 2000: Released "MC Delight" in response to "Rappers Delight" issue.

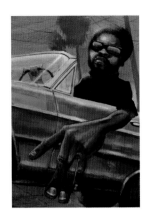

ICE CUBE (page 112)

O'Shea Jackson, b. 1969, Los Angeles, CA

- Rapper, member of N.W.A.; known for South Central L.A. point of view; producer, director, and actor.
- 1988: Wrote majority of lyrics on N.W.A.'s first album *Straight Out of Compton*.
- 1990: Released first solo album *AmeriKKKa's Most Wanted*.
- 1991: Acting debut in *Boyz in the Hood*.
- 1992: Released album *The Predator*.
- 1995: Cowrote and starred in film *Friday*.
- 2006: Honored at VH1 Hip Hop Honors.
- 2010: TV premiere *Are We There Yet*.
- 2010: Released ninth album *I Am the West*.

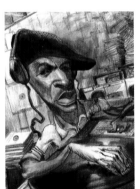

GRANDMASTER FLASH (page 32)

Joseph Saddler, b. 1958, Bridgetown, Barbados

- Raised in South Bronx, NY.
- Most famous for his group Grandmaster Flash and the Furious Five.
- Developed three standard DJ techniques: the Quick Mix Theory, Cuttin' (which inspired scratching), and the Clock Theory.
- 1981: Released "The Adventures of Grandmaster Flash on the Wheels of Steel" (the first time record scratching appeared on a record).
- 1982: *The Message* goes platinum.
- 1990s: Musical director for *The Chris Rock Show*.
- 2007: GFFF became the first rap group to be inducted into the Rock and Roll Hall of Fame.

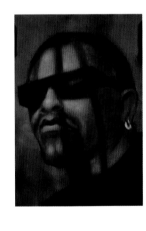

ICE-T (page 108)

Tracy Marrow, b. 1958, Newark, NJ

- Raised in South Central, Los Angeles.
- Ex-pimp and ex-thief turned pioneer of West Coast Gangsta Rap, actor, and author.
- Known for taking on subjects of politics, racism, the CIA, and police in his lyrics.
- 1984: Appeared in *Breakin'*.
- 1987: Released debut album *Rhyme Pays*.
- 1991: Released album *O.G. Original Gangster*.
- 1991: Starred in *New Jack City*
- 1991: Won Grammy for Best Rap Performance by a Group for *Back on the Block*.
- 1992: "Cop Killer" sparks national controversy and debate about violence in the media.

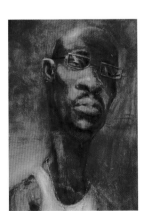

GURU (page 96)

Keith Edward Elam, b. 1961, Roxbury, MA; d. 2010

- AKA Gifted Unlimited Rhymes Universal, MC Keithy E.
- Rapper; known for his fusions of jazz and hip hop.
- 1987: Founded Gang Starr with DJ Premier
- 1993: Released first solo album *Jazzmatazz*, Vol. 1.
- 1995–2007: Released *Jazzmatazz*, Vol. 2, 3, and 4. The series featured jazz legends including Ramsey Lewis, Branford Marsalis, and Herbie Hancock, plus collaborations with Isaac Hayes, the Roots, and Erykah Badu.

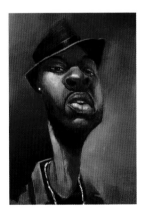

J DILLA (page 138)

James Dewitt Yancey, AKA Jay Dee, b. 1974, Detroit, MI; d. 2006

- MC, musician, and one of hip hop's most prolific producers for artists, including Busta Rhymes, De La Soul, the Pharcyde, the Roots, A Tribe Called Quest, and more.
- Late 1980s–early 1990s: Formed Slum Village.
- 1996: Released Slum Village's debut album, *Fantastic, Vol 1*.
- 2001: Earned two Grammy nominations for Common's "The Light" and Erykah Badu's "Didn't Cha Know."
- 2001: Released his solo debut, *Welcome 2 Detroit*.
- 2002: Teamed up with L.A. producer Madlib to form Jaylib.

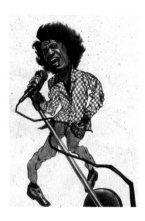

JAMES BROWN (page 16)

- AKA the Godfather of Soul, b. 1933, SC; d. 2006
- Award-winning singer, songwriter, dancer, and bandleader; highly influential to hip hop.
- 1956: Released "Please, Please, Please," which sold over a million copies.
- 1958: Released "Try Me," which reached #1 on the R&B charts.
- 1970: Released "Funky Drummer," said to be the most sampled individual song of all time, referenced in over 186 different hip-hop songs.
- 1984: Brown collaborated with Afrika Bambaataa on the single "Unity."
- Brown's works can be heard in over 1,200 hip-hop songs, making him the world's most sampled recording artist in history.

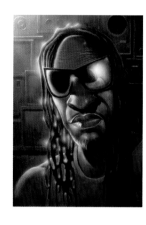

KOOL HERC (page 22)

Clive Campbell, AKA the Father of Hip Hop, b. 1955, Kingston, Jamaica

- Famous for inventing the DJ break-beat.
- 1967: Moved to Bronx, NY.
- 1973: Herc and his sister Cindy host a "Back-to-School Jam" in the recreation room of their building at 1520 Sedgwick Avenue. Herc premiered his innovative break-beat technique on the turntables and sparked a revolution in hip-hop culture. Recruited by Herc, Coke La Rock spits crowd-pleasing rhymes on the mic, which inspired "rapping" and a wave of new MCs overnight.
- 1984: Appeared in *Beat Street*.
- 2004: Honored at the VH1 Hip Hop Honors.
- 2007: 1520 Sedgwick Avenue recognized by state of New York as the birthplace of hip hop.

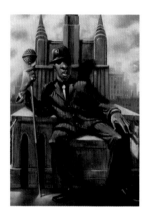

JAY-Z (page 126)

Shawn Carter, b. 1969, Brooklyn, NY

- Street hustler turned rapper, producer, and mogul.
- 1994: Appeared on Big Daddy Kane's "Show & Prove."
- 1996: Formed Roc-A-Fella Records with Damon Dash and Kareem Biggs.
- 1996: Released debut platinum-selling album *Reasonable Doubt*.
- 1999: Cofounded Rocawear.
- 2001: *The Blueprint* debutes at #1 on the *Billboard* 200.
- 2004: Named President of Def Jam Records and part-owner of the New Jersey Nets.
- 2008: Ranked #7 in the *Forbes* Celebrity 100 list.
- 2009: Released *The Blueprint 3*, his 11th album to reach #1 on the *Billboard* 200 (current record holder for solo albums).

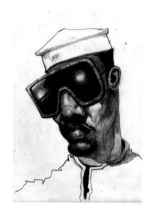

KOOL MOE DEE (page 36)

Mohandas Dewese, b. 1962, New York, NY

- Pioneer rapper; widely considered one of greatest of all time.
- 1970s: formed the Treacherous Three.
- 1981: Won infamous battle with Busy Bee Starski at club Harlem World.
- 1984: Appeared in *Beat Street*.
- 1986: Released first solo self-titled album, which ranked #83 on *Billboard*.
- 1990: Appeared on Quincy Jones' album *Back on the Block*, which won Grammy for Album of the Year.
- 1991: Appeared on *Boyz in the Hood* soundtrack.
- 2000: Appeared on *Love & Basketball* soundtrack.

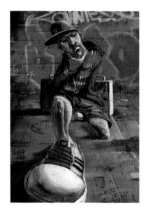

KEN SWIFT (page 56)

Kenneth Gabbert b. 1966, Brooklyn, NY

- Break-dance pioneer; established foundational techniques and styles.
- 1981: Co-vice president of Rock Steady Crew with Frosty Freeze.
- 1983–84: Appeared in *Wild Style* and *Beat Street*.
- 1983: RSC appeared on the *Letterman Show* and in *Flashdance*, achieving national attention.
- 1996: Cocreated off-Broadway's first hip-hop musical *Jam on the Groove*.
- 2010: Lifetime Achievement Award from Ultimate B-boy Championship.
- 2010: Awarded the NEA American Masterpieces in Dance Award.
- 2011: Named #2 Iconic Dancer of the Century by CNN's *Icon* program.

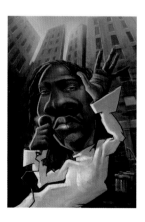

KRS-ONE (page 70)

Lawrence Kris Parker, b. 1965, Brooklyn, NY

- AKA Knowledge Reigns Supreme Over Nearly Everyone, the Teacher.
- Rapper; known for his politically-conscious lyrics.
- Raised in South Bronx.
- 1984: Formed Boogie Down Productions (BDP) with Scott La Rock.
- 1986: "Bridge Wars" feud begins between KRS and MC Shan regarding the origins of hip hop.
- 1987: Released *Criminally Minded*, dissing Shan in "South Bronx."
- 1993: Solo album *Return of the Boom Bap*, featured "Sound of da Police," a statement against institutionalized racism.
- 2008: BET Hip Hop Lifetime Achievement Award.

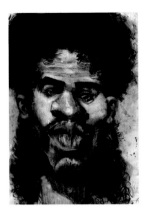

KURTIS BLOW (page 40)

Kurtis Walker, b. 1959, Harlem, NY

- One of the first commercially successful rappers; producer, actor.
- 1972: Started out as a b-boy and DJ.
- 1979: First rapper signed by major label (Mercury).
- 1980: Released "The Breaks," first rap single certified gold.
- 1980: First rapper to sample, record a national commercial, and use a drum machine; released ten albums over next eleven years.
- 1985: Collaborated with Bob Dylan; appeared in film *Krush Groove*.
- 1995: Radio host, Power 106.
- 2000s: Cofounder of the Hip Hop Church.

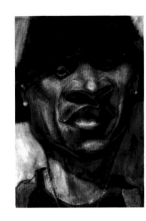

LL COOL J (page 76)

James Todd Smith, b. 1968, Bay Shore, NY

- AKA Ladies Love Cool James.
- Rapper, actor, author, and entrepreneur; one of hip hop's most revered talents.
- 1984: Met Rick Rubin; released Def Jam's first single "I Need a Beat."
- 1985: Released platinum debut album *Radio*.
- 1985: Cameo in film *Krush Groove*, about Def Jam's beginnings.
- 1990: Released "Mama Said Knock You Out," later winning Grammy for Best Rap Solo Performance.
- 2000: Released platinum album *G.O.A.T.*, #1 on *Billboard*.
- 2006: Launched apparel company Todd Smith.
- Presently stars in *NCIS: Los Angeles*.

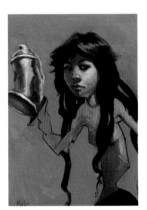

LADY PINK (page 62)

Sandra Fabara, b. 1966, Ambato, Ecuador

- Raised in Queens, NY.
- One of few female pioneer graffiti artists; work featured at Whitney Museum of American Art, Metropolitan Museum of Art, Brooklyn Museum of Art, and in Groninger Museum collections.
- 1979: Began her career writing graffiti while studying at the High School of Art and Design.
- 1983: Starred in film *Wild Style*.
- 1984: Featured in Martha Cooper's book *Hip Hop Files*.
- 1984: First solo art show at Moore College of Art.
- 2006: Featured at Brooklyn Museum of Art.
- Currently runs mural painting company PinkSmith Designs.

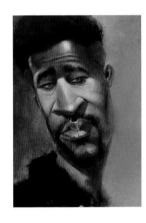

MARLEY MARL (page 42)

Marlon Williams, b. 1962, Queens, NY

- Pioneer hip-hop super-producer; one of the first to sample and reprogram breakbeats.
- Central producer for Cold Chillin' Records.
- 1980s: Produced Juice Crew (members included Big Daddy Kane, Biz Markie, MC Shan, Roxanne Shanté, Master Ace, and Kool G Rap); notorious for the Bridge Wars feud with Boogie Down Productions.
- 1980s: Cohosted legendary WBLS "Rap Attack" show with Mr. Magic.
- 1990: Produced LL Cool J's "Mama Said Knock You Out."
- 1990s: Worked with Rakim, TLC, Lords of the Underground, Fat Joe.
- 2007: Produced *Hip Hop Lives* with KRS-One, squashing past rivalry.

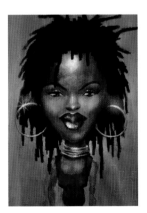

LAURYN HILL (page 98)

b. 1975, East Orange, NJ

- Singer, rapper, musician, actor, producer; known for fusion of MCing and singing skills.
- Early 1990s: Member of the Fugees.
- 1993: Starred in *Sister Act 2: Back in the Habit*.
- 1994: First album *Blunted on Reality* sold over 2 million copies.
- 1996: Second album, Grammy Award–winning *The Score*, went multi-platinum.
- 1998: Released solo album, *The Miseducation of Lauryn Hill*, earning five Grammys, including Album of the Year and Best New Artist.
- 2002: Reemerged with famed MTV *Unplugged* performance.
- 2004: Fugees briefly reunited.
- 2010: Headlined the Rock the Bells Tour.

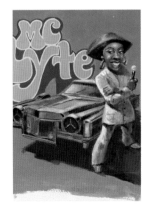

MC LYTE (page 94)

Lana Moorer, b. 1971, Brooklyn, NY

- First female rapper to release a solo album.
- 1988: Released debut album *Lyte as a Rock*.
- 1990: First rapper to perform at Carnegie Hall.
- 1993: Released fourth album *Ain't No Other*, featuring Grammy-nominated single "Ruffneck."
- 1996: Album *Bad as I Wanna B* featured up-and-coming Missy Elliot on "Cold Rock a Party."
- 2003: Nominated for Grammy for *Da Undaground Heat Vol. 1*.
- 2006: Donated belongings to Smithsonian hip-hop history collection.
- 2006: First solo female rapper to be honored at VH1 Hip Hop Honors.
- 2007: Coached Shar Jackson to win MTV's *Celebrity Rap Superstar*.

MELLE MEL (page 34)

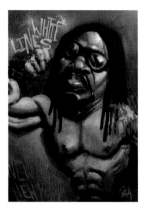

Melvin Glover, b. 1961, Bronx, NY
- Lead rapper and songwriter for Grandmaster Flash and the Furious Five.
- First rapper to call himself "MC" (Master of Ceremony).
- 1979: GFFF released "Super Rappin.'"
- 1982: Released "The Message," a seminal song in hip-hop history.
- 1983: Recorded "New York New York."
- 1983: Recorded "White Lines"—music video starred Laurence Fishburne, directed by Spike Lee.
- 1984: Featured on Chaka Khan's Grammy award–winning song "I Feel for You."
- 2007: Inducted into the Rock and Roll Hall of Fame.

MR. WIGGLES (page 52)

Steffan Clemente, South Bronx, NY
- Member of Rock Steady Crew, Electric Boogaloos, and Zulu Nation.
- Creator of essential popping, locking, floating, and tutting moves.
- 1980 to present: Performed thousands of shows in hundreds of countries worldwide.
- Early 1980s: Featured dancer in Wild Style, Beat Street, and at the Kennedy Center Honors.
- 1986: One of the first hip-hop dancers to perform in a Broadway show, The Mystery of Edwin Drood.
- 1989: Codeveloped hip-hop musical Jam on the Groove.
- 2004: Rock Steady Crew received a VH1 Hip Hop Honors award.

MICHAEL JACKSON (page 18)

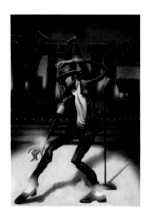

b. 1958 Gary, IN; d. 2009
- 1966: Joined his brothers to become the Jackson Five.
- 1979: Released Off the Wall, produced by Quincy Jones.
- 1982: Released Thriller, which became the highest-selling album worldwide, selling over 70 million copies.
- 1983: Historical performance debuting the "back-slide" during live broadcast of Motown 25: Yesterday, Today, Forever, Motown's 25th anniversary TV special.
- Sold more than 750 million records worldwide.
- Twice inducted into the Rock and Roll Hall of Fame.
- Thirteen Grammy wins; American Music Awards' Artist of the Century.

MUHAMMAD ALI (page 12)

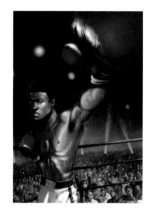

Cassius Marcellus Clay Jr., b. 1942, Louisville, KY
- Boxer; famous for his speed, wit, lyrical speech, political activism, and civil disobedience.
- 1960: Won the Light-Heavyweight Olympic Gold Medal.
- 1964: Won World Heavyweight Championship.
- 1966: Drafted and refused military service.
- 1967: Found guilty of refusing to serve in armed forces, stripped of championship title, banned from boxing for over three years.
- 1975: Beat Frazier in the "Thrilla in Manila."
- 1998: Named a United Nations Messenger of Peace.
- 2005: Received Presidential Medal of Freedom, the highest US civilian honor.

MISSY ELLIOT (page 130)

Melissa Elliot, b. 1971, Portsmouth, VA
- Rapper, producer; known for eccentric style and sound.
- Only female rapper with six albums certified platinum.
- Early 1990s: Formed R&B group Fayze, produced by friend "Timbaland" Mosley.
- 1996: Cowrote/produced multiple tracks for Aaliyah's album One in a Million with Timbaland.
- 1996: Appeared on MC Lyte's hit "Cold Rock a Party."
- 1997: Album Supa Dupa Fly featured "The Rain" (groundbreaking video directed by "Hype" Williams).
- 2001: Released Miss E...So Addictive, featuring hit "Get Ur Freak On."
- 2003: Album Under Construction Grammy-nominated for Best Rap Album and Album of the Year.
- 2005: Won AMA for Favorite Female Hip Hop Artist.
- 2007: Honored at VH1 Hip Hop Honors.

NAS (page 100)

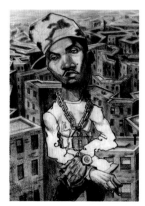

Nasir bin Olu Dara Jones, b. 1973 Brooklyn, NY
- AKA Nasty Nas.
- Rapper; known for powerful, poetic lyrics.
- 1991: Performed on Main Source's "Live at the Barbeque."
- 1994: Released Illmatic, widely considered one of the greatest albums in hip hop.
- 1996: "If I Ruled the World" (featuring Lauryn Hill) and "Street Dreams" (remix featuring R. Kelly) won Nas mainstream attention.
- 2001–2005: Highly publicized feud with Jay-Z.
- 2006: Released Hip Hop is Dead, which began the "Hip Hop is Dead" movement.

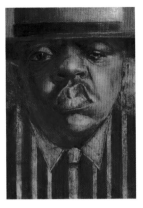

NOTORIOUS B.I.G. (page 124)

Christopher Wallace, b. 1972, Brooklyn, NY; d. 1997

- AKA Biggie Smalls.
- Rapper; one of main figures in feud between East and West Coast hip hop.
- 1992: Featured in *The Source*'s "Unsigned Hype" column as an aspiring rapper.
- 1992: Signed to Sean Combs' Bad Boy Records.
- 1994: Released debut album *Ready to Die*, which went platinum four times, shifting attention back to the East Coast rap scene.
- Early 1990s: Formed Junior M.A.F.I.A., launching Lil' Kim's career.
- 1997: Released fifteen days after his death, *Life After Death* hit #1 on the U.S. Album *Billboard* 200 charts.

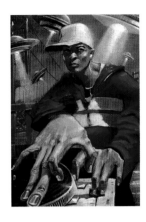

QBERT (page 132)

Richard Quitevis, b. 1969, San Francisco, CA

- DJ; known for significant innovations in scratching techniques.
- 1990: Joined FM20 with Mix Master Mike and DJ Apollo.
- 1990: FM20 invited to join Rock Steady Crew by Crazy Legs.
- 1992–94: DMC World Champion.
- 1994: Released solo album *Demolition Pumpkin Squeeze Musik*.
- 1995: Formed Invisibl Skratch Piklz.
- 1997: Inducted into the DMC DJ Hall of Fame.
- 2000: Created Thud Rumble, a media management company.
- 2001: Released first animated hip-hop movie *Wave Twisters*.
- 2009: Founded Qbert Skratch University.

PRESIDENT OBAMA (page 148)

Barack Hussein Obama, b. 1961, Honolulu HI

- 1983: Graduated from Columbia University and moved to Chicago, where he worked to rebuild communities in need.
- 1991: Graduated Harvard Law School and began teaching at the University of Chicago in 2002, continuing community service.
- 1997: Began first of three terms in the Illinois State Senate.
- 2004: Keynote Speaker at the Democratic National Convention.
- 2004: Elected to the United States Senate.
- 2008: Elected 44th President of the United States.

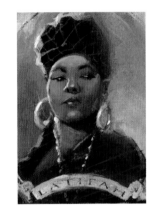

QUEEN LATIFAH (page 86)

Dana Owens, b. 1970, Newark, NJ

- Pioneer female MC, actor, author, entrepreneur.
- 1980s: Formed group Ladies Fresh as beatboxer; joins Afrika Bambaataa's Afrocentric Native Tongues collective.
- 1988: Solo demo hit radio; signed with Tommy Boy Records.
- 1989: Released first album, the feminist-flavored *All Hail the Queen*, featuring classic single "Ladies First."
- 1991: Created management company Flavor Unit, which later represented clients OutKast and Naughty by Nature.
- 1991: Acting debut in *Jungle Fever*.
- 1993–98: Starred in her FOX sitcom, *Living Single*.
- 2001: CoverGirl Cosmetics spokesmodel.
- Since 1990s, numerous film and music award nominations and wins.

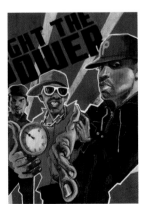

PUBLIC ENEMY (page 84)

Chuck D (Carlton Douglas Ridenhour), Flavor Flav (William Drayton, Jr.), Terminator X (Norman Lee Rogers); b. 1959–66, NY

- Pioneer rap group; known for militant, politically-charged lyrics.
- 1980s: Formed at Adelphi University, NY; Chuck D released tape of his rap "Public Enemy #1."
- 1987: Signed by Def Jam, began to tour with the Beastie Boys; released album *Yo! Bum Rush The Show*.
- 1990: Released *Fear of a Black Planet* (selected for preservation by Library of Congress, 2005), including "Fight the Power."
- 1990–93 Nominated for Best Rap Performance Grammy.
- 1991: Released single "Bring the Noise," a collaboration with thrash metal band Anthrax.

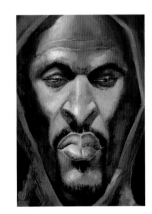

RAKIM (page 68)

William Griffin Jr., b. 1968 Long Island, NY

- Rapper; widely considered by both mainstream and legendary peers to be one of the best of all time.
- Raised in Wyandanch, NY.
- 1986: Teamed with Eric B., forming seminal duo.
- 1987: Duo released *Paid in Full*, considered a benchmark in hip hop for both Rakim's innovative internal rhyming technique and Eric B.'s heavy sampling.
- 1990: Released *Let the Rhythm Hit 'Em*.
- 1995: *Paid in Full* certified platinum.
- 1997: Released his first solo album, *The 18th Letter*.

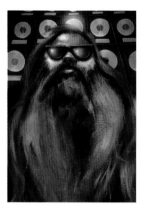

RICK RUBIN (page 74)

Frederick Jay Rubin, b. 1963, Long Beach, NY

- Grammy Award-winning producer of Run-D.M.C., Public Enemy, the Beastie Boys, and more.
- Founded Def Jam Records his senior year of high school, focused on punk rock.
- 1983: Coproduced T La Rock's "It's Yours" with DJ Jazzy Jay, marking transition into hip hop.
- 1984: Officially formed Def Jam with Russell Simmons; first release was LL Cool J's "I Need a Beat."
- 1986: Produced "Walk this Way" with Run-D.M.C. and Aerosmith.
- 2007: Listed in *Time* magazine as 100 Most Influential People in the World.

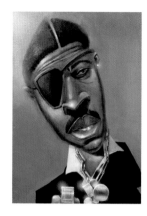

SLICK RICK (page 48)

Ricky Walters, b. 1965, London, UK

- AKA MC Ricky D, Rick the Ruler,
- Rapper; known for his original style of storytelling.
- 1975: Moved to the Bronx, NY; formed Kangol Crew in high school with Dana Dane.
- 1985: Performed on Doug E. Fresh's "La Di Da Di."
- 1988: Released debut solo album, *The Great Adventures of Slick Rick*, which hit #1 on *Billboard* R&B, featuring "Children's Story."
- 1999: Released fourth album, *The Art of Storytelling*.
- 2008: Honored at the VH1 Hip Hop Honors.

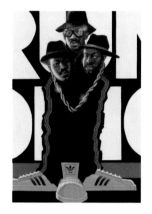

RUN-D.M.C. (page 78)

Joseph Simmons (Run), Darryl McDaniels (D.M.C.), Jason Mizell (Jam Master Jay); b. mid 1960s; Mizell, d. 2002

- Known as first global, mainstream rap sensation, for style, technique, and image.
- Early 1980s: Formed in Hollis, Queens, NY.
- 1983: Released first singles "It's Like That," "Sucker MCs."
- 1985: *King of Rock* first rap video to air on MTV.
- 1986: Album *Raising Hell* included "Walk this Way" (with Aerosmith) and "My Adidas"; one of the best selling rap albums of all time; double-platinum within months.
- 2007: Named "The Greatest Hip Hop Group of All Time" by MTV, VH1.
- 2009: Second hip-hop group ever inducted into the Rock and Roll Hall of Fame.

SNOOP DOGG (page 116)

Calvin Broadus, b. 1971, Long Beach, CA

- Rapper, actor, producer, pimp, hustler, household name; known for his appeal to both the 'hood and Hollywood.
- As a teenager, recorded homemade tapes with cousin Nate Dogg and friend Warren G.
- 1992: Featured in Dr. Dre's album *The Chronic*, marking career explosion.
- 1993: Released *Doggystyle* through Death Row Records, making the West Coast "G-funk" sound widely popular.
- 1996: Released *Tha Doggfather*.
- 2004: Created Snoop Youth Football League.
- 2008, 2009: Prepared baked goods as a guest on *The Martha Stewart Show*.

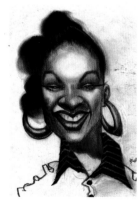

SHA-ROCK (page 44)

Sharon Green

- Raised in Bronx, NY.
- 1970s: First female MC.
- Would sneak out of her house to attend Kool Herc's parties.
- 1976: Joined the Funky Four Plus One More.
- 1980: Released "That's the Joint," which was ranked #41 on VH1's 100 Greatest Songs of Hip Hop (2008).
- 1981: First hip-hop group to perform on national TV on *Saturday Night Live* with Blondie.
- 1984: Performed with group Us Girls in *Beat Street*.
- 2002: Developed daughter Eboni Fox's (AKA T-Rock's) entertainment career.
- 2010: Published book *Luminary Icon*.

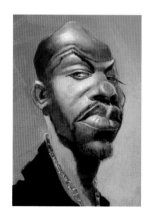

TOO SHORT (page 102)

Todd Shaw, b. 1966, Los Angeles, CA

- Raised in East Oakland, CA
- Rapper; known for West Coast hustler themes and raw lyrics; producer, actor.
- 1983: Released debut song "Don't Stop Rappin'."
- 1986: Cofounded Dangerous Music record label (later became Short Records and Up All Nite Records).
- 1993: Appeared in film *Menace II Society*.
- 1999: Came out of retirement, releasing 11th album, *Can't Stay Away*; guest appearances included Jay-Z, P. Diddy, E-40.
- 2006: Released *Blow the Whistle*, which went to #14 on the *Billboard* charts.
- 2008 Honored by the VH1 Hip Hop Honors.

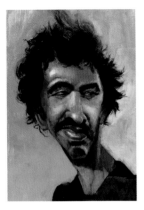

TRACY 168 (page 60)
Michael Tracy, b. 1958, New York, NY

- Pioneer graffiti artist; known for founding the "wildstyle" in the early 1970s and for his philosophy of unity and nonviolence.
- 1972: Founded the graffiti crew "Wanted."
- 1978: Began painting wall murals; first commission was for French Charley's Bar on Webster Avenue in Bronx. Became known for wall murals relaying positive messages and memorializing victims of urban violence.
- 2006: Featured in the Brooklyn Museum of Art.

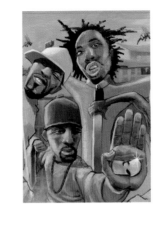

WU-TANG CLAN (page 144)
RZA (Robert Diggs), GZA (Gary Grice), Ol' Dirty Bastard (Russell Jones), Method Man (Clifford Smith), Raekwon (Corey Woods), Ghostface Killah (Dennis Coles), Inspectah Deck (Jason Hunter), U-God (Lamont Hawkins), Masta Killa (Jamal Turner); b. 1966–71; ODB d. 2004

- Rap group formed in 1993, Staten Island, NY.
- Known for distinct hard sound, martial arts ideologies, and teamwork mission for success.
- RZA coproduced and produced all group and solo albums released by WTC members.
- 1993: Released debut album *Enter the Wu-Tang (36 Chambers)*.
- 1994: Method Man first member to release solo album.
- 1995–96: ODB, Raekwon, GZA, and Ghostface released solo albums.
- 1997: Released multi-platinum *Wu-Tang Forever*, debuted at #1 on *Billboard*.
- 2007: Released *8 Diagrams*.

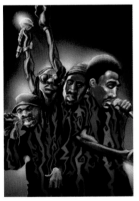

A TRIBE CALLED QUEST (page 90)
Q-Tip (Kamaal Fareed), Phife Dawg (Malik Taylor), Ali Shaheed Muhammad, Jarobi White; b. 1970–71, NY

- Known for positive music and Afrocentric aesthetic.
- Formed in 1985 in Queens, NY.
- Part of the Native Tongues Collective, along with other groups like De La Soul, Jungle Brothers.
- 1990–98: Released five albums.
- 1999: *The Love Movement* nominated for a Grammy Award for Best Rap Album.
- 1998: Disbanded.
- 2005: Received a Special Achievement Award at the Billboard R&B Hip Hop Awards.
- 2006: Reunited.
- 2007: Honored at the VH1 Hip Hop Honors.

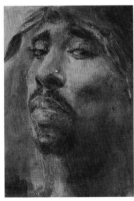

TUPAC (page 122)
Tupac Amaru Shakur, b. 1971, Harlem, NY; d. 1996

- Raised in NY; Baltimore, MD; Oakland, CA; and Marin City, CA
- Top-selling rapper, actor.
- One of main figures in feud between East and West Coast hip hop.
- Mother, Afeni Shakur, was a member of the Black Panthers.
- 1990: Backup dancer and roadie for Digital Underground; debuted rapping skills on DU's "Same Song."
- 1991: Released first solo album *2Pacalypse Now*.
- 1992: Film debut in *Juice*.
- 1995: Released *Me Against the World* from prison, which went #1 on the *Billboard* 200.
- 2010: "Dear Mama" inducted into the Library of Congress' National Recording Registry for its cultural, historical, and aesthetic significance.